A. C. SEWTER

BA. AND
ROCOCO
ART

with 176 illustrations

T & H

UDSON

To my friend and colleague
Frank Jenkins,
whose encouragement sustained me
while writing the architectural chapters

© 1972 Thames and Hudson Limited, London
Filmset by Keyspools Ltd, Golborne, Lancashire
Printed by Imprimeries Studer S.A., Switzerland
Bound by Van Rijmenam n.v., The Netherlands

0 500 62004 0 CLOTHBOUND
0 500 63004 6 PAPERBOUND

Contents

Acknowledgments

The publishers are indebted to the museums and collectors who provided photographs of works in their possession, and also to the following individuals and institutions who supplied photographs or allowed them to be reproduced.

Copyright A.C.L. Brussels 50, 68, 122; Alinari 105; Anderson 98, 99; B. T. Batsford 174; W. G. Belsher 43; Dr. Alan Braham 175; Bulloz 48, 54, 70, 76, 118, 119; A. C. Cooper 82; Copyright *Country Life* 126, 130; Courtauld Institute of Art, University of London 78, 146, 167; Deutsche Fotothek Dresden 171; Gabinetto Fotografico Nazionale 3, 24, 109, 143; Giraudon 47, 52, 58, 91, 117, 128, 136; Hirmer Fotoarchiv 170; A. F. Kersting 125, 140; Lauros-Giraudon 63; National Monuments Record London 127; Mansell-Alinari 1, 2, 5, 9, 12, 13, 15, 19, 20, 23, 25, 26, 29, 30, 87, 145, 163; Mansell-Anderson 4, 8, 14, 18, 27, 33, 34, 38, 41, 77, 101, 102, 104, 106, 107, 108, 113, 158, 159, 176; Bildarchiv Foto Marburg 120, 168, 169; Mas 28, 36, 45, 46, 65, 81, 121, 139; Georgina Masson 100, 110; Malta Government 31; F. A. Mella 162; Ministry of the Environment 124; Archives Photographiques Paris 116, 129, 177; Studio Piccardy 67; G. Rampazzi 160; Reilly & Constantine 144; Studio R. Remy 49; Rijksdienst v.d. Monumentenzorg 123; Sansoni 22; Scala 6, 10, 11, 17, 40; Toni Schneiders 165, 166; Helga Schmidt-Glassner 164; Tom Scott 138, 150; S.C.R. Photo Library 141; A. C. Sewter 111, 114; Edwin Smith 115, 172, 173; Walter Steinkopf 131; Leonard & Marcus Taylor Ltd. 142; Eileen Tweedy 148, 153, 156; John Webb (Brompton Studio) 35, 55, 61, 152, 157.

The history of art is a continuous process, and not a series of separate cycles of birth, development and decay. Yet there are some periods when achievement seems to reach very high levels of quality and vitality, some periods of rapid transformation, and others of relative stagnation, such as, for example, the last years of the 16th century. The great masters of the High Renaissance were all dead. Raphael had died in 1520 at the age of 37, and the last of the giants, Jacopo Tintoretto, at the age of 76 in 1594. The whole generation of the inventors of Mannerism, from Rosso and Parmigianino to Cellini, Bronzino and Vasari, had passed from the scene by 1574. In Italy, the stage was left to painters like Federico Zuccaro, Palma Giovane, Federico Barocci and Cesare d'Arpino. The sculptor Giovanni da Bologna lived until 1608, but all his most important works were done before the end of the 16th century. In architecture too, Palladio, Vignola and Sansovino were all dead. Only in northern Europe was any vitality left in the Mannerist tradition, with artists such as Hendrik Goltzius, Abraham Bloemart, Marten de Vos and Paul Bril in the Netherlands, Jacques Callot and Jacques Bellange in France, and the German Adam Elsheimer. More decisively than at any time since the beginning of the Renaissance, about 1425, the 1590s mark the end of one phase and the beginning of another.

The deliberate eccentricity of Mannerism had removed art, tightly constricted by rules and prohibitions, from the experience of ordinary people. The Council of Trent, called in 1545, must bear a large share of responsibility for this situation. Charged with the tasks of settling the disputes on questions of religious doctrine raised by the schisms of the Reformation, of reforming ecclesiastical abuses, and of taking action against infidels and heretics, its findings, published in 1564–8, consisted, in the main,

of a reaffirmation of all the challenged dogmas. The chief documents which it produced consisted of a Catechism and a set of ten rules for the prohibition of books. One consequence was an increase in the power and activity of the Inquisition, which charged a number of artists, such as Veronese and Ammanati, with introducing improprieties. The restrictiveness of late Mannerist art is well expressed in the work of its principal theorist, Giovanni Paolo Lomazzo, whose *Treatise on the Art of Painting* was published in 1584. The following is a typical passage: 'Whatever action a figure is engaged in, its body must always appear so twisted that if the right arm is extended forward or makes any other gesture designed by the artist, the left side of the body shall recede and the left arm be subordinate to the right. Likewise, the left leg shall come forward and the right leg recede.' An escape from such a systematic strangulation of creative talents had become an urgent necessity. Revitalization of the arts depended on the removal of the barriers between the world of the senses and that of the spirit, the renewal of contact between art and nature. This is precisely what the Baroque artists achieved, inspired by a conviction of the power of the body to express the spirit. For the Baroque artist, in the words of J. B. Dubos's *Critical Reflections upon Poetry and Painting* (1719), 'the first aim of Painting is to move us'.

The new style came as a release and a fulfilment, and led to an exuberance and splendour of artistic production which made the 17th century one of the great periods of European culture, in painting, sculpture, architecture, poetry, music, science and philosophy.

'Baroque' was originally a term of abuse, apparently derived from the Portuguese word 'barroco', meaning a large, irregularly shaped pearl, which by extension came to mean anything contorted or eccentric. The term began to gain more general currency only towards the end of the 18th century, when Francesco Milizia, in his *Dizionario delle Belle Arti,* published in 1797, defined it as 'the ultimate in the bizarre: it is the ridiculous carried to extremes'.

The use of the word without pejorative intention dates from Heinrich Wölfflin's book *Renaissance und Barok,* published in 1888. He saw the art of the later 16th and early 17th centuries not as a mere degenerate, over-ornamented version of Renaissance classicism, but as a

style in many ways opposite to that of the Renaissance. In that book, and in the later *Principles of Art History* (1915), Wölfflin attempted to define its characteristics; his analysis employed a series of opposed pairs of concepts: linear and painterly, plane and recession, closed form and open form, unity and multiplicity, and so on. These criteria are by no means clear-cut or precise, especially when applied to the interpretation of style in a variety of media – painting, drawing, sculpture and architecture. Wölfflin himself admitted that many works which belong historically to the Renaissance might be more painterly, more recessional, more open in composition than those created in the Baroque period. Nevertheless, the influence of his analytical methods has been profound, largely because of his perceptive responses to individual works. But in two important respects his conclusions no longer seem to be valid. Firstly, the period to which he applied the term Baroque was the eleven decades from about 1520 to 1630, with the year 1580 marking the attainment of the mature Baroque style. Art historians now apply the term Baroque to the style which emerged about 1600 or shortly afterwards, and lasted throughout the 17th century. Secondly, Wölfflin tended to endow the notion of Style with a kind of independent existence, as if artists or works of art were mere instruments for some supra-personal force, suggesting that Renaissance and Baroque might be regarded as manifestations of contrary principles which alternately gain dominance of man's sensibility in a kind of pendulum swing of history. Literary and musical historians have tended, recently, to 'use the term Baroque as a label to cover everything from Bernini's convoluted columns to Milton's lofty poetry and the intricately wrought chorales of Bach', as Frederic V. Grunfeld has put it. The danger of such a usage lies in the ease with which it leads to the assumption that everything produced within those limits of time is Baroque in the same sense, whereas it is often the differences and contrasts which are more striking than the similarities.

Art historians in recent years, indeed, have been inclined to stress a number of divergent or even contrary tendencies in the art of the 17th century. Germain Bazin, for instance, in his book *The Baroque,* has indicated so many divergent elements within the art of the 17th and 18th centuries that the concept of a unified Baroque style

no longer seems tenable. The individual work of art and the individual artist must be studied first, then the more general cultural context. Any definition of the Baroque implicit in this book must emerge from this process of study.

The term Rococo is even less satisfactory as a general label for the art style of a period. Within the six or seven decades during which it flourished, other stylistic move‑ments were perhaps of equal importance: Palladianism, Neo‑Classicism and early Romanticism. One can say only that it is one style among several through which the culture of the 18th century expressed itself. The word itself, first applied derisively late in the century, apparently derives from the French term *rocaille*, which referred to the accumulations of rockwork, shells, plants and scrolls fashionable in French decoration of the time of Louis XV. Originally, the Rococo was no more than a style of ornament. Art‑historians have extended its application to painting, sculpture, and architecture, but in discussions of eighteenth‑century art, usage of the terms Baroque and Rococo is still inconsistent and confusing. The music of Vivaldi, Scarlatti, Handel, Bach and Rameau, for instance, is commonly referred to as Baroque; so also are the churches of Neumann, Prandtauer, Dientzenhofer and Zimmermann; but the paintings of Watteau, Boucher and Fragonard, and even Chardin, Hogarth and Gainsborough are usually called Rococo. There is, indeed, such continuity of development in architecture, for instance, from the Roman Baroque of Bernini, Pietro da Cortona and Borromini, through the north Italians Guarini and Juvarra to the 18th century achievements in Germany and Austria, that it is difficult to see the last as the flowering of a new style, rather than as a late phase of the Baroque style.

Since this last phase of the Baroque overlapped in time the beginnings of new stylistic movements, the account in this book of art in the first three quarters of the 18th century must be incomplete. In the succeeding volume, which will deal with the period of Neo‑Classicism and Romanticism, other aspects of the art of these decades will be considered.

CHAPTER ONE

Signs of change: Early Baroque painting in Italy

About 1595, Annibale Carracci, the most gifted of a family of distinguished artists from Bologna, where they had collaborated in the decoration of various palaces, was summoned to Rome by Cardinal Odoardo Farnese in order to decorate the gallery on the first floor of the Palazzo Farnese (*Ill. 2*), a task in which he was assisted, between 1597 and 1604, by his brother Agostino and by several pupils. The theme of the frescoes was the loves of the gods of antiquity, illustrated by scenes from Ovid's *Metamorphoses*. The decorative scheme, in some respects typically Mannerist, also provides evidence of a new sort of sensibility.

Above the cornice, simulated herms support an imaginary higher cornice which appears to carry the curved vault of the ceiling, containing three painted scenes. The central one is surrounded by a painted imitation of a carved and gilded frame; the two lateral ones by tapestry-like borders. Between each pair of herms are simulated bronze medallions with reliefs, and in the alternating spaces are scenes glimpsed, as it were, through the imagined architectural structure. Against the bases of the herms sit a series of nude youths, clearly recalling, as do the bronze medallions between them, features of Michelangelo's Sistine Chapel ceiling. And in the centre of each wall, painted as if on separate framed canvases, are pictures apparently standing at an angle upon the real cornice, and held at the top corners by little satyrs seated upon the imaginary upper cornice. In the corners of the coving, through apparent openings in the structure, little winged *putti* are silhouetted against the sky. Despite the crowding and overlapping of many elements, every part has a clear function and spatial logic.

These frescoes in the Palazzo Farnese are of seminal importance for the art of the early 17th century: not only

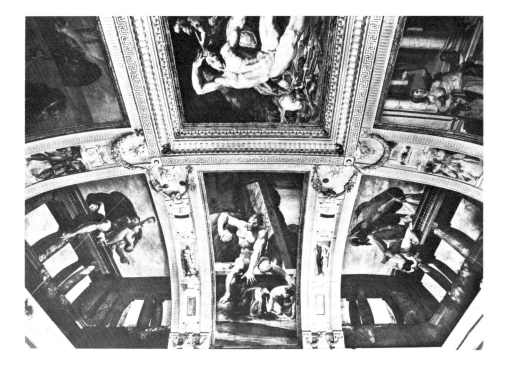

1 PELLEGRINO TIBALDI (1527–
96) *Ceiling of the Palazzo Poggi,
now the University, Bologna, 1550–
60. Fresco*

do they suggest the example of Michelangelo, but they also, especially in the scenes of *Bacchus and Ariadne* and *Galatea,* make deliberate references to antique sarcophagi and to Raphael, as the *putti* do to those of Correggio. Carracci sought here to recapture the clarity of the classical spirit. One of his means was a return to the working method of Raphael and Michelangelo; the whole complex was carefully prepared in an immense series of drawings, ranging from rough sketches of compositions to detailed studies from the nude.

Nevertheless, certain aspects of the scheme are in no sense classical. The scenes in the imitated canvases standing upon the cornice, and most especially the *Polyphemus hurling a rock at Acis* (*Ill. 3*), have a massiveness, a gravity, a passionate expressiveness, and a tendency to burst forward out of their frames. Many aspects of the entire scheme were undoubtedly influenced by one of the masterpieces of Bolognese Mannerism, Pellegrino Tibaldi's ceiling decoration in the Palazzo Poggi (now the University) in Bologna (*Ill. 1*) painted in the 1550s. Carracci's scheme is more complex and fragmented, and in this respect more Mannerist. But, whereas Tibaldi's

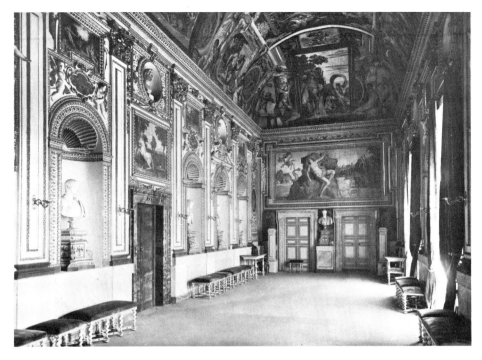

2 ANNIBALE CARRACCI (1560–1609) *Ceiling of the Gallery, Palazzo Farnese, Rome, 1597–c. 1600. Fresco*

3 ANNIBALE CARRACCI (1560–1609) *Polyphemus hurling a rock at Acis (detail of Ill. 2)*

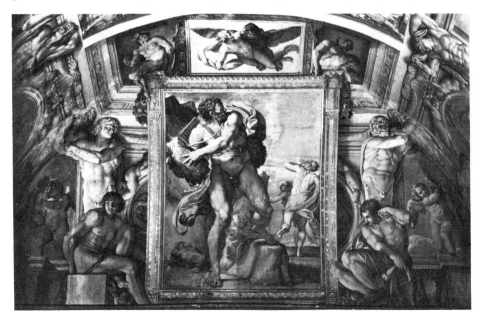

4 ANNIBALE CARRACCI (1560–
1609) *The Flight into Egypt, c.
1603. Oil on canvas, 4′×7′ 7″
(122×230). Doria-Pamphili Gal-
lery, Rome*

figures are all set in imaginary pictorial space beyond the
real painted surfaces, Carracci's most expressive figures
are apparently inside the architectural structure, thus
involving the spectator far more intimately in the drama
of the whole. This new assertion of involvement with
human values is very significant.

Whereas the Mannerist artist's essential aim was, as
Vasari put it, 'to show his ability', which led him into all
sorts of ingenious conceits and eccentricities, Carracci
combined his adherence to great ancient and modern
artistic authorities with a renewed direct study of nature.
His drawings of the nude are as remarkable for their
naturalism as for their sense of mass and their economy
of statement, and a painting like the *Butcher's Shop*, in
the gallery at Christ Church, Oxford, evinces a direct-
ness of contact with everyday common life which was
quite unknown to Italian Mannerism. The same blend-
ing occurs in his landscapes. In *The Flight into Egypt*
(Rome, Doria-Pamphili Gallery) (*Ill. 4*) the principles
of composition have been derived from the study of
Titian's landscape backgrounds and drawings, and of
Paolo Veronese's landscapes, such as those in the Villa
Maser, but they are rendered with the conviction of
direct response.

Lodovico Carracci, the eldest of the three artists of the
family, remained in Bologna, where he ran the Academy
which he and his cousins founded in 1585. His paintings,

mostly altarpieces, had less originality and vitality than Annibale's, but he too exerted an important influence on the painters of the next generation, especially in the passionate, ecstatic or tender feeling expressed by his figures, and in the rich colour and light effects of such pictures as *The Holy Family with St Francis* (Cento, Museo Civico) (*Ill. 5*), painted in 1591.

In the same years when the Carracci were at work on the Farnese ceiling, Michelangelo Merisi, known as Caravaggio from the place of his birth, was also at work in Rome, where he arrived about 1590–2, after having served an apprenticeship in Milan to a minor painter called Simone Peterzano, reputedly a pupil of Titian. Caravaggio's early Roman works are mostly smallish pictures with emblematic or allegorical connotations, as for example the *Bacchus* in the Uffizi at Florence (*Ill. 6*). The still-life parts show great accomplishment; the drawing of the figures is comparatively unsure. But the figures claim attention, whereas the backgrounds are almost totally undefined.

5 LODOVICO CARRACCI (1555–1619) *Holy Family with St Francis,* 1591. Oil on canvas, 7′ 5″×5′ 5″ (225×166). *Museo Civico, Cento*

In the *Bacchus*, the focus is on the sensuous curves of the shoulder, and the effeminate, alluring facial expression. These homosexual implications are borne out in other pictures by Caravaggio, for instance, the *Lute Player* in the Hermitage Museum in Leningrad and *Love Victorious* (Berlin, Staatliche Museen). The question of the relationship between Caravaggio's character and his work is unavoidable. Throughout his life, the violence of his temperament brought him into conflicts with individuals and with the authorities; he was often in gaol, though usually some artist friend or influential person managed to secure his release. In 1606, however, Caravaggio killed a certain Ranuccio Tommasoni in a fight and was himself wounded. He fled from Rome, and a few months later reappeared in Naples, painting pictures for churches, while friends in Rome endeavoured to obtain a pardon for him. Early the following year he was in Malta, painting portraits of the Grand Master of the Order of St John, and receiving the commission for the great altarpiece of *The Beheading of John the Baptist* for the Oratory of the Conventual Church (now in the Museum of the Co-Cathedral of St John, Valletta) (*Ill. 12*), as well as being admitted into the Order. Less than three months later, a criminal commission was charged with the duty of collecting information about offences by him. Caravaggio, however, managed to escape from the prison of St Angelo, in violation of his oath of obedience, and was ignominiously expelled from the Order. This time he fled to Sicily, where he painted altarpieces for churches in Syracuse, Messina and Palermo, but he returned to Naples a year later. There he was attacked and so severely wounded that reports of his death reached Rome, where Cardinal Gonzaga was on the brink of success in his efforts to obtain a pardon. In July 1610 Caravaggio took a ship for Rome, but was arrested at Porto Ercole, by a tragic and ironic mistake, and lost all his belongings on the ship, which had left without him. Destitute and ill with malaria, he died at the age of thirty-six in a village nearby on 31 July, the very day on which his papal pardon was announced.

How could this 'corrupt and stinking member', in the words of the Knights of Malta, have created great works of religious art, which influenced the course of development of European painting? There are, indeed, plenty of signs in Caravaggio's paintings of the more repulsive

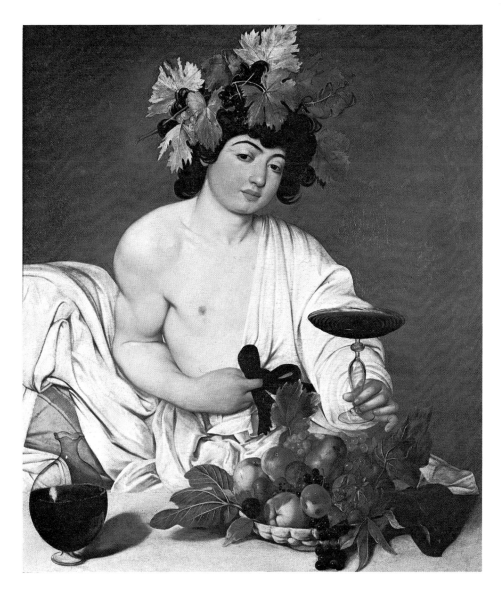

sides of his character, but also numerous indications of his tenderness, sympathy, and genuine religious devotion. His contradictory character lent a dramatic and compelling intensity to all his creations.

In discussions of his style, his realism and his chiaroscuro have always been given primary emphasis. According to Karel van Mander, a contemporary, Caravaggio maintained that 'all works are nothing but childish

6 CARAVAGGIO (1573–1610) *Bacchus, c. 1591. Oil on canvas, 37⅜″ × 33½″ (95 × 85). Uffizi, Florence*

17

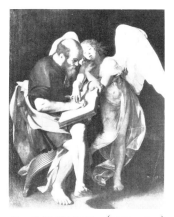

7 CARAVAGGIO (1573–1610)
The Inspiration of St Matthew,
1602 (destroyed). Oil on canvas,
7′ 4″ × 6′ (223 × 183). Formerly
Kaiser Friedrich Museum, Berlin

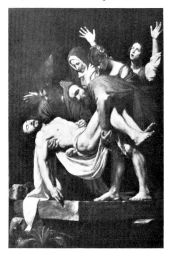

8 CARAVAGGIO (1573–1610)
The Entombment of Christ, c. 1603.
Oil on canvas, 9′ 10″ × 6′ 6″ (300 ×
203). Vatican Gallery, Rome

trifles . . . unless they are made and painted from life. . .' This literalness and the absence of any attempt to idealize his models may be seen in the first version of *The Inspiration of St Matthew* (now destroyed) (*Ill. 7*), painted for the Contarelli Chapel in the church of San Luigi dei Francesi in Rome. The saint is presented as a squat, weatherbeaten peasant whose hand, resting on the page of the open book, is guided by a young angel. The clergy objected to it, considering it improper, but realism was a means to the end of conveying the most tangible and immediate physical sensation. Caravaggio's treatment of space is even more significant. The saint's left foot seems to project out of the picture-space towards the spectator, and the dark background throws the forms into relief, without conveying any sensation of recession. In the surviving version (still in the church for which it was painted), he gives a similar forward projection to the stool, one foot of which hangs unsupported over the edge of the platform which limits the composition at the bottom, and the eye-level is such that the spectator looks upward at the entire subject. The nearest comparable case in Caravaggio's work of such a low viewpoint is the *The Entombment of Christ* (Rome, Vatican Gallery) (*Ill. 8*), where the eye-level corresponds with the top of the stone slab on which the bearers of the holy corpse stand. The psychological effect of this angle of view is perhaps not unconnected with the fact that *The Entombment* was the most enthusiastically admired of Caravaggio's works throughout the 17th century. But his normal preference was for a point of view which brought the spectator into the most intimate relationship with the subject, as in the *Madonna di Loreto* (Rome, Sant' Agostino) (*Ill. 12*), in which the eye-level helps the viewer to identify himself with the adoring peasants.

The almost totally non-spatial scheme of composition in these early pictures has two consequences: the rarity of landscape in Caravaggio's art – there are only two pictures in which landscape plays a part of any importance, namely the *Rest on the Flight into Egypt* and *The Sacrifice of Isaac* (Florence, Uffizi), unless one also accepts as by Caravaggio the *St Francis in Ecstasy* in the Wadsworth Atheneum at Hartford, Connecticut – and the tendency, especially in his two paintings, of *The Crucifixion of St Peter* and *The Conversion of St Paul,* for the church of Santa Maria del Popolo in Rome, to make the figures fill

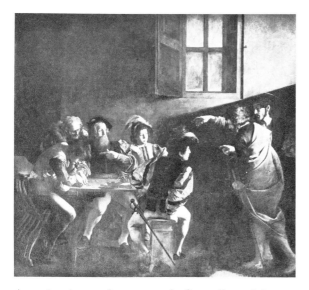

9 CARAVAGGIO (1573–1610)
*The Calling of St Matthew, 1599–
1600. Oil on canvas, 10′ 9″ ×
11′ 5″ (328 × 348). Contarelli
Chapel, San Luigi dei Francesi,
Rome*

the entire picture, almost up to the frame. Later, it is true, in the great Valletta *Beheading of John the Baptist, The Burial of St Lucy* at Syracuse, and *The Raising of Lazarus* (Messina, Museo Nazionale), Caravaggio left spaces in the upper parts of the canvases, but he limited recession by the indication of architectural backgrounds closing the compositions at points not far behind the figures.

His revolutionary use of chiaroscuro, most clearly seen in *The Calling of St Matthew* (*Ill. 9*), one of the three pictures painted for San Luigi dei Francesi, possibly had a related purpose. The dramatic lighting is clearly non-realistic; the window in the background seems not to affect the illumination of the interior at all.

All these devices – realism, the use of viewpoints on a level with the subjects, the concentration of the figures in the immediate foreground, the avoidance of background recession, the dramatic lighting – were aimed at making Caravaggio's subjects seem physically present to the beholder; this objective was Caravaggio's most important contribution to the genesis of the Baroque.

The chronology of his development, despite some controversial dating, is essential to the understanding of his historical role. The composition of *The Martyrdom of St Matthew* (*Ill. 10*), one of his most important early commissions (1602), is based upon dynamic outward movements contradicted by downward and inward ones.

19

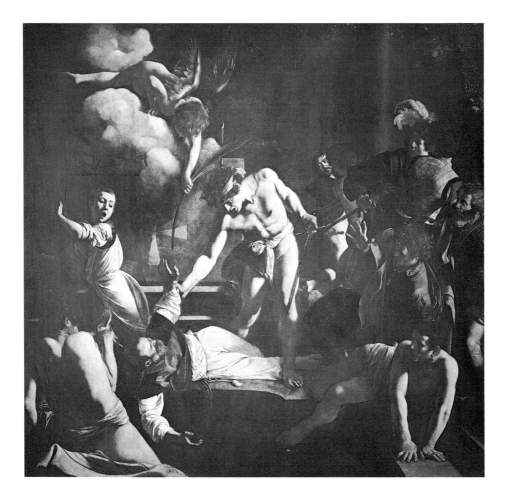

10 CARAVAGGIO (1573–1610)
*The Martyrdom of St Matthew,
1602. Oil on canvas, 10′ 9″ ×
11′ 5″ (328×348). Contarelli
Chapel, San Luigi dei Francesi,
Rome*

Similar agitated and contrary movements in the first rejected canvas of *The Conversion of St Paul* (Rome, Odescalchi–Balbi collection) show that, at this stage of his development, Caravaggio sought to use the visual excitement of such violent linear discords, which are more Mannerist than Baroque, as a means of expressing the intensity of the dramatic action. Even as late as in two major works of his Neapolitan period, the *Madonna of the Rosary* (Vienna, Kunsthistorisches Museum) and *The Seven Works of Mercy* (Naples, Pio Monte della Misericordia), something of this Mannerist agitation persists, but by 1605 Caravaggio had turned to quieter, subtler means of expression in the *Madonna di Loreto* (Rome, Sant' Agostino) (*Ill. 12*), while it is the self-absorption of the

mourners and the absence of any such display of gesture which give intensity of pathos to *The Death of the Virgin* (Paris, Louvre), probably painted (or at least begun) in the same year.

Paradoxically, it was in his last troubled years of flight that the artist achieved a unique quietude and mystery. In the *Adoration of the Shepherds* at Messina (Museo Nazionale), his use of the stillness of space is something quite new. Most interesting of all, perhaps, is the Valletta picture of *The Beheading of the Baptist (Ill. 11)*, where Caravaggio employed a more carefully considered archi‚ tectural setting than in any other picture. The figures are arranged almost symmetrically within a semi‚circle set somewhat to the left, against the background of a palace with a great arched doorway. Salome, bending forward with her great dish, balances the figure of the executioner holding the saint's head by its hair. Between them stand Herodias and the gaoler; the body of the Baptist lies across the centre of the composition. On the right, two men watch the gruesome scene through a barred window. For all its ordered geometry, conveying the sense of some inescapable ritual, this great canvas is painted with spontaneity and has a texture totally unlike that of the earlier pictures. It stands, as it were, halfway between Raphael's *Liberation of St Peter* in the Vatican Stanze

11 CARAVAGGIO (1573–1610) *The Beheading of St John the Bap‚ tist, 1608. Oil on canvas, 11' 10"× 17' 1" (361 × 520). The Museum of the Co‚Cathedral of St John, Valletta*

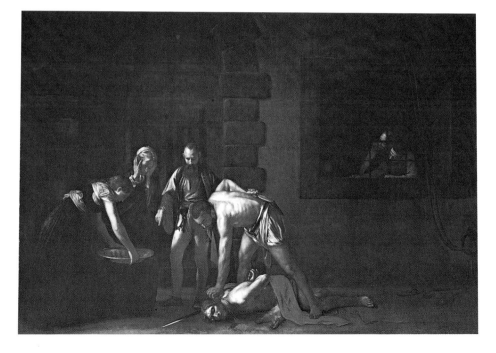

(which may possibly have suggested to Caravaggio the barred prison window) on the one hand, and Rembrandt's *Night Watch* (in which the background is curiously similar) on the other. It is one of the great masterpieces of the century.

The perfection of balance between formal design and intensity of expression is not maintained in *The Burial of St Lucy* (Syracuse, Santa Lucia) and *The Raising of Lazarus* (Messina, Museo Nazionale), but an energy and freedom of brushwork, an almost Expressionist urgency in the crowding together of figures, remind one of Rembrandt rather than of anything painted in the 16th century, and indicate the immensity of Caravaggio's achievement in eighteen years.

Both Annibale Carracci and Caravaggio exercised potent influences on the development of 17th century painting. Caravaggio had no school and no pupils, but from the first establishment of his fame in Rome by the pictures at San Luigi dei Francesi, imitations, mainly of his early genre scenes, had become a recognizable movement, of which Bartolommeo Manfredi, the Dutchman Gerrit van Honthorst, and the Frenchman Le Valentin were the chief protagonists. In Naples a Caravaggesque style was adopted by Giovanni Battista Caracciolo, and by the Spaniard Jusepe de Ribera. The Fleming Lowys Finsonius carried Caravaggism to France: Honthorst, Hendrik Terbrugghen and Dirk van Baburen transmitted it to Utrecht, which became the centre of Caravaggism in the north. The master's late works had less influence, but the Bolognese Lionello Spada was in Malta at the same time, and in some works was close to Caravaggio in style; while the Sicilian painter Alonzo Rodriguez absorbed a little from direct contact with him in Messina.

Most of these followers responded to specific elements of Caravaggio's style rather than to his personality, and in many cases the influence was gradually modified. Caravaggism as a movement declined after 1620.

The Carracci, on the other hand, not only founded and directed a regular academy in Bologna, but Annibale was followed to Rome by a number of brilliant young artists whom he trained as pupils and assistants. The next stage in the development of the Italian Baroque style and the origins of the Baroque proper may be traced in the works of these men during the ensuing twenty years.

12 CARAVAGGIO (1573–1610) Madonna di Loreto, c. 1604. Oil on canvas, 8′ 6″×4′ 11″ (260×150). Sant'Agostino, Rome

CHAPTER TWO

High Baroque painting in Italy

Domenico Zampieri, known as Domenichino, had been an assistant to Lodovico Carracci before going to Rome in 1602 to help Annibale on the Farnese ceiling; his is the charming landscape with a virgin and unicorn. In his independent works of the next two decades, Domenichino at first adopted a position even more determinedly classical than his master's, but gradually evolved towards a more dynamic style. The change is apparent in his two fresco representations of *The Execution of St Andrew*, the first in San Gregorio, Rome, painted in 1608, the second on the ceiling of the choir in Sant'Andrea della Valle, painted between 1622 and 1628. In the earlier painting (*Ill. 13*), the scene is set beside a Roman temple; its portico rises exactly centrally in the composition, and the foreground space is defined by lines of marble paving corresponding precisely with the orthogonals and trans⁄

13 DOMENICHINO (1581–1641)
The Execution of St Andrew, 1608–
10. Fresco. San Gregorio, Rome

versals of the perspective. Within this somewhat rigid setting, the figures are disposed in three distinct groups. In the right foreground, the saint lies on a table parallel to the picture-plane, surrounded by executioners, one of whom upsets the symmetry of the group with his dynamic diagonal movement. With an equally vigorous counter-diagonal, a soldier pushes back a group of women and children; other spectators watch from the portico. In spite of a few energetic movements, the composition establishes a complete formal equilibrium. In the later painting (*Ill. 14*), partly no doubt because of its awkward asymmetrical shape, dictated by the structure of the ceiling, the architectural setting has no such regularity; to right of centre, a wall ending in an attached half-column leads into a deep perspective recession; the body of the saint, suspended between posts to which his limbs are tied, also recedes steeply in the same direction. One figure, who has been tying the saint's foot to a post, sprawls on the ground as the rope breaks; the others move about in a variety of postures. In the perspective of this scene there

14 DOMENICHINO (1581–1641) *The Execution of St Andrew,* *1622–8. Fresco. Sant'Andrea della Valle, Rome*

25

is no concession whatever to the angle from which it is seen. All the compartments on this ceiling, indeed, except one which represents St Andrew ascending to heaven, are painted as if they were to be hung on a wall. The whole effect is more mobile, but this is still a classical style, in the distinctness of the individual figures, and in the attempt to establish an equilibrium of forces.

The four pendentives below the dome in the same church, painted by Domenichino in the same period, display a quite different style (*Ill. 15*). Instead of being set back in a space beyond the actual painted surface, the figures seem to burst forth from the wall into the real space of the interior. They are not distinct and separate, but overlap and coagulate, as it were, in collective masses. The influence of Correggio's frescoes in the cathedral at Parma has softened Domenichino's earlier linearity.

In this development, however, Domenichino was overtaken by Giovanni Lanfranco, born in Correggio's own city and a pupil of Agostino Carracci before becoming an assistant to Annibale in the Farnese Gallery. From the beginning of his independent career, Lanfranco's work had a comparatively free and painterly character, and his colour a Parmese warmth. Around 1610, he seems to have made a renewed study of Correggio, especially of his method of representing the dome figures as if seen from directly below (*di sotto in su*). This, together with a newly-acquired interest in chiaroscuro, enabled him to develop a style with an altogether new emotional impact. Domenichino, who had counted on continuing his work at Sant'Andrea della Valle into the interior of the dome, lost that commission to Lanfranco. This dome (*Ill. 16*), painted in 1625–7, is covered with a single immense composition, in which all sense of the actual painted surface disappears. This was the decisive moment of the emergence of the full Baroque, and of the defeat (for purposes of church decoration, at least) of Carracciesque classicism. The separate articulation of parts has been superseded by the unity of the whole, and the dominance of the melodic line by colouristic harmony. As G. P. Bellori wrote some forty-five years later, 'this painting has rightly been likened to a full choir, in which all the sounds together make up the harmony . . . no particular voice is listened to especially, but what is lovely is the blending and the general cadence and substance of the singing.'

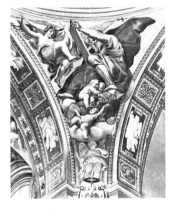

15. DOMENICHINO (1581–1641)
*St Mark, 1627–8. Fresco. Sant'
Andrea della Valle, Rome*

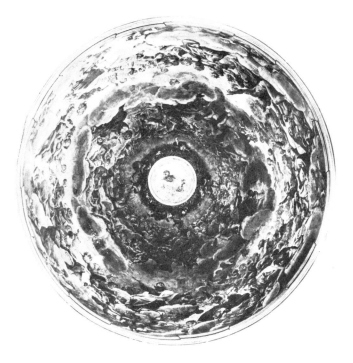

The rivalry, indeed antagonism, between the two artists was continued in the next decade at Naples, where again Domenichino painted the pendentives and Lanfranco the dome of the chapel of San Gennaro in the cathedral. Domenichino's work in the cathedral was received with some hostility. It was interrupted several times when he fled from the city, and his fresco in the cupola of the treasury chapel, left uncompleted at his death in 1641, was subjected to the final indignity of being handed over to Lanfranco to finish.

But the classicism Domenichino stood for was by no means dead. His landscapes are the progenitors of those of Claude and Poussin, the latter of whom was his pupil, and owed more to him than to any other painter. As a painter of altarpieces, he achieved, in his immense *Last Communion of St Jerome* (Rome, Vatican Gallery) (*Ill. 18*) painted in 1614, a perfect summation of early Baroque style, combining a moving realism of expression with a lucid compositional order.

The one artist among his contemporaries whom Domenichino reckoned a greater man than himself was Guido Reni, who had worked under the Carracci in

16 GIOVANNI LANFRANCO (1582–1647) *The Assumption of the Virgin, 1625–7. Fresco. Sant' Andrea della Valle, Rome*

27

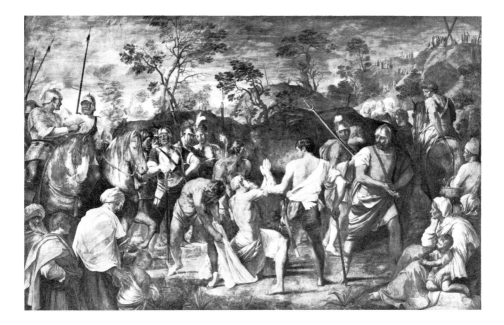

17 GUIDO RENI (1575–1642)
St Andrew led to Martyrdom, 1608.
Fresco. San Gregorio, Rome

18 DOMENICHINO (1581–1641)
The Last Communion of St Jerome,
1614. Oil on canvas, 8' 5"×13' 9"
(256 × 419). Vatican Gallery,
Rome

Bologna in the 1590s, and arrived in Rome not long after 1600. Though still a classicist by temperament, after an early response to Caravaggio's dramatic lighting, in his *Crucifixion of St Peter* (Rome, Vatican Gallery) of 1604–5, Reni developed a personal manner in marked contrast to Domenichino's version of classicism. At San Gregorio in Rome, Reni's 1608 fresco of *St Andrew led to Martyrdom* (*Ill. 17*) confronts Domenichino's *Scourging*. Against the background of a landscape broken with irregular hillocks and trees, the procession moves in a continuous rhythm across the scene, halting only momentarily in the middle where the saint kneels in adoration of the cross on a distant hilltop. This subordination of individual figures to a total rhythm is already Baroque, though groups of spectators are still placed across the foreground corners in the Mannerist way. Similarly, Reni's fresco of *Aurora* (*Ill. 19*), painted in 1613–14 on the ceiling of the Casino Rospigliosi in Rome, transmutes the antique classicism of Carracci's *Bacchus and Ariadne* into an elegant, flowing rhythm; yet it is still treated exactly as if it were a canvas to be hung on a wall.

Guido's career after his return to Bologna in 1622 did not advance the development of the Baroque. Compared with the vigorous and sophisticated linear design of interweaving rhythms passing from one figure to another

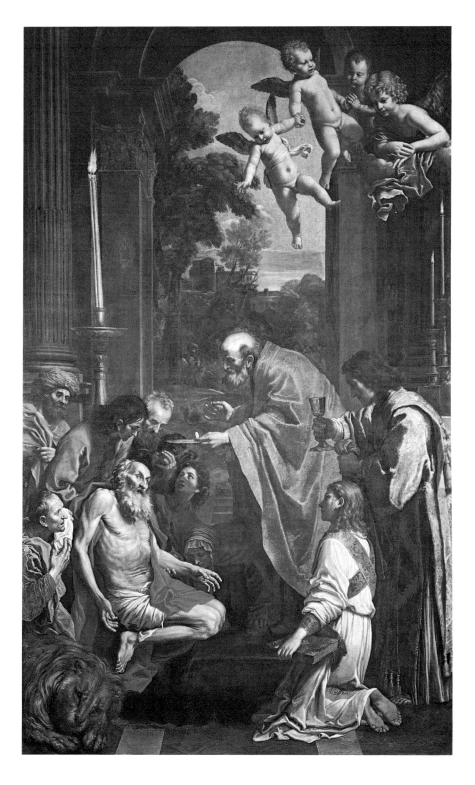

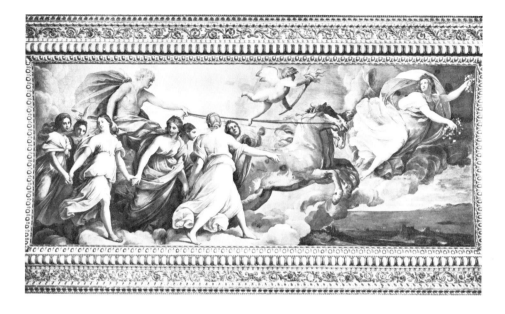

19 GUIDO RENI (1575–1642)
Aurora, ceiling of the Casino Ros-
pigliosi, Rome, 1613–14. Fresco

in his 1611 *Massacre of the Innocents* (Bologna, Pinacoteca) (*Ill. 21*), his later canvases seem remarkably cool and static. The elements of realism, of Caravaggesque dramatic lighting, and of intense emotional expression in that picture gave place to graceful idealism, silvery tones, and a kind of 'operatic' expression in his figures. In the later works, frequently exquisite in colour, the breadth and sweep of the brushwork never disrupts the integrity of his surfaces or outlines. But the development of the Italian Baroque passed, on his departure from Rome, into the hands of another younger painter.

Giovanni Francesco Barbieri, known as Guercino, came from Cento, between Ferrara and Bologna. A pupil of Lodovico Carracci, he had also early in his career absorbed a great deal of the Venetian feeling for rich colour and painterly texture, as well as a fondness for strongly contrasted schemes of light and shade. By the time he arrived in Rome in 1621 he had already painted a number of impressive altarpieces, based upon his master's style, but with an energy, a power, and an intensity quite beyond Lodovico's capacity. The sheer natural genius displayed in these early works is well exemplified by *Elijah fed by ravens* (London, Denis Mahon collection) (*Ill. 23*). Guercino's most important commission in the years 1621–3 was the ceiling fresco of the Casino Ludovisi, similar in subject to Reni's in the Casino

Rospigliosi, but in startling contrast to it. No longer is the subject confined to a framed panel; it seems to exist outside the building, as Aurora in her chariot sweeps across the sky. The boldness of the tonal contrasts, the freedom and bravura of the handling, and the brilliance and luminosity of the colour are all the more breathtaking because of the smallness of the building. Just as the real plane of the ceiling seems dissolved away in a great airy space, so the figures of *Day* (*Ill. 22*) and *Night* at the ends of the room seem to burst into the real interior. The illusory pictorial space completely overwhelms the actual architectural structure.

If he had painted nothing else, Guercino would still, by reason of this work, have to be regarded as of at least equal importance with Lanfranco as the creator of the full Baroque style. Paradoxically, at this point the painter began to modify his style in the direction of Carracciesque classicism. The great altarpiece of *The Burial of St Petronilla* (Rome, Capitoline Gallery) (*Ill. 20*), painted in the same years, is almost the last of his youthful masterpieces. The great sweeping diagonal rhythms, the broken patterns of light and shade, and the force of action and expression in even the minor figures unfortunately disappear from his later works. Only in his drawings, and especially in his pen and ink landscapes, did he retain the inspiration of his early period.

Many of the most brilliant achievements of the Italian Baroque painters are to be found on ceilings, where illusion of an infinite recession into space was overwhelming in its impact. Illusion, whether at the service of a theatrical sense of decoration, or of religious emotion, is an essential element of the Baroque style.

This style reached its Italian climax in the work of Pietro Berrettini, generally known from the place of his birth as Pietro da Cortona. As an architect he is less important than Bernini and Borromini, but as a decorator he is pre-eminent. His early work, for example the fresco of *Santa Bibbiana refusing to worship pagan gods* (*Ill. 24*), painted in 1624–6 in the church of Santa Bibbiana in Rome, is still very much affected by an archaeological classicism, derived from his studies after the antique, undertaken for the antiquarian Cassiano del Pozzo. Nonetheless, his touch is already freer and broader than Domenichino's, and his composition more spirited. That church was Bernini's first architectural commission,

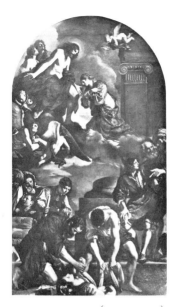

20 GUERCINO (1591–1666) *The Burial of St Petronilla*, 1621–3. Oil on canvas, 23′ 7″×13′ 10″ (720×423). Capitoline Gallery, Rome

21 GUIDO RENI (1575–1642) *The Massacre of the Innocents*, 1611. Oil on canvas, 8′ 9″×5′ 7″ (268× 170). Pinacoteca, Bologna

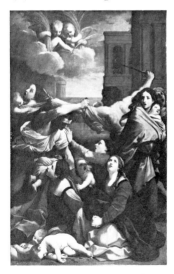

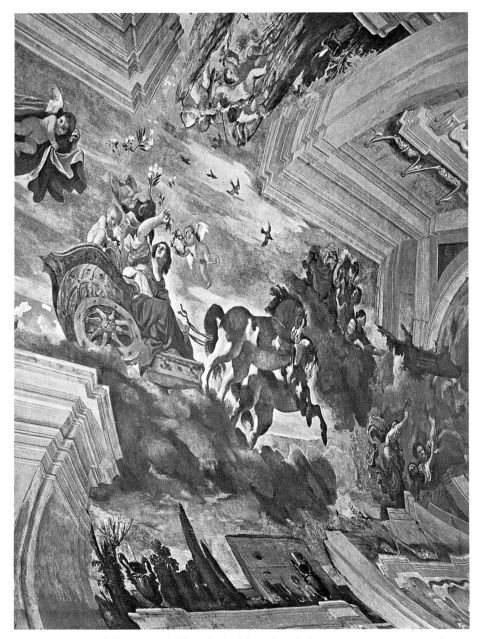

22 GUERCINO (1591–1666) *Day, detail of the ceiling of the Casino Ludovisi, Rome, 1621–3. Fresco*

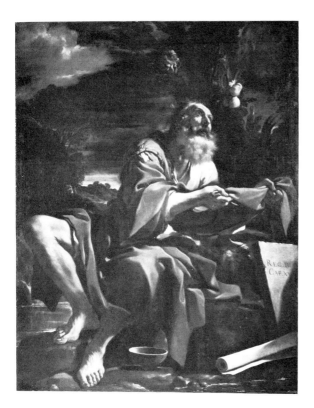

23 GUERCINO (1591–1666)
*Elijah fed by ravens, 1620. Oil on
canvas, 6' 3"×5' 1" (190×156).
Denis Mahon Collection, London*

built in the same years, and contained his statue of the
titular saint. The direct contact between the two artists
evidently helped to mature Cortona's genius. By 1629,
when he painted *The Rape of the Sabines* (Rome, Capitol-
ine Gallery) (*Ill.* 25), his figures had acquired a more
vital and more positively sculptural character; one group
in fact derives directly from Bernini's *Rape of Proserpina*.
But the dynamic complex of movements, both across
the surface and in depth, is brilliantly organized. The
architectural elements are so placed as to lend stability
to the scene and to emphasize its energy, and the looser
handling of the brush contributes to the general sense of
flowing movement; the colour has acquired a Venetian
warmth, the result of Cortona's studies of some paintings
by Titian then in the collection of Cardinal Ludovisi in
Rome.

Even this picture, however, fails to prepare one for the
masterpiece which Cortona painted in 1633–9 on the
ceiling of the great hall of the Palazzo Barberini (*Ill.* 26).

33

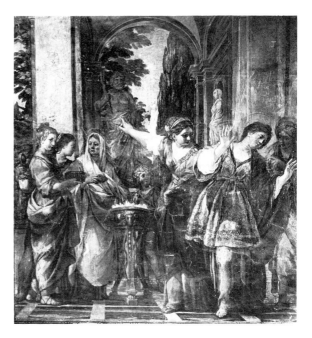

24 PIETRO DA CORTONA
(1596–1669) *Santa Bibbiana re-
fusing to worship pagan gods, 1624–6.
Fresco. Santa Bibbiana, Rome*

The openings through the illusionistic architectural framework seem to unite the interior space with the great pictorial space. The air appears to circulate into and out of the building, carrying with it figures flying and seated on clouds. The architecture is enriched with an im-aginative profusion of sculptural motifs; in the centre Divine Providence is surrounded by an aureole of light at the topmost level. Architecture, sculpture and painting are united in a scheme of breathtaking magnificence.

When, in 1637, Cortona interrupted his work, one of the places he went to was Venice. This city, and especially the influence of Paolo Veronese, contributed essential elements to his achievement in uniting the tradition of Bolognese-Roman classicism with mobile sculptural form and with Venetian colouristic splendour, and en-abled him to carry decorative fresco-painting to what Rudolf Wittkower has called 'a sudden and unparalleled climax'.

None of Cortona's easel paintings nor his later decor-ations, from the *Four Ages of Man* and the ceilings in the grand-ducal apartments of the Palazzo Pitti, Florence, to the frescoes in Santa Maria in Vallicella and the Palazzo Pamphili in Rome, surpass his achievement in the Barberini ceiling. But, especially in the Pamphili ceiling,

34

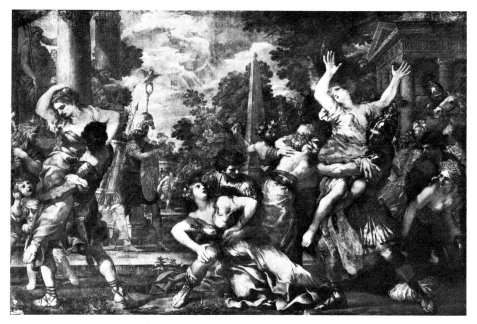

25 PIETRO DA CORTONA (1596–1669) *The Rape of the Sabines, 1628–9. Oil on canvas, 9′×13′ 10″ (275×423). Capitoline Gallery, Rome*

26 PIETRO DA CORTONA (1596–1669) *Detail of the ceiling of the Great Hall, Palazzo Barberini, Rome, 1633–9. Fresco*

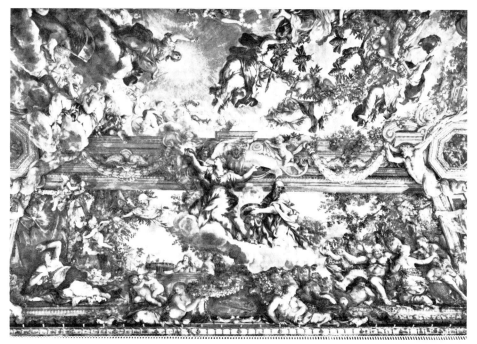

his colour became still more radiant and transparent, presaging the lightness and delicacy of 18th century Rococo style. In the last phase of his career there was a renewed emphasis on classical elements in his style, and his compositions became rather more severe and geo-metrically ordered, possibly in response to influence from Poussin; but he remains the supreme exponent of the Italian Baroque at its most sumptuous and exuberant.

Perhaps all great periods of art are based upon a pre-carious balance between contrary forces. In the Renais-sance, which discovered the means of creating the illusion of spatial depth, concern for the integrity of the two-dimensional picture-plane opposed its unbridled exploitation. In the 17th century, the contrary forces may be described in several ways: aspiration towards the expression of spiritual and emotional qualities was op-posed by an earthy realism; fondness for dynamic design by admiration of the calm and static qualities of antique classicism; a love of theatrical illusionism, rich colours and elaborate textures, by admiration for severity and linear simplicity. If one side of this aesthetic conflict dominated in the High Baroque decoration of Pietro da Cortona, the other side was by no means without its adherents in the very same period.

The balance maintained in the work of Annibale Carracci broke down in the next generation, and gave way to the open opposition of style between Domeni-chino and Lanfranco. A similar conflict occurred between Cortona and Andrea Sacchi. Sacchi had been a pupil of Albani, himself a pupil of the Carracci, and his early work was very much of the Carracci school. By about 1625-7, when he painted *St Gregory and the Miracle of the Corporal* (Rome, Vatican Gallery), his style had become distinctly Baroque in its asymmetry, its emotion-alism, and its colour. In 1627-9 Sacchi collaborated with Cortona, who was still working essentially in the Carracci tradition, on the frescoes of the Villa at Castel Fusano; but by the time he painted *St Romuald describing his Vision* (Rome, Vatican Gallery) (*Ill. 27*) about 1638, he had renounced Baroque excitement and rhetoric.

In his writings, too, Sacchi emphasized the importance of propriety, decorum and natural movement, the neglect of which, he thought, had caused the decline of art. Most important of all, he insisted that, since it was only through expression, gesture and movement that each figure could

contribute its quota to the meaning of a composition, the number of figures must be kept to an essential minimum. On the contrary, Cortona maintained that a painting, like an epic poem, should have many episodes in addition to its central theme: that these were not only necessary for the magnificence of the result, but required for the general pattern of light and shade. Sacchi's ideas, his rejection of the more purely sensuous and decorative aspects of art, received widespread and influential support, most notably from G. P. Bellori, who deplored the naturalists, with their realistic rather than idealized representations of men. Thus began the battle between hedonism and classicism, between the Rubenists and the Poussinists, which continued through the following century.

The artist who supplied Baroque classicism with its greatest masterpieces was Poussin who, although he worked principally in Rome, was a Frenchman and is therefore discussed in another chapter. Of the many Italian painters who may be considered followers of Sacchi, none was of the first rank. G. F. Romanelli, originally a pupil of Cortona, evolved a personal style midway between the two. His figures have a touch of Raphaelesque grace and dignity, and his colour is often charming; but he is never an exciting artist. Giovanni Battista Salvi, known as Sassoferrato, was the most conservative, not to say reactionary, of these classicists. The simple devotional feeling of his style was tainted with insipidity and too easily became stereotyped through repetition.

The greatest successor of Pietro da Cortona in grand decorative undertakings was the Neapolitan painter Luca Giordano. His early work was much influenced by the realism of Caravaggio and Ribera, but, like Cortona, he was most affected by the Venetian colouristic approach, absorbed on a visit to that city in 1653. His method of composition was essentially the brilliant improvisation, and his tremendous verve and speed of execution earned him the nickname of Luca Fa Presto. He was in demand in many Italian cities, but his most brilliant achievements were his ceiling frescoes of the Grand Staircase in the Escorial (*Ill. 28*) and in the Royal Palace at Madrid, where he was court painter for ten years at the end of the century.

Otherwise, the most outstanding later Baroque decorative painters in Italy were Giovanni Battista Gaulli,

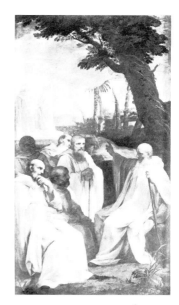

27 ANDREA SACCHI (1599–1661) *St Romuald describing his Vision, c. 1638. Oil on canvas, 10′ 2″ × 5′ 9″ (310 × 175). Vatican Gallery, Rome*

37

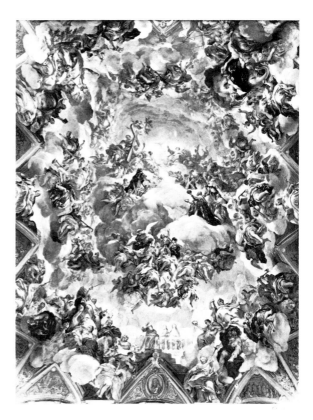

28 LUCA GIORDANO (1632–
1705) *Ceiling of the Grand Stair-
case, Escorial, c. 1692–4. Fresco*

generally known as Bacciccia, and Andrea Pozzo.
Bacciccia, a Genoese, settled in Rome in 1657; there he
painted the great masterpiece of late Baroque decoration –
the ceiling of the nave in Vignola's church of Il Gesù
(*Ill. 29*). Here, the concept of a picture-plane is abso-
lutely denied. The lowest figures appear to be within the
building itself, sweeping up into the great imaginary
space above, or plunging downward on their way to
perdition. Illusionism is carried to such a point that some
of these figures, modelled in stucco, cast real shadows on
the ceiling. Effects of perspective and foreshortening pro-
duce an impression of limitless upward recession towards
the aureole of light surrounding the Holy Name of Jesus.
The Jesuit ambition to transport the worshipper in a
vortex of emotion into the very presence of the deity could
hardly be more forcefully illustrated.

Andrea Pozzo had himself entered the Jesuit Order in
1665. He came from Milan to Rome in about 1680. He

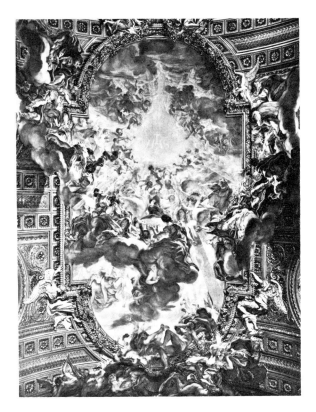

29 BACCICCIA (1639–1709) *The
Triumph of the Name of Jesus,
ceiling of the nave of Il Gesù, Rome,
1674–9. Fresco*

was principally a virtuoso of perspective, and his most
important work is the series of frescoes on the ceilings of
the nave, dome, apse and transepts of the church of Sant'﹣
Ignazio, painted after 1685. The nave ceiling (*Ill. 30*)
is framed, as it were, by a great open colonnade erected on
top of an imaginary upper storey of the church, and con﹣
tinued to an apparently enormous height. Perched upon
ledges round its sides is a large number of figures in al﹣
most every conceivable variety of posture. In the centre, a
wide vista opens towards the minute figure of St Ignatius
being received with open arms by Christ, surrounded by
angels and clouds, and emitting a divine radiance. Un﹣
fortunately, there is only one point, in the centre of the
nave, from which this ultimate in perspectives really
works.

Italian painting of the second half of the 17th century
was long out of favour with collectors and critics, but it
was a period immensely rich in talents of a high order, of

whom comparatively few have yet been studied in depth.
Mattia Preti, for example, originally from Calabria, and
active at various stages of his career in Rome, Modena,
Naples and elsewhere, may well be seen eventually as
one of the outstanding figures of his time. His early
contacts with Caravaggism in Naples left lasting traces
in his work, based always on a robust realism. Arriving
in Rome about 1630, he was obviously much impressed
by the drama, energy and light effects of Guercino's early
works, but he responded equally to the Carracci and
Domenichino. From Venetian art he derived a taste for
rich, warm colour; and at mid-century, in his frescoes
at Sant'Andrea della Valle, his designs, though com-
pact, were filled with movement. About 1656–60, his
discovery of the work of the young Luca Giordano in
Naples may have rendered his brushwork looser, freer,
and broader. Yet the intensity of his feeling and the vigour
of his forms and postures protect him from the dangers
of eclecticism. In 1661 he settled in Malta, where he
painted the ceiling of the conventual Church of St John,
in oil directly on the stone. This great work is devoted
to scenes from the life of the Baptist, and contains a series
of saints and heroes of the Order of St John. These figures
are in the Michelangelesque tradition of Tibaldi and
Annibale Carracci, and have a characteristic grandeur
of form and nobility of bearing. The principal scenes are
all framed with richly decorated (and somewhat Manner-
ist) architecture, and although most of the figures appear
silhouetted against the sky, the perspectives are not of the
di sotto in su variety. Drama is powerfully conveyed by
means of striking poses and large gestures, all the forms
being modelled by contrasting patterns of light and shade.
Here Preti once more achieves a unification of the Baroque
and Classicist tendencies of which perhaps no one else
in his generation was capable. Among his great pro-
duction of altarpieces and easel pictures, the one which
shows his dramatic power and his sonorous orchestration
of tone at its most impressive is *The Martyrdom of St
Catherine* in the Parish Church of Zurrieq (*Ill. 31*), the
Maltese village where he lived during an outbreak of the
plague at Valletta in 1675.

In Venice, the most important painter of the first half of
the century was Bernardo Strozzi, a Genoese, who worked
in Venice from about 1631 until his death in 1644, in a
highly energetic and rhythmical style which influenced

*30 FRA ANDREA POZZO (1642–
1709) The Apotheosis of St Ig-
natius, ceiling of the nave of Sant'
Ignazio, Rome, 1691–4. Fresco*

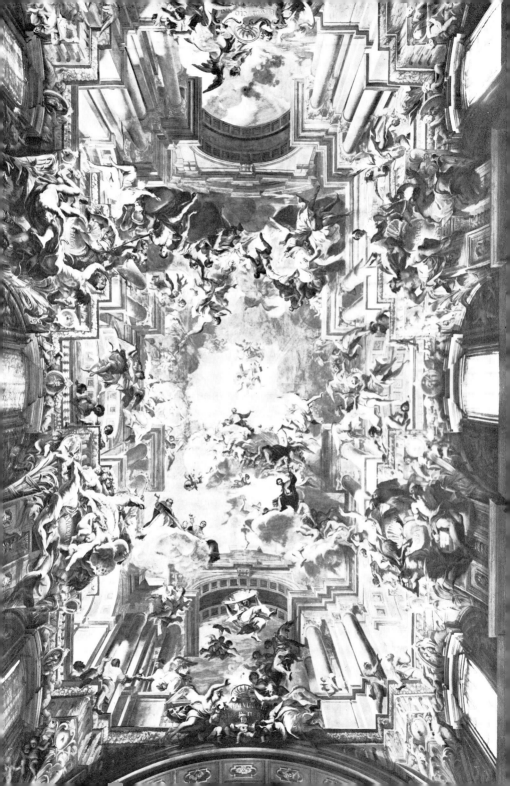

painters of the next generation such as Domenico Feti,
Francesco Maffei and Sebastiano Mazzoni.

In Naples, Caravaggio left in his wake a school
dominated by his influence. The most important of its
members was Ribera, who is discussed in the next
chapter. Lesser figures such as Giovanni Battista
Caracciolo and Massimo Stanzione were joined by
Artemisia Gentileschi and the Fleming Matthias Stomer,
whose Caravaggesque style had been formed in Rome.
In the middle decades of the century a refined and
individual style was developed by Bernardo Cavallino,
a colourist of exquisite and daring originality, and a
draughtsman of rare lyricism, with an exceptional gift for
subtlety of expression in his heads. But the greatest
eccentric of the Neapolitan school was Salvator Rosa,
who repudiated both the classicism of Sacchi and his
school, and the princely splendours of Cortona and the
High Baroque decorators. A natural rebel against all
establishments, he was a prototype of the Romantic con-
ception of the artist as a fiercely independent genius
propelled by his inspiration alone. His creative energies
led him to express himself in poetry, music, satires and
acting as well as in painting and etching, not to speak
of his legendary youthful adventures as a brigand
and revolutionary. He was born in Naples in 1615, and
studied there under Francesco Fracanzano and Aniello
Falcone, from the latter of whom he derived an interest in
battle-pictures. Salvator's Battles, such as the most famous
one in the Louvre in Paris, are wild melées, full of fury,
terror and savagery. Another side of his personality comes
out in his harbour scenes, of which there is a fine example
in the Palazzo Pitti in Florence. In composition, and in its
glow of golden sunlight, this owes an immense debt to
Claude Lorrain; but it is more animated, and richer in
colour than Claude's pictures.

In Florence, between 1640 and 1649, Salvator also
painted a number of landscapes; and though in his
later years in Rome he abandoned his earlier subjects of
bandits, soldiers and fishermen in settings of wild moun-
tain and coastal scenery, in favour of the religious and
historical ones approved by the classical theorists, it is
upon his landscapes that his eventual fame and import-
ance rested. Great rocky crags, storm-wrecked and
broken trees, leaden and threatening skies are painted
with a tempestuous rhythm of brushstrokes. Man seems

*31 MATTIA PRETI (1613–99)
The Martyrdom of St Catherine, c.
1675. Oil on canvas, 14′×7′ 6″
(428×230). Parish Church of St
Catherine, Zurrieq, Malta*

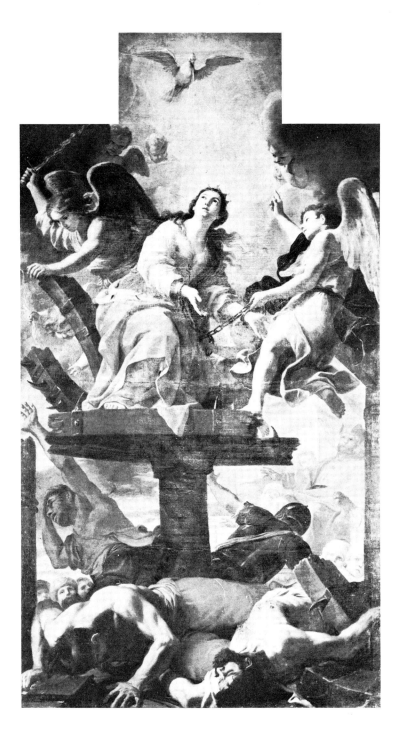

little and insignificant amid the great forces of the elements. Although the structure of his compositions does not differ fundamentally from Claude's, the spirit is the very opposite of Claude's gentle calm. Much of the wildness and violence survives in his later Roman works, devoted to classical stories, but these were more or less without historical consequences.

Salvator has been called a 'second-rate talent', but for the 18th century his landscapes appeared as the ultimate expression of the emotional, anti-classical aspects of art.

A painter whose genius was in some ways akin to Salvator's was Pietro Testa, from Lucca. He was trained under Domenichino, and spent periods working with Pietro da Cortona, as a collaborator with Gaspard Dughet, and as one of the artists employed in the classicist enterprises of Cassiano del Pozzo. His melancholic temperament and excitable fantasy must have been in painful conflict with this Roman environment. The force of his poetic inventiveness found clearest expression in his drawings and etchings.

Florence produced no painter of absolutely first rank during the whole Baroque period. Even before the beginning of the century, Lodovico Cigoli had, in his 1597 *Martyrdom of St Stephen* (Florence, Palazzo Pitti), used powerful diagonal movements, deep recession, and interlocked groupings of figures which remarkably anti-cipated the Baroque style; but his stylistically uncertain later works make this anticipation look almost acci-dental. One of the most striking, indeed unforgettable, of Florentine 17th century pictures, Cristofano Allori's *Judith with the head of Holofernes* (Florence, Palazzo Pitti), has a certain sinister power, in spite of its curious and eclectic mixture of influences from Leonardo da Vinci (in Judith's head), from Caravaggio (especially in the lighting and in the severed head of Holofernes), and from Van Dyck (in the rich, heavy draperies). But Francesco Furini, best known for his seductive female nudes, and Carlo Dolci, in the latter part of his career an obsessional painter of over-finished and usually maudlin religious images, can hardly inspire much enthusiasm today.

One of the most interesting and personal of North Italian artists, as draughtsman and etcher as well as in painting, was Giovanni Battista Castiglione of Genoa. In his work, something of Bassano's bucolic vein mingles with an awareness of Rubens and even of Rem-

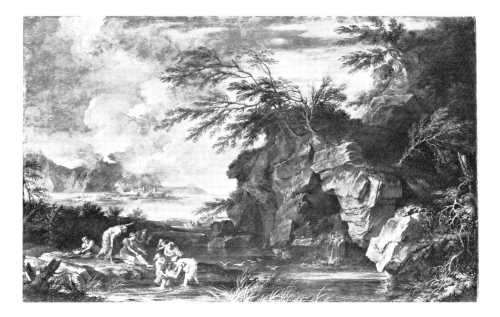

brandt, to produce a result which is certainly lively, if at times a little over-excited.

In Rome itself, in the last decades of the century, the leading position was occupied by Carlo Maratti. Trained under Andrea Sacchi, he practised, in ceiling frescoes, portraits and altarpieces, a version of the High Baroque always restrained by some classical feeling, which showed itself at first in his sense of ordered design, but towards the end of his long career in a series of Madonnas, Raphaelesque in type but swathed in ample Baroque draperies, who are so far removed from human reality as to seem incapable of changing the expressions on their faces. Often claimed as early forerunners of 18th century Neo-Classicism, they clearly signal the approaching end of the Baroque tradition.

32 SALVATOR ROSA (1615–73) The Finding of Moses, c. 1650. Oil on canvas, 4′×6′ 8″ (123×203). Detroit Institute of Arts

CHAPTER THREE

Baroque painting in Spain

Spanish painting in the 17th century, though closely linked at many points with Italian art, nevertheless developed distinctive characteristics. The first master of Spanish Baroque painting was Francisco Ribalta, in whose works violent contrasts of light and shadow emphasize the sculptural relief, as well as the expressiveness of his figures. But the sources of this system of chiaroscuro seem to have been partly Spanish, in the work of the 16th century painter Fernandez de Navarrete, and partly Italian, in that of Sebastiano del Piombo, the Venetian of the first half of the 16th century who worked closely with both Raphael and Michelangelo, and whose paintings Ribalta is known to have copied. In any case, Ribalta's artistic personality has an intense sobriety totally unlike Caravaggio's emotional violence, though knowledge of Caravaggio's work may have later confirmed his already developed style.

Ribalta's reputation, however, remained local, whereas that of Jusepe de Ribera, who may have studied under him in Valencia before going to Italy, became international. Little is known of the early years of Ribera's career. Soon after 1610 he was in Lombardy; soon afterwards in Parma, and then in Rome, where he was influenced above all by Caravaggio. By 1616 he seems to have settled in Naples, where he worked for the rest of his career. He received many honours, becoming a member of the Academy of St Luke in Rome in 1626, a knight of the Order of Christ in 1652, and court painter to a succession of Spanish viceroys in Naples.

Although both of the leading characteristics of Ribera's style, his strongly contrasted chiaroscuro and his realism, derive primarily from the art of Caravaggio, his technique was highly original. His forms are richly modelled in solid pigment, with the strokes of the brush giving a coarse, earthy texture to the surface. The paradox of

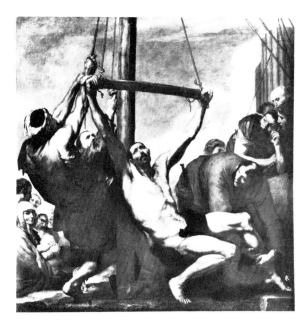

33 JOSE DE RIBERA (1591–1652) *Martyrdom of St Bartholomew, c. 1630. Oil on canvas, 7′ 8″× 7′ 8″ (234×234). Prado, Madrid*

Ribera's art lay in his ability to express spiritual, or at least deeply humanistic feelings in realistic terms. His hermits and martyrs are rustic and peasant-like in their physical attributes, their lumpy bones, their sun-dried and crinkled skins, but at the same time they are absorbed in profound religious experience. Ribera not only developed the chiaroscuro of Caravaggio with a sense of the revelatory quality of light playing upon textured surfaces, but he gave to his shadowed spaces a sense of mystery and serenity which Caravaggio only rarely approached. He could project a humble and lucid simplicity, in such pictures as the *Adoration of the Shepherds* (Paris, Louvre), the *Penitent Magdalene* (Madrid, Prado), or the *St Agnes* (Dresden, Gemäldegalerie), or an intense compassion, as in *The Entombment of Christ* (Paris, Louvre), or the *Martyrdom of St Bartholomew* (Madrid, Prado) (*Ill. 33*), and on occasion an exalted, visionary quality, as in *The Holy Trinity* in the Prado.

Ribera's influence dominated the Neapolitan school for some years, and was considerable also in Spain, where his works were greatly admired and collected. But of all his pupils and followers it was perhaps Luca Giordano, in such early works as his *Job tormented,* in the Sacristy of the Escorial, who came closest to the quality of the great Spanish master.

47

The most deeply religious art of the time was produced by Spanish painters. Almost all the work of Francisco Zurbarán was painted in response to the patronage of the austere monastic orders influenced by such Quietist writers as Miguel de Molinos. This aspect of Counter-Reformation religious thought, eventually stigmatized as heretical, emphasized the possibility of direct contact between the dedicated individual soul and the voice of God. The voice of God came from outside the self, and was not heard as a consequence of deliberate will and thought, but might be prepared for by the cultivation of spiritual quietude and passive receptivity. In the work of an artist influenced by such a philosophy, one could obviously not expect any display of dexterity in handling, or any delight in personal idiosyncrasies of brushwork, much less any indulgence in the luxury of brilliant colours, or the pleasures of the senses. There is, indeed, a strain of asceticism in Zurbarán's personality. The realism of textures in draperies and objects is always less important in his art than the sense of stillness and purity with which he surrounds them. Even in his still-lifes, such as the marvellous one in the Prado with four vessels standing on a table, he presents the simplest of everyday objects in a spirit of reverence, even adoration, as if they were symbols of God's bounty to man. In his figure compositions, he shows no interest in deep illusionist recessions or in effects of movement. The figures often stand against completely plain and dark backgrounds. On those occasions when he does use a more complex background, as in *The Vision of St Benedict* (Madrid, Academy of San Fernando) (*Ill. 34*), the receding façade of the architecture seems to have less reality than the heavenly vision of Christ, the Madonna and the angelic musicians which is superimposed upon it. This master of the textures of draperies exercised a restraint and severity in his handling of colour, and a simplicity – almost a naïveté – in his compositions which occasionally remind one of the Netherlandish masters of the 15th century, whose works he almost certainly knew from examples in Spanish collections. Although he received a number of important commissions in Seville, Madrid, Guadalupe and elsewhere, and must have been highly regarded in his own time, his name seems to have lapsed into obscurity soon afterwards, to be restored to its rightful place among the greatest of Spanish painters only in the present century.

34 FRANCISCO DE ZURBARÁN (1598–1664) *The Vision of St Benedict, 1635–40. Oil on canvas, 6′ × 3′ 3″ (185 × 100). Academy of San Fernando, Madrid*

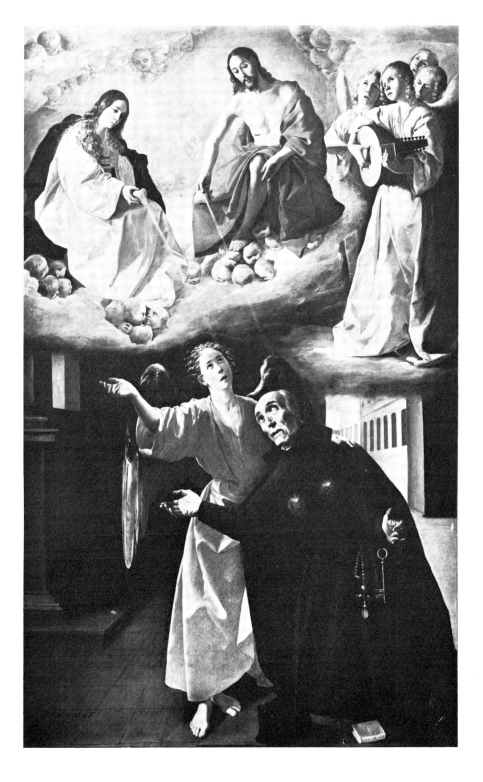

The art of Diego Velasquez takes its place far more intimately in the context of European developments, yet in many ways it is as exceptional, and as much a product of a unique temperament. Born in Seville in 1599, he spent a brief period in the studio of Francisco Herrera the elder, before being apprenticed in 1511 to Francisco Pacheco, an accomplished painter, whose studio contained an important collection of drawings and prints, through which the young Velasquez acquired a knowledge of a wide range of European art. The dominant influence on the young painter's early works, however, was that of Caravaggio, or rather of his Italian and especially his Flemish followers. Such works as the *Old Woman frying eggs* (Edinburgh, National Gallery) and *Christ in the House of Mary and Martha* (London, National Gallery), both painted about 1618–19, seem to be related to the genre-scenes of such an artist as Joachim Bueckelaer, possibly known to Velasquez through engravings. But the schemes of light and shade which he adopted from Caravaggesque sources were never pressed to extremes. His treatment of the figures, and of the spaces that surround them, has something of the calm and reflective quality which is so impressive in Zurbarán. This stillness is most striking in the masterpiece of these early years, the *Water-Carrier* of 1619, at Apsley House, London (*Ill. 37*). The focal centre of the composition is the glass goblet of crystal-clear water held in the hands of both the water-carrier and the boy, establishing a gentle and sympathetic relationship between them, while the man's left hand rests, almost caressingly, on the great earthenware jug whose massive form, in the strongest light, occupies the foreground. The subtlety and profundity of feeling beneath the restrained simplicity of the surface lift this picture out of the class of common genre scenes to which it apparently belongs.

In the last years of his early period at Seville, Velasquez also painted several religious subjects, which begin to show marked stylistic changes. The *Immaculate Conception* and *St John on Patmos* (both London, National Gallery) depart from the dark and predominantly earthen colours of the realistic canvases, and introduce high-keyed and delicate shades of mauve, blue and pink, handled with a freer style of brushwork.

In 1623 Velasquez went to Madrid, and was almost immediately taken into the service of the royal court, as a

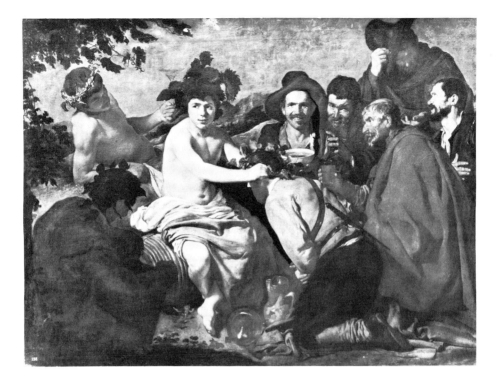

result of the success of his portrait of Philip IV. Here, he found himself in an infinitely more sophisticated cultural ambience, with opportunities to study at leisure the superb and probably unrivalled collection of master‚ pieces from Italy and elsewhere assembled in the royal palaces. His portraits of the next six years, as one may see in the *Conde–Duque de Olivares* (New York, Hispanic Society), reflect the influence of Titian's Spanish royal portraits. Another work of these years, however, the so‚ called *Topers* (Madrid, Prado) (*Ill. 35*) – actually it respresents Bacchus rewarding the winner of a drinking contest – still shows strong traces of Caravaggism, mixed with other influences. The heads of some of the figures could almost belong to Ribera's mathematicians or philosophers; the draperies of the semi‚nude Bacchus are strongly suggestive of Titian, as is also the nude figure holding a wineglass in the background on the left. But the whole conception has a boisterous humour which is a quality quite new in Velasquez's art, due, most likely, to the impact of Rubens who, for eight months in the years 1628–9, shared Velasquez's studio. The primary reasons

35 DIEGO VELASQUEZ (1599–1660) *The Topers, 1628/9. Oil on canvas, 5′5″ × 7′5″(165 × 225). Prado, Madrid*

51

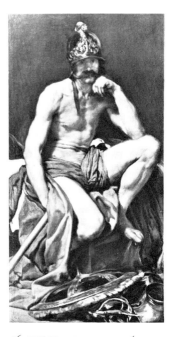

36 DIEGO VELASQUEZ (1599–
1660) *Mars, c. 1642–4. Oil on
canvas,* 5′ 10″×3′ 1″ (179×95).
Prado, Madrid

37 DIEGO VELASQUEZ (1599–
1660) *The Water-Carrier, 1619.
Oil on canvas,* 41½″×31½″ (105×
77). *Wellington Museum, Apsley
House, London*

for Rubens's visit were diplomatic, but while in Madrid he carried out an immense programme of work, painting portraits of the king, the queen and other members of the royal family, as well as some thirty-odd copies after Titian, Raphael and Tintoretto. The vigour of Rubens's personality, the ripe sensuousness of his forms, the flow and variety of his technique must have made an immense impression upon Velasquez. It was probably on the advice of Rubens that, in June 1629, Velasquez set out for Italy.

After copying the work of Tintoretto in Venice, meeting Guercino at Cento, studying Michelangelo and Raphael in Rome, and Ribera in Naples, Velasquez returned to Madrid in 1631. His Italian experiences had given him a fuller sense of the possibilities of light, atmosphere and space; and his brushwork had become more deft and free. In the great equestrian portrait of *Olivares* (N.Y., Metropolitan) (*Ill. 40*), painted in 1634, he not only showed his complete mastery of Titianesque dignity, but went beyond his Italian models with a new and scintillating way of rendering the play of light upon fabrics. The great picture of *The Surrender of Breda* (Madrid, Prado), completed by 1635, possibly owes something of its splendour and nobility to his studies of Veronese; but portraits like *Philip IV in brown and silver* (London, National Gallery) and *The Infante Balthasar Carlos in hunting costume* (Madrid, Prado) mark Velasquez's attainment of full maturity and individuality. This is the period when he comes closest to the Baroque.

Between 1636 and 1648 a great deal of Velasquez's energy was spent in court duties, which permitted him little time for painting. Nevertheless it was during this period that he created some of his strangest and most personal pictures, including the *Aesop, Menippus* and *Mars,* and his studies of dwarfs, jesters and buffoons. The *Mars* (Madrid, Prado) (*Ill. 36*), for example, hardly seems an entirely serious attempt to create an image of the god. It is a picture of an elderly model – a deserter from a company of dragoons, as one critic has put it – nude except for a loincloth and helmet, with a shield, sword and other accoutrements lying on the ground at his feet. Though his pose faintly recalls that of one of Michelangelo's seated statues above the Medici tombs in Florence, the naturalism of the treatment makes one more aware of the model posing in the studio than of any con-

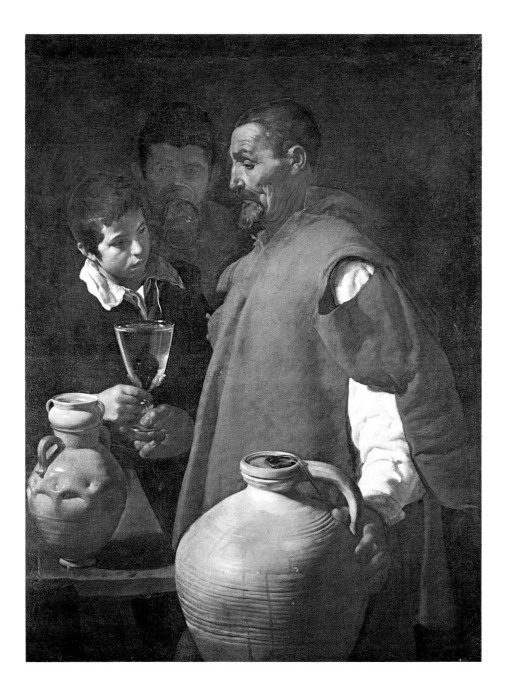

cept of martial valour. Perhaps the pensive attitude, and
the face – its details almost lost in the shadow of the
helmet – deliberately provoke a question. What does it
mean? There is a gentle irony, too, in the pictures of
dwarfs and buffoons, such as that of the grinning and
squinting *Don Juan Calabazas* (Madrid, Prado). The
artist's attitude is no more one of revulsion than it is of pity
or condescension; he records with a remarkably cool
objectivity.

In 1649–51 Velasquez made a second journey to Italy,
primarily to acquire paintings and sculpture for the royal
collection. He painted several pictures while he was in
Rome, including the superb *Innocent X* (Rome, Palazzo
Doria), which is among the greatest of Baroque portraits
– an almost terrifying revelation of personal character, of
power residing in the hands of a somewhat brutal, un-
scrupulous and shifty man. By comparison, the delicacy
and lightness of the two views of the *Medici Gardens*
(Madrid, Prado), also painted in Rome, seem miracles of
sensibility. Like the *Rokeby Venus* (London, National
Gallery) (*Ill. 41*), these landscapes are touched upon the
canvas with such an evanescent delicacy, the colours and
tones are recorded with such fidelity to the optical
sensation that they could easily be mistaken for products of
the 19th century. It has been claimed that the *Venus* is
derived from an engraving by Philip Galle after Antonie
van Blocklandt; but the subject was first popularized by
Titian, and the Venetian inspiration is as evident as in the
portrait of the Pope.

After his return to Madrid in 1651, Velasquez was
appointed Grand Marshal of the Palace, and put in
charge of the royal art collection, as well as being res-
ponsible for public festivities, royal journeys and other
matters. In his last nine years he found time to paint only
a dozen or so pictures, but these include a number of his
finest masterpieces. Of all his paintings, *Las Meniñas*
(*The Maids of Honour*) (Madrid, Prado) (*Ill. 39*) most
completely expresses his involvement in the life of the
court, his sensitive and reflective observation. The scene
is a room in one of the royal palaces, in which the little
Infanta Margarita is being offered by one of her maids of
honour, with a low curtsy, a tray with a little bottle of
scent or water. But the effect is the very reverse of formality;
it is an intimate, almost casually chosen moment. Two
figures are conversing; a child rests a foot on a dog; a

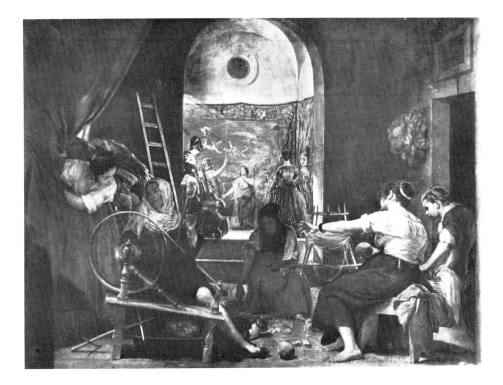

chamberlain lifts a curtain; the artist himself is at work on a painting; in a sense, nothing of any importance is happening. Yet Velasquez here gives us the subtlest and most difficult of all things to convey by pictorial means, a complex of personal relationships. It is possible to analyze the picture's subtle compositional devices, but analysis and explanation do not dispel its magic and mystery. The light which moves in from the doorway at the back, to be reflected back from an unseen mirror on to the little princess, to fall from an unseen window on the right on to the maid's hair, and to lose itself in the shadows of the high ceiling, still seems to be real light rather than mere paint. This astonishing achievement suggests that Velasquez may have seen interior scenes by Dutch masters, but this is surely among the very greatest achievements of European painting.

Las Hilanderas (Madrid, Prado) (*Ill. 38*) is hardly less remarkable. The scene is the interior of a tapestry workshop, with women engaged in spinning and weaving. The picture has a classical theme – the legend recorded by Ovid, of Arachne's weaving contest with Pallas

38 DIEGO VELASQUEZ (1599–1660) *Las Hilanderas (The Tapestry Weavers)*, c. 1653/4. Oil on canvas, 7′ 3″×9′ 6″ (220×289). Prado, Madrid

55

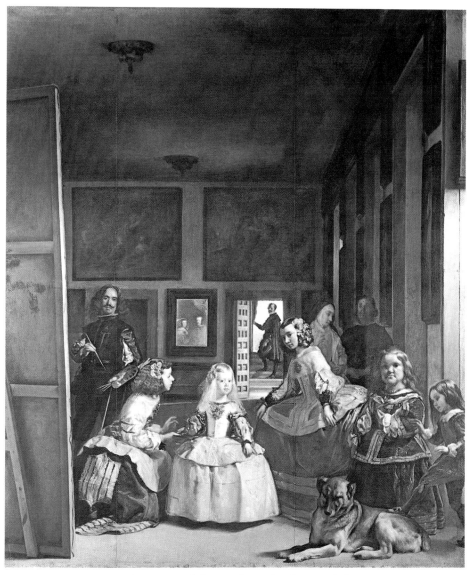

39 DIEGO VELASQUEZ (1599–1660) *Las Meninas (The Maids of Honour)*, c. 1656. Oil on canvas, 10′ 5″×9′ 1″ *(318×276)*. Prado, Madrid

56

Athene – but what interested the artist must have been the complex of movements which fill the picture. For the very first time in art, the optical disappearance of the whirring spokes of the spinning wheel is accurately recorded. And, to hold together so much movement, Velasquez has given at least one of his figures a statuesque form based upon one of Michelangelo's athletes on the Sistine ceiling, and has contained everything within a

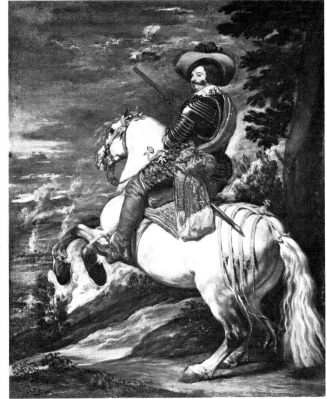

40 DIEGO VELASQUEZ (1599–1660) *Conde-Duque de Olivares, 1634.* Oil on canvas, 4′ 1″ × 3′ 4″ (124 × 102). The Metropolitan Museum of Art, New York

41 DIEGO VELASQUEZ (1599–1660) *The Rokeby Venus, c. 1650.* Oil on canvas, 4′ × 5′ 10″ (122 × 177). By courtesy of the Trustees of the National Gallery, London

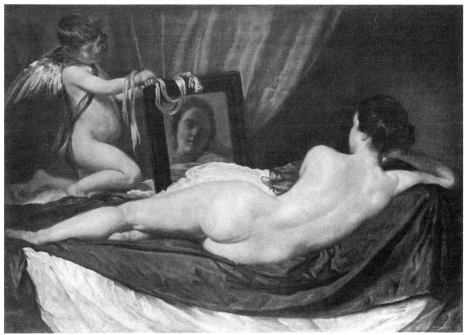

42 DIEGO VELASQUEZ (1599–1660) *The Infanta Margarita Teresa in pink (detail)*, c. 1654. Oil on canvas, 4′ 3″ × 3′ 3″ (128.5 × 100). *Kunsthistorisches Museum, Vienna*

43 ALONSO CANO (1601–67) *The Vision of St John the Evangelist*, 1635–8. Oil on canvas, 33″ × 17¾″ (84 × 45). *By courtesy of the Trustees of the Wallace Collection, London*

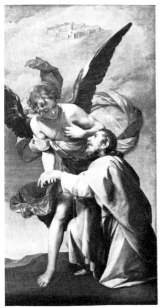

Raphaelesque architectural framework. From a technical point of view this is another consummate achievement. Possibly one should also consider the subject-matter's implicit moral theme of the folly of human pride, even in artistic creation, as the final statement of Velasquez's personal philosophy.

The appeal of Velasquez's last portraits is more immediate (*Ill. 42*). These grave, delicate children, almost swallowed by the pomp of their costumes, have a pathos which is never overstated. They have grace and dignity, but also a modesty and reserve which reflect the highest ideals of Spanish aristocratic manners.

Velasquez's influence on other painters was less than might have been expected. His son-in-law Juan Bautista del Mazo came nearest to understanding the subtlety and restraint of his portraits and interior scenes, but even Mazo's charming portrait group of *The Artist's Family* (Vienna, Kunsthistorisches Museum) lacks the informality as well as the vibrancy of light of Velasquez's *Maids of Honour*. Juan Carreño could approach the sensitivity of Velasquez's interpretation of personality, as in his *Queen Mariana* (Madrid, Prado), but added nothing to the great master's achievement.

Religious subjects did not constitute an important part of Velasquez's output, although such pictures as his *Christ crucified* and *The Coronation of the Virgin* (both Madrid, Prado) are characteristic of his emotional restraint. On the contrary, religious subjects formed by far the greatest part of Murillo's production. Born in Seville, like Velasquez, his whole career was spent there. His early works, painted between 1640 and 1645, rely on the examples of Zurbarán and Ribera, and his cycle of eleven paintings on Franciscan themes, done in 1645–6 for the Franciscan monastery at Seville, which effectively established his reputation, are still essentially scenes of contemporary life, but with a relaxed grace and dramatic chiaroscuro, which already show a tendency towards a more overtly emotional style.

His later paintings of beggar boys and flower girls are seldom realistic, but serve rather to display his virtuosity in delicate colouristic variations, soft and melting brushwork and warm hazy atmosphere. In composition, his religious pictures are often indebted to Rubens or Titian, and in both composition and colour *The Marriage Feast at Cana* (Birmingham, Barber Institute) (*Ill. 46*) must

owe much to a study of Veronese. Nonetheless, Murillo's Madonnas, Holy Families, or Infant Baptists have quite distinctive and personal qualities – tenderness, charm and warmth, and a contented and joyful sense of devotion; they sometimes approach sentimentality, but are always executed with a seductive touch. As a portraitist Murillo exhibited a more direct and simple approach, and in his rare landscapes achieved a certain drama; but it must be by his religious works that his reputation is judged.

Among Spanish painters of less importance, the most interesting was Alonso Cano, distinguished also as architect and sculptor. He was born in Granada, but studied under Pacheco and Juan del Castillo in Seville, where his independent career began. Between 1638, when he went to Madrid, and 1652, he painted a considerable number of pictures of religious subjects. In the latter year he returned to his native city, where he became a preben-dary of the cathedral, the façade of which was his chief work in architecture, and for which he painted some important canvases. In this later period, his style became softer, possibly as a result of influence from Murillo; but his earlier style, well exemplified in *The Vision of St John Evangelist* (London, Wallace Collection) (*Ill. 43*), from a series of Apocalyptic subjects, had more individuality. This picture is tonally brilliant, with forms harder than Murillo's, and defined by strong chiaroscuro; but a great deal of its intensity is due to the taut energy of the linear design. Cano stands rather apart from his Spanish contemporaries as the representative of a somewhat classical and eclectic sort of Baroque.

In the second half of the 17th century, Spanish painting moved towards the Baroque in the work of such men as Antonio Pereda, Mateo Cerezo and Fray Juan Rizi. *The Immaculate Conception* by Juan de Valdes Leal (Seville, Museo de Pinturas) (*Ill. 44*) well illustrates this tendency. By comparison, Murillo's treatments of this subject look simple and monumental. Leal surrounds his Virgin with hosts of flying cherubs who impart an effervescent movement to the surface. He was also an original colourist, who developed a broken and excited, almost impressionist, manner of brushwork. This phase of Spanish Baroque draws towards a close with Claudio Coello, whose *Triumph of St Augustine* (Madrid, Prado) (*Ill. 45*), painted in 1664, brought to Spain the illusion-ism and freedom of movement in space which had been

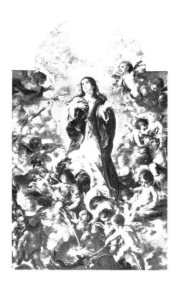

44 JUAN DE VALDES LEAL (1622–90) *The Immaculate Con-ception, 1660. Oil on canvas, 10' 6" × 6' 7" (319 × 201). Museo de Pinturas, Seville*

45 CLAUDIO COELLO (1642–93) *The Triumph of St Augustine, 1664. Oil on canvas, 8' 11" × 6' 8" (271 × 203). Prado, Madrid*

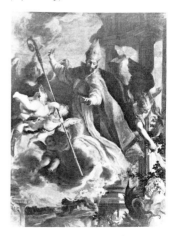

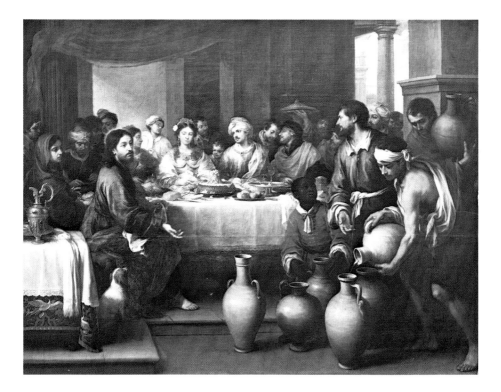

46 BARTOLOMÉ MURILLO
(1618–82) *The Marriage Feast at*
Cana, 1670–80. Oil on canvas,
5′ 10″×7′ 8″ (179×235). Barber
Institute of Fine Arts, Birmingham

learnt from the Italians. From the end of the 17th century, Spain produced no painter of distinction until Goya, with the possible exception only of Luis Melendez, a still-life artist of austere taste who continued the tradition established by Zurbarán.

CHAPTER FOUR

French Baroque painting

French artists were rather slow to respond to Baroque ideas, and when, eventually, a French form of Baroque established itself, it inclined markedly towards the more classical aspects of the style. The French painter Le Valentin was among the earliest followers of Caravaggio, but he spent the whole of his career in Rome, and hardly influenced the course of French painting. A painter of Flemish origin, Louis Finson (known as Finsonius), who also absorbed some elements from Caravaggio's Roman works, mixed with typically late-Mannerist ones, was active for a number of years in Provence, until his death in 1617. But painting in Paris continued to be dominated by essentially Mannerist styles, as for instance in the court portraiture of Frans Pourbus the younger. The most vital French art of the opening decades of the 17th century was centred in Nancy, where Jacques Callot and Jacques Bellange, both primarily etchers and draughtsmen, created a remarkable late efflorescence of Mannerism. Callot had spent ten years in the service of the Grand Duke in Florence, etching and engraving a number of plates of fairs, public festivities and cere-monies, figures of the *Commedia dell'arte,* beggars and hunchbacks. But on the death of Cosimo II in 1621 he left Florence and returned to Nancy, there to produce his most moving work, the series of *Grandes Misères de la Guerre,* published in 1633. He condensed into the tiny dimensions of these plates an intensity of horrified observation of the incredible brutalities of the Thirty Years' War which makes them one of the most out-standing documents of protest in art.

An event which might have been expected to change the course of French painting was the great series of can-vases painted by Rubens for Marie de' Medici in 1622-5, and installed in the gallery of the Luxembourg Palace. In fact, however, these early masterpieces of the Baroque

(which will be discussed later) were so remote from the current French taste that their immediate influence was negligible. It was left for much lesser artists to usher in the process of change. Claude Vignon, born in Tours, was in Rome about 1616–24, where he learnt something from Caravaggio's naturalism, but more from the intense and emotional style of Adam Elsheimer and his Dutch follower Pieter Lastman. In certain works of the 1620s he seems curiously to anticipate Rembrandt, but Vignon remained an isolated figure in French painting.

Simon Vouet had a much more decided effect on the course of development of the French school. After travels to the Near East, and some years in Italy, he re/turned to France in 1627, and, except for the short period of Poussin's activity there in 1642–3, he enjoyed the dominant position among painters in Paris until his death. Roman influences, primarily from Lanfranco and Guercino, gave his numerous altarpieces for Parisian churches and monasteries a Baroque character, usually tempered by a compositional classicism like that of Anni/bale Carracci's followers. But in his decorative schemes, of which some of the most important, at Fontainebleau, in the Palais Royal, and in the Hôtel Séguier, no longer survive and are known only through the engravings of Michel Dorigny, he introduced into France the steep perspectives and the spatial illusionism which were typical of the new taste. His facial types and the stressed linearity of his figures and draperies often recall Guido Reni; and although, like Pietro da Cortona, he was in/debted to the Venetians for his colour, his handling never acquired the richness of Cortona's mature style.

Such Italian influences in Paris were reinforced by the two visits of Giovanni Francesco Romanelli to carry out some decorative schemes in the Bibliothèque Nationale and in the Louvre. Of the other French painters who in various ways reflected early Baroque influences one of the most interesting was Georges de la Tour of Lorraine. He may have visited Rome and made contact there with some of Caravaggio's followers such as Le Valentin or perhaps Bartolommeo Manfredi, but his works of the 1630s are closer to those of Dutch Caravaggists like Honthorst and Terbrugghen, so it is more probable that his contacts were with Utrecht. Even in his early works, such as the *St Jerome* (Stockholm, National Gallery), there is, in addition to the rather dry naturalism, a distinctive quality

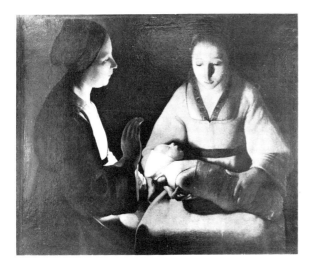

of stillness which derives from the sharpness of the linear
design and its classical balance and integration. Later,
especially in the candle-lit religious scenes, of which the
Christ and St Joseph (Paris, Louvre), the *St Sebastian*
(Berlin–Dahlem, National Museum), and the *Nativity*
(Rennes, Musée) (*Ill. 47*) are examples, a Caravaggesque
naturalism is retained, but with a unique sense of
contemplative calm. Background detail is almost totally
eliminated, and forms and surfaces are treated with
unusual breadth and simplicity. These are intensely
moving pictures; in their profound religious feeling they
are closer to Zurbarán than to any Italian or Dutch
contemporaries.

The work of Louis Le Nain and his brothers Antoine
and Mathieu also shows some indebtedness to Italo-
Dutch art. All three were born in Laon and settled in
Paris by 1630; but Louis may possibly already have
visited Rome and seen some of the pictures of Pieter van
Laer, known as Bamboccio, whose genre scenes repre-
sented peasants and the common people of the towns.
This was the kind of subject for which Louis Le Nain
became known in the 1640s. His peasants, for all their
rags, are presented sympathetically. Le Nain's touch is
gentle, and his colouring centres around muted greys
and browns, but he had a very special sensibility for
atmosphere and light. His compositions are calm and
rather static, and his realism is strongly tempered with

63

classical feeling. One of the most grave and dignified of his pictures, the *Blacksmith in his forge* (Paris, Louvre) (*Ill. 48*), is reminiscent of the traditional iconography of Vulcan at his forge, but no mythological intention is indicated, and the picture takes its place among the earliest renderings of an ordinary artisan and his family in their everyday situation. It is interesting to compare this picture with Velasquez's *Forge of Vulcan* (Madrid, Prado); the semi-nude figures of the Velasquez, the presence in it of Apollo emitting a divine radiance, and the concen-trated attention of Vulcan and his assistants, emphasize the absence of any narrative content in the Le Nain. In the Le Nain the effect of light from the glowing furnace unifies the whole picture-space and the figures which occupy it. Despite his rather limited range, the level of Le Nain's attainment enables his work to sustain this sort of comparison without discredit.

The stylistic influences brought to France by Philippe de Champaigne were of a quite different kind. He was born in Brussels, and trained there under the landscape painter Jacques Fouquier. Coming to Paris in 1621, he was soon employed in decorative work in the Luxem-bourg Palace. His style in his early years, as we see it in *The Adoration of the Magi* (London, Wallace Collection), painted about 1630, reveals strong links with the school of Rubens, though Champaigne already tended to modify the characteristic powerful movements of that painter's compositions. His early portraits, too, such as the well-known one of *Cardinal Richelieu* (London, National Gallery), are based upon types established by Van Dyck, but with crisper and more sculptural hand-ling of the draperies. This tendency of his development towards a restrained naturalistic classicism is well illustrated by a comparison of two treatments of the same subject, *The Presentation in the Temple*. The earlier version (Dijon, Musée) (*Ill. 49*) painted in 1629–30 for the Carmelite church in Paris, is still Baroque in the diagonal vista of the architectural setting and the emphatic move-ments of the figures towards the centre. In the later version (Brussels, Musée des Beaux Arts) (*Ill. 50*) of 1642, the whole composition has acquired a frieze-like and almost symmetrical character; the centralizing movements are less marked, and the whole design is firmly held by the framework of architecture. The draperies are now closely modelled upon Roman statues; the tonality is high-keyed,

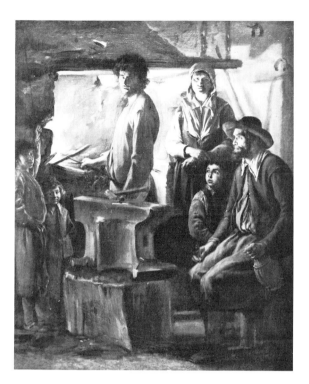

without deep shadows, and the sharply differentiated local tints are pure and almost unbroken.

Undoubtedly Champaigne was confirmed in his classical tendencies by contacts with the art of Poussin, whom he must certainly have met during the decorating of the Luxembourg Palace; very likely their acquaintance was renewed during Poussin's visit to Paris in 1640–2. But in two classes of his mature work Champaigne's style was entirely his own: in portraiture and in monu‑ mental representations of the single figure of Christ.

The seriousness – one might almost say the solemnity – of his group portraits is exemplified by the canvas of *The Mayor and Sheriffs of the City of Paris* (Paris, Louvre), painted in 1648, in which self‑consciously dignified officials are symmetrically ranged on either side of a small altar. But Champaigne's best portraits are perhaps those of individual figures, often at half‑length, frequently wearing black, and shown against plain backgrounds. The austerity of this manner of presentation allowed him

65

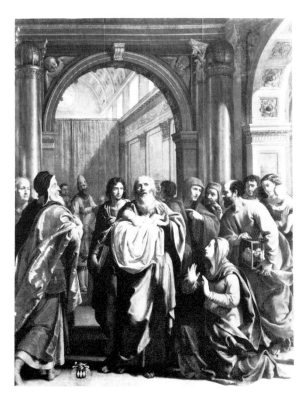

49 PHILIPPE DE CHAMPAIGNE
(1602–74) The Presentation in the
Temple, 1629–30. Oil on canvas,
13′ 1″×10′ 9″(398×327). Musée
des Beaux Arts, Dijon

to concentrate all attention upon the sharply observed and
sensitively drawn features and expression. Despite the
close parallel with Dutch bourgeois portraiture of the
same period, Champaigne's sitters entirely lack the
flamboyance and panache of Hals's, and his careful,
smooth, clear technique is utterly unlike Rembrandt's.

About 1643, he made contact with the convent of the
austere Catholic sect of Jansenists at Port Royal, for
which he painted some of his most remarkable works,
which exhibit a striking severity of taste. The best known
is the votive portrait of his daughter, who was a nun
in the convent, in company with the prioress who
kneels in prayer beside her, painted in 1662 and now in
the Louvre. The Christ on the Cross, also in the Louvre,
painted in the last year of his life, presents the figure
frontally, against a background with a view of Jerusalem,
but consisting mostly of sky. The body of Christ is
naturalistically rendered, avoiding overt emotionalism;
yet in its directness, simplicity and great intensity it is a
compelling image.

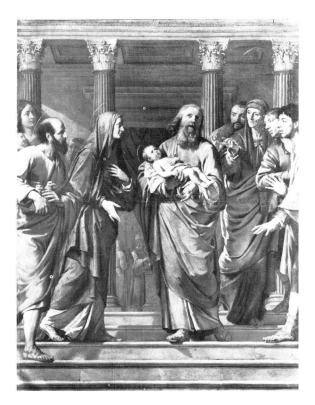

50 PHILIPPE DE CHAMPAIGNE
(1602–74) *The Presentation in the
Temple, 1642. Oil on canvas, 43″×
33¾″ (114.5×90.5). Musée des
Beaux Arts, Brussels*

Although Champaigne was a considerable artist, his importance is altogether surpassed by that of Nicolas Poussin, the supreme exponent of Baroque classicism not only for France, but for the whole of Europe.

Poussin first went from his native village in Normandy to study in Rouen, and then to Paris, where he worked from 1612 until 1624. Towards the end of that period he had participated in the decorative work at the Luxem, bourg Palace under Duchesne. No paintings by him which are indubitably of that time are known, but a series of drawings illustrating the *Metamorphoses* of Ovid, done in 1623–4, already shows his interest in classical poetry, although their style is still heavily indebted to the School of Fontainebleau. After his arrival in Rome in 1624, Domenichino's work exercised a powerful in, fluence upon him. The setting of *The Triumph of David* (Dulwich Gallery) (*Ill 51*), for example, with its groups of onlookers on the raised podium of a temple in the background, recalls Domenichino's *Execution of St Andrew* in San Gregorio, though the disposition of the

67

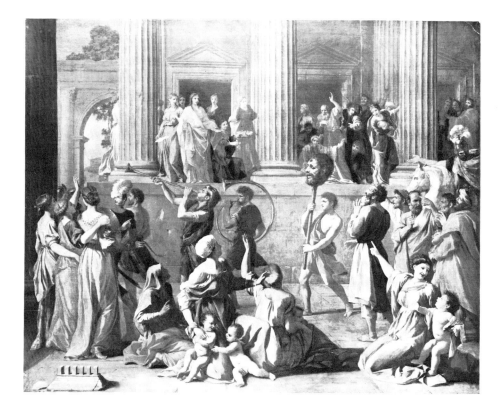

51 NICOLAS POUSSIN (1593/4–
1665) *The Triumph of David,*
1624–29. Oil on canvas, 3′ 10″×
4′ 9″ (117×146). By permission
of the Governors of Dulwich Picture
Gallery, London

52 NICOLAS POUSSIN (1593/4–
1665) *The Inspiration of the Poet,*
1629–30. Oil on canvas, 6′×7′
(184×214). Louvre, Paris

53 NICOLAS POUSSIN (1593/4–
1665) *Shepherds of Arcadia,*
1650–55. Oil on canvas, 33¾″×
47⅝″(85.5×121.5). Louvre, Paris

68

figures in the foreground is quite different. During his
first ten years in Rome Poussin learnt a great deal from
paintings by other artists as well, notably from Raphael
(see, for example, the very Raphaelesque composition of
Poussin's *Parnassus* in the Prado at Madrid), and from
Veronese (whose influence was primarily colouristic).
That he was aware of the challenge of the emerging
High Baroque is evident in two large altarpieces painted
in 1628–30, the *Martyrdom of St Erasmus* (Rome, Vatican)
painted for St Peter's, and *The Virgin appearing to St James*
(Paris, Louvre), apparently commissioned for the church
of Saint-Jacques at Valenciennes. The strong chiaros-
curo effect in both these pictures, and the way in which
the figures fill the foreground space, suggest that Poussin
had been impressed by Guercino. But the influence
which proved most lasting, and most congenial to
Poussin's own temperament, was that of antique sculp-
ture. The figure of the muse in one of the masterpieces of
his early period, *The Inspiration of the Poet* (Paris, Louvre)

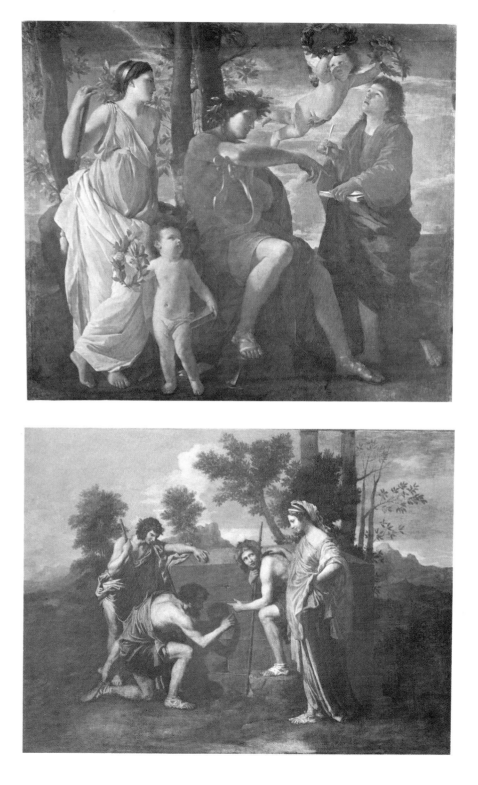

(*Ill. 52*), probably painted a little before 1630, in fact derives from an antique bas-relief. On the other hand, the Apollo is rather Raphaelesque; and the clear and glowing colour is a result of Poussin's studies of Titian.

About 1629–30 he became seriously ill, and on recovery married, and apparently withdrew from any competition to secure commissions for churches and great palaces. The works of the 1630s are smaller in scale, with figures always less than life-size, as was suitable for the smaller houses of the circle of learned gentlemen for whom he now principally worked. The pictures of the following few years, like *The Inspiration of the Poet*, are pervaded by poetic feeling, which makes them, for many people, his most appealing works. Until about 1633, when religious subjects, mostly from the Old Testament, begin to reappear, they illustrate themes from classical poetry and from Tasso. At first the subjects, such as *Rinaldo and Armida, Echo and Narcissus, Diana and Endy-mion,* and *The Death of Adonis,* are somewhat melancholy ones, but in the middle years of the decade the mood becomes gayer, with the first Bacchanals reflecting a re-newed influence from Titian. This mood affects par-ticularly his treatment of the nude, which in pictures like *The Childhood of Bacchus* (Paris, Louvre), or *Venus sur-prised by Satyrs* (Zurich, Kunsthaus) has a delicious sensuous warmth. Another consequence of Titian's influence was the development of Poussin's interest in landscape, later to become an important aspect of his work. In the same period he painted a considerable variety of Biblical and classical subjects; and one of his most beautiful pictures of the thirties, *The Arcadian Shepherds* (Chatsworth, Duke of Devonshire) (*Ill. 55*), has as its subject the reminder of the presence of death even in the land of perfect bliss.

Poussin's stylistic evolution is often puzzling and occasionally inconsistent; nevertheless it seems clear that the romantic feeling and warmth of colour, the rather rough textures and free handling of the works of the first half of the thirties tend to be supplanted by a colder, more linear and more strictly classical manner. *The Adoration of the Golden Calf* (*Ill. 56*), painted about 1636, is very much a transitional work. Poussin has so controlled and systematized the movements of the group of dancing figures that they have the appearance of a bas-relief; and the counter-balancing of movements gives the group as a

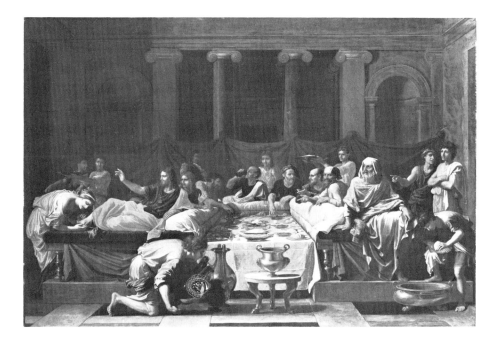

whole perfect integration and equilibrium. A number of paintings and drawings of these years show that such problems of grouping fascinated Poussin. He seemed to be trying to freeze the dancers into an instant's immobility. In this picture, the groups of Israelites surrounding Moses in the right half of the composition are still in the old manner, which looks by comparison somewhat disorderly. The process of intellectual analysis and control was eventually applied to all the component elements of Poussin's designs. The heads were to become more idealized, the forms rendered in harder and more sculptural terms, the paint substance itself was to become drier, and the colour less glowing and broken. In other words, all the more sensuous and naturalistic aspects of painting were to be sacrificed in favour of abstract principles of art and the philosophical implications of the subject.

The process which was begun in *The Golden Calf* continued through the remaining twenty-nine years of the artist's life; but first he had to suffer the interruption of a year and a half in Paris, to which he was summoned by the king and Cardinal Richelieu, in order to decorate the long gallery of the Louvre, and to paint altarpieces and other pictures. The gallery decorations, much admired in their time, do not survive. The altarpiece for the chapel

54 NICOLAS POUSSIN (1593/4–1665) *The Sacrament of Penance, 1644–8. Oil on canvas, 3' 10"× 5' 10" (117 × 178). Duke of Sutherland Collection, on loan to the National Gallery of Scotland, Edinburgh*

71

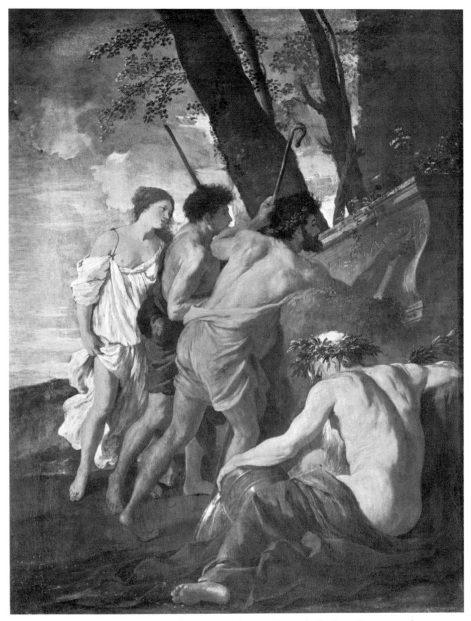

55 NICOLAS POUSSIN (1593/4–1665) *The Arcadian Shepherds, 1630–40. Oil on canvas, 39¾″×32¼″ (101×82). Reproduced by permission of the Trustees of the Chatsworth Settlement*

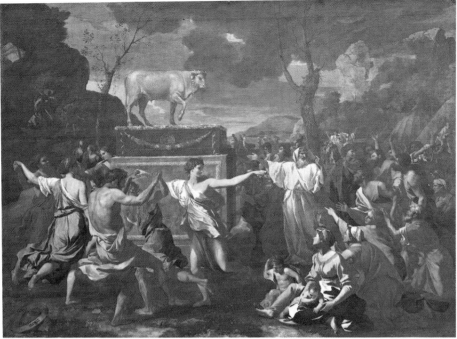

56 NICOLAS POUSSIN (1593/4–1665) *The Adoration of the Golden Calf, c. 1636. Oil on canvas,
5′ × 6′ (154 × 214). By courtesy of the Trustees of the National Gallery, London*

57 NICOLAS POUSSIN (1593/4–1665) *The Holy Family on the Steps, 1648. Oil on canvas,
27″ × 38½″ (68.5 × 97.5). National Gallery of Art, Washington, D.C. (Samuel H. Kress Collection)*

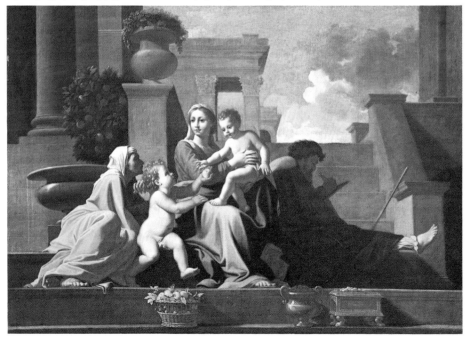

of the Jesuit Novitiate in Paris was unfavourably received, and the allegory painted for a ceiling in the cardinal's palace, with its *di sotto in su* perspective, was hardly the kind of work which suited Poussin's special gifts. In September 1642 he returned to Rome, never to leave it again. But his visit had enabled him to make contacts with new patrons in France, men like Fréart de Chantelou, who continued to buy his pictures.

The series of *The Seven Sacraments* painted for Chante-lou must certainly be accounted among the most typical and important works of the years 1644-8. Poussin had painted a set of these subjects for Cassiano del Pozzo about 1636; but the second series (now on loan at the National Gallery of Scotland in Edinburgh) has a new severity and solemnity of style. Each sacrament is symbol-ized by a scene from the life of Christ or of the Virgin, painted in accordance with Poussin's conception of the principles of antique art. Despite the severe, symmetrical restraint of their architectural settings, however, the com-positions are less relief-like than those of the earlier set. This is apparent, for example, in *Penance* (*Ill. 54*), in which Mary Magdalene anoints the feet of Christ during the feast in the house of Simon the Pharisee. The table recedes in steep perspective in the centre, emphasizing the depth of the picture-space; but this is firmly closed by the Ionic columns and pilasters of the back wall, and the foreground plane is still dominant, with the figures of Christ and the Magdalene balancing those opposite of a servant boy washing Simon's feet. The two outdoor sub-jects – *Baptism* and *Ordination* – also show this new plastic conception of space.

But the painting in which Poussin's methods of organ-izing his compositions in this mature phase of his career are most lucidly demonstrated is *The Holy Family on the Steps* (Washington, National Gallery) (*Ill. 57*), painted in 1648. The perspective is viewed at an upward angle, the effect of which is enforced by the rising recession of the two sets of steps, running the full width of the canvas, beyond the top of which one sees the upper part of a Corinthian temple. This receding slope corresponds closely with the pyramidal form of the group of figures, with the head of the Christ Child set almost precisely at mid-point. Every element is calculated with geometrical exactitude, even to the placing of the objects on the lowest step. Neither the action nor any expression of sentiment in

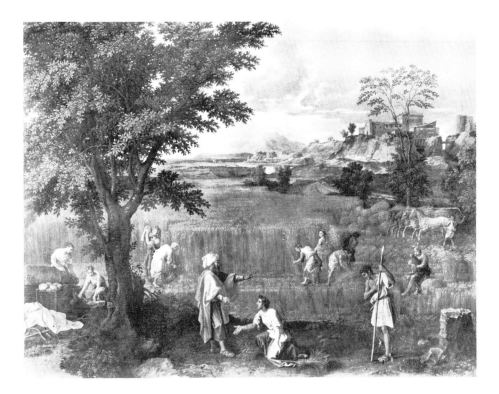

the figures disturbs the mathematical regularity of the design. The real beauty and drama of the painting exist in the opposition and balance between solid and void, cylindrical and cubic forms, the hard textures of stone and the soft ones of foliage, drapery and flesh, the upward movement of the perspective and the weight of the architecture, the mobility of the figures, clouds and light in the static framework of the setting.

Just occasionally, among the late works, there is an expression of passionate emotion, as in the *Entombment of Christ* (Dublin, National Gallery) of *c.* 1655–7, or of agitated movement, as in *The Finding of Moses* (Dorking, Mrs Derek Schreiber); but, in general, Poussin seemed to prefer the monumental stillness and reflective calm of the version of *The Shepherds of Arcadia* (Paris, Louvre) (*Ill. 53*) painted between 1650 and 1655. Works from which all realism, almost all action and expression, and all traces of spontaneity in handling have been purged, could verge upon emptiness or insipidity. Poussin's pure and accurate colour sense is one of the means by which

58 NICOLAS POUSSIN (1593/4–1665) *Summer: Ruth and Boaz, 1660–64. Oil on canvas, 3′ 10″ × 5′ 3″ (117 × 160). Louvre, Paris*

75

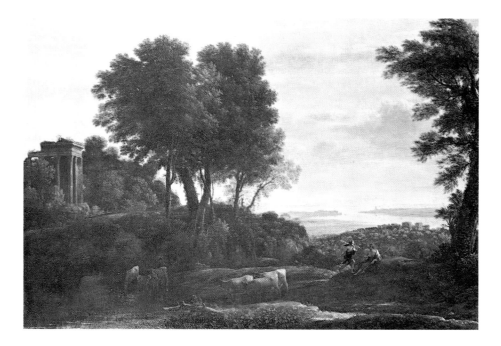

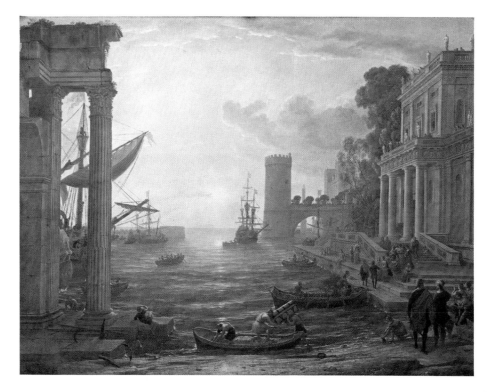

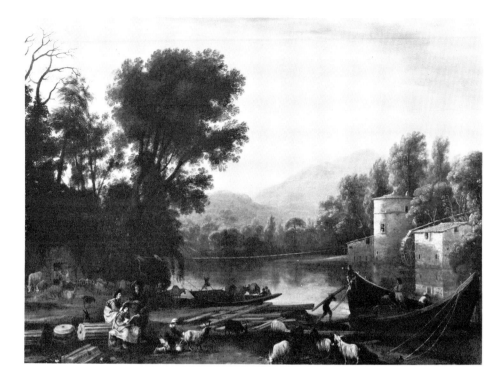

spective becomes less significant than the vibration of light proceeding from the disc of the rising or setting sun, boldly included as the focal point of the entire com-position. Most critics have written about the 'infinity' of Claude's distances; the term is perhaps a misleading one. He created far distances, it is true, but careful examination of an example such as *The Embarkation of the Queen of Sheba* (London, National Gallery) (*Ill. 60*) shows how he sought deliberately to limit the recession in order to keep the space palpable, and the composition self-contained. The composition is so arranged as to be read from the left, across the foreground to the lower right corner, then along the quayside and the façade of the palace to the bridge and circular tower which close the harbour and provide a natural full stop. Beyond, the vista of the further palace and the tall *pharos* is interrupted by the bridge, which im-poses on it a plane parallel to that of the picture surface; this further recession thereby loses much of its force. It is to be read like a footnote, and not as part of the primary structure of the picture. Even the horizon, seen between the round castellated tower and the mole to the left of the

61 CLAUDE LORRAIN (1600–82) *The Mill, 1631. Oil on canvas, 24″×33½″ (61×85). By courtesy of the Museum of Fine Arts, Boston, Mass. (Seth K. Sweetser Residuary Funds)*

79

harbour's mouth, is interrupted by a distant island; and the rays of the sun at just this point are reflected from the surface of the little waves, dividing the picture into two unequal but balanced parts. The movement of the light and water from the distance is reinforced by the arrange, ment of the schooner and the three boats which bring the eye back to the starting point in the lower left corner.

In one of his most beautiful designs of the 1650s, *Apollo guarding the herds of Admetus* (Holkham, the Earl of Leicester), the emphasis of the composition is upon the shaded middle-distance, with a marvellous luminosity in the distance beyond it. In the last phase of his develop, ment the tones become more ethereal; both the landscape itself and the buildings in it seem of less solid material than the substance of atmosphere and less important than the evocation of poetic mood.

Two other notable French landscape painters evolved their styles under the influences of Claude and, more especially, of Poussin. Gaspard Dughet, Poussin's brother-in-law and assistant (who later adopted his name), painted landscapes in which violent winds, storms and great rocks and mountains express the wilder aspects of nature, as in such pictures as the *Land Storm* (Edinburgh, National Gallery), the *Seascape with Jonah and the Whale* (Windsor Castle), or *The Calling of Abraham* (London, National Gallery). At times, he was capable of a rich elegiac mood, as in the *Landscape near Albano, evening* (London, National Gallery) (*Ill. 62*). The composition of this was possibly suggested by a draw, ing of Titian's; and the best of Dughet's mountain land, scapes with hill cities recreated that 'romantic' mood of melancholy solemnity which made Titian's landscapes one of the great sources for southern European landscape art. Dughet's importance in his own time, however, rested rather on the landscape frescoes which he executed in Roman palaces and in the church of San Martino ai Monti, through which landscape attained a new prominence and dignity. Jean François Millet, known as Francisque, was an imitator of Poussin and Dughet, and of less interest than Sebastien Bourdon, who painted in a great variety of styles at different periods of his career, and in his last years worked in a rather softened and sweetened version of Poussin's mature style.

The place which Poussin might have taken in painting within his own country fell, in consequence of his with,

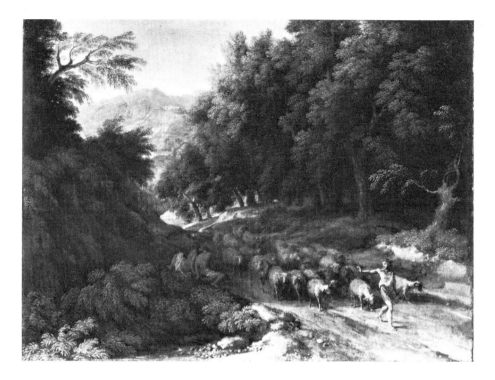

drawal from the scene, to rather lesser men, the dominant figure among whom was undoubtedly Charles Le Brun. Trained in the studios of François Perrier and Vouet, he was in Rome for four years from 1642, studying under Poussin and also the Baroque decorators, chiefly Pietro da Cortona. His first inclination towards a vigorous Baroque, which can be seen in his pre-Italian *Hercules and Diomedes* (Nottingham Art Gallery), was tempered by his studies with Poussin. Back in Paris, he was employed for religious and decorative painting, but did not receive his first commission for Louis XIV until 1661, when he painted *The Family of Darius before Alexander* (Paris, Louvre). In style it is a compromise between the decorative manner of Cortona and Poussinesque classicism.

Le Brun's success, however, with every kind of pictorial and decorative undertaking, was complete. He became principal painter to the king, successively Rector, Chancellor and Director of the Royal Academy, and director of the Gobelins tapestry manufactory. He supplied designs for all the great schemes of decoration in

62 GASPARD DUGHET (1615–75) Landscape near Albano : evening, 1640–50. Oil on canvas, 19″×26″ (48.5×66). By courtesy of the Trustees of the National Gallery, London

the royal palaces, received commissions for portraits, altarpieces, historical subjects, etc., and in his writings, especially the *Méthode pour apprendre à dessiner les Passions*, established the accepted academic art doctrine. This in-volved the rejection of the Baroque in favour of the classicism of Poussin; nevertheless, Le Brun's own paintings, and particularly his altarpieces and designs for tapestry, such as the *Triumph of Alexander* (Versailles) (*Ill. 63*), incline more to the Baroque of Rubens and Cortona than to Poussin's classicism.

Le Brun's natural talents were undeniably great. His portraits are perceptive, and have a restrained opulence in colour. He established, as Poussin could hardly have done, a school of French decorative painters whose achievements gave a richness to architectural interiors almost rivalling that of the Italians. Among his assistants and collaborators, Adam Frans van der Meulen, a Fleming who specialized in landscapes with hunts and battles, and Jean-Baptiste Monnoyer, a still-life and flower painter, contributed to the splendours of the court and palaces of the nobility. Eustache Le Sueur, of the same generation as Le Brun, was second in importance to him as a decorative artist. Trained in Vouet's studio,

63 After CHARLES LE BRUN (1619–90) *The Triumph of Alex-ander, Gobelins tapestry. Château de Versailles*

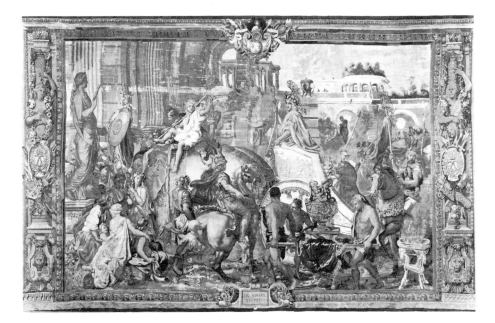

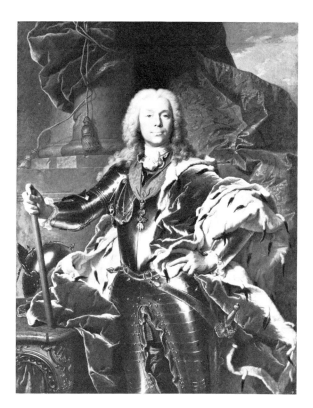

64 HYACINTHE RIGAUD (1659–
1743) *Prince Wenzel von Liechten-
stein, 1740. Oil on canvas, 32¼" ×
25⅝" (82 × 65). Liechtenstein Col-
lection, Vaduz*

he never experienced the attraction of Cortona's ripe
Baroque. His decorative paintings of the later 1640s in
the Hôtel Lambert show him moving from the style of
Vouet towards a gentle classicism influenced by Poussin's
earlier style. In his later works, especially the series
illustrating the life of St Bruno, painted for the Carthu-
sians in Paris, he evolved a more personal classicism, full
of devotional feeling, but with none of Poussin's
intellectual rigour.

After the death in 1683 of the king's chief minister Jean
Baptiste Colbert, who had been primarily responsible for
the organization of the arts, Le Brun was by degrees re-
placed in royal favour by Pierre Mignard, a professed
opponent of Poussinism, and an advocate of the more
colouristic Baroque or Rubenist manner. His abilities
were by no means equal to those of his rival, and Mig-
nard's paintings – even most of his portraits, which are
perhaps his most distinctive works – now seem weak in
design and too profusely decorative in detail.

Whatever Mignard's limitations, the favour he enjoyed at the end of his career may be regarded as indicative of the more fully Baroque taste of the last generation of painters in Louis XIV's reign. The decorative works of Charles de la Fosse, the historical and religious canvases of Antoine Coypel, and the portraits of Nicolas de Largillière and Hyacinthe Rigaud all have greater vigour, brilliance and variety of colour, freer handling and richer textures than the more sober works of Le Brun's generation. Rigaud especially marks the success of the new style. From the end of the 1680s he was almost exclusively occupied with portraits of the royal family and court officials, ambassadors and soldiers. These portraits (*Ill. 64*) have a tremendous Baroque assurance and swagger. The brilliantly high-lighted armour, the wind-blown draperies of gorgeously coloured velvets or silks, the grand gestures, have a spirit which makes it easy to excuse his often cold and rather laborious execution. At least, with Rigaud, French 17th century painting makes its exit with an impressive flourish.

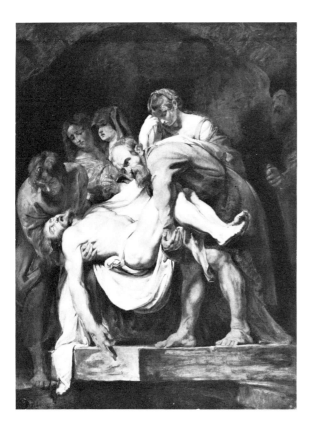

66 PETER PAUL RUBENS (1577–
1640) *The Entombment of Christ
(after Caravaggio), 1613–15. Oil
on panel, 34¾″ × 25¾″ (88.5 ×
65.5). National Gallery of Canada,
Ottawa*

Duke of Lerma (Madrid, Prado) (*Ill. 65*); but Rubens's
powerful originality is already apparent in the changes
he made in Titian's grand conception. Whereas Titian's
design moves across the canvas in a plane almost exactly
parallel to it, Rubens turns his figures in steep fore-
shortening, so that the massive forms of horse and rider
seem to break through the picture-plane altogether,
giving the picture a quite new dynamic force.

While in Rome, Rubens was among the first to recog-
nize the genius of Caravaggio, whose *Entombment of
Christ* he copied, or rather paraphrased, with significant
differences from the original. Rubens's version (Ottawa,
National Gallery of Canada) (*Ill. 66*) in the first place
substitutes for most of the sharply contrasting local colours
of Caravaggio's original a series of closely related reds;
he gives the body of the dead Christ much greater mass
and softness, altering the angle between the thighs and the
trunk, and throwing the head further back; and he com-

65 PETER PAUL RUBENS (1577–
1640) *The Duke of Lerma on
horseback, 1603. Oil on canvas,
9′ 6″ × 6′ 9″ (289 × 205). Prado,
Madrid*

87

pletely rearranges the background figures, eliminating the woman who raises her hands in despair, and moving the others round so that they form a single curve leading the eye to the head of Christ. All these changes (and others almost equally significant, such as the omission of the plant in the lower left corner) give greater unity and concentration to the conception.

Towards the end of his Italian years Rubens produced a work with most of the characteristics of his mature style. In *The Madonna adored by Saints* (Grenoble, Musée des Beaux Arts) (*Ill. 68*), painted in 1607–8 (it was the first version of the altarpiece for Santa Maria in Vallicella, which had to be removed because its surface reflected the light), the forms are powerfully modelled, rich varieties of colour and texture are developed in draperies, flesh, architecture, sky, armour and foliage; and in spite of a basically symmetrical design and a shallow pictorial space, great vitality is achieved by carefully placed asymmetrical features, moving draperies and effects of light. This is almost a fully Baroque picture, not least in the ecstatic emotionalism of the central figure of St Gregory.

Soon after his return to Antwerp in 1608, the remaining traces of Mannerism were to be swept away. In the altar-piece of *The Raising of the Cross* (Antwerp Cathedral), painted in 1610–13, a single receding diagonal unites the entire complex of figures. It is true that *The Descent from the Cross* (also in Antwerp Cathedral) (*Ill. 67*), painted about the same time, still employs a relatively shallow space, but all the nine figures of this composition are gathered, with masterly skill, into a single rhythmic se-quence of tremendous plastic variety, against the back-ground of an ominously dark sky. Rubens's success was almost immediate and complete. He was appointed in 1609 as painter to the Archduke Albert and Arch-duchess Isabella, Regents of the Spanish Netherlands; in the same year he married the beautiful Isabella Brant; commissions poured in upon him, and young men clamoured for admission as pupils in his studio.

Two features of his style are of special importance: one is the embracing dynamism of his rhythmic compositions, best exemplified in such pictures as *The Wild Boar Hunt* (Dresden, Gemäldegalerie) and the *Battle of the Amazons* (Munich, Pinakothek). Even in relatively static subjects, like the *Adoration of the Magi* (Antwerp, Royal Museum)

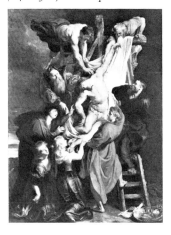

67 PETER PAUL RUBENS (1577–1640) *Descent from the Cross, c. 1612. Oil on panel, 7′ 10″ × 10′ 2″ (240 × 310). Antwerp Cathedral*

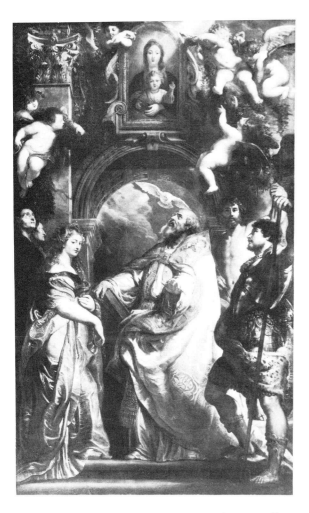

68 PETER PAUL RUBENS (1577–
1640) *The Madonna adored by
Saints, 1607/8. Oil on canvas,
15′ 7″×9′ 4″ (474 × 285). Musée
des Beaux Arts, Grenoble*

painted in 1624, the design has a tremendous impelling
force, binding all the figures together in a sequence which,
at whatever point the eye begins its exploration of the
surface, carries the attention irresistibly to the Christ
Child and thence to the kneeling adorer. The second is
Rubens's use of light as one of the principal means of
establishing unity within the picture. Though he was
sufficiently interested in the researches of the Caravaggists
into effects of night and artificial light to paint one or two
pictures himself in this vein, such as *Old Woman warming
herself* (Dresden, Gemäldegalerie) of 1622, he tended

89

more and more to favour softly diffused daylight rather
than strongly contrasted schemes. In this, it was the great
Venetians whom he followed. In a picture like *The Rape
of the Daughters of Leucippus* (Munich, Alte Pinakothek)
(*Ill. 69*), painted about 1618, not only is the light
Venetian, but also the frank and exuberant sensuality in
the rendering of the nude.

Another outstanding feature of Rubens's mature style
is the variety and fluency of his execution. In this, indeed,
he was unapproachable. He seems always to have known
exactly how to obtain every kind of effect, whether with
solid impasto, swiftly moving strokes of colour, almost
dry scumbles, or thin liquid glazes which allow under-
painting to glow through. His technique plays an im-
mensely important role in the unity and vitality of his
pictures.

He was especially well fitted by temperament and
abilities for the decoration of large spaces. It is a very
great pity that, of his greatest decorative schemes, only his
series of canvases for the ceiling of the Banqueting House
in Whitehall still remains in its original situation. The
decorative project for the church of the Jesuits in Antwerp,
involving no less than thirty-nine pictures for the ceilings
of the side aisles and galleries, an altarpiece for the high
altar and further altarpieces for lateral chapels, was des-
troyed in the fire of 1718, except for the altarpieces which
were removed in time to escape the flames, but subse-
quently dispersed. Of the series of twenty-one huge
paintings of *The History of Marie de' Medici*, painted in the
1620s for the Queen Mother's new Palais du Luxembourg
in Paris, only half of the originally projected scheme sur-
vives in the Louvre, but something must certainly have
been lost with their removal from the settings for which
they were intended. This series, however, illustrates
perfectly Rubens's skill in adapting himself to the require-
ments of his patrons, the autocratic princes and monarchs
of the Counter-Reformation. Nothing could better
express their sense of divine mission than one of the series,
The Journey of Marie de' Medici (*Ill. 75*), attended by Power
and heralded by Fame and Glory. Rubens blithely
ignores the historical fact that in the battle of Ponts-de-
Cé, represented in the background, the Queen's forces
were ignominiously routed by those of the king. The
Queen is presented with such splendour and pride that
the inconvenient facts of history become unimportant.

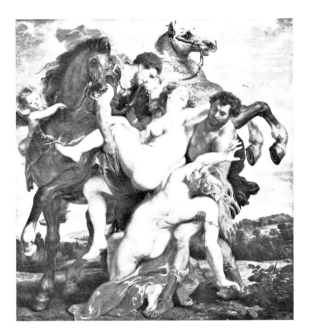

69 PETER PAUL RUBENS (1577–
1640) *The Rape of the Daughters
of Leucippus, c. 1618. Oil on canvas,
7′ 3″×6′ 10″ (222×209). Alte
Pinakothek, Munich*

Rubens was in great demand by princes and monarchs all over Europe, from Vincenzo Gonzaga to Charles I of England and Philip IV of Spain. His scope and accomplishment were unrivalled: portraits, histories, allegories, religious subjects, hunting scenes, landscapes, mythologies. Under his direction, engravings after his designs were produced and published by a school of engravers and woodcutters, through which his style and influence were disseminated over the entire continent.

In the field of landscape painting, Rubens's achieve-ment was of special importance. In his early years he collaborated on a number of occasions with Jan Brueghel, younger son of Pieter Brueghel the Elder, who evolved a type of delicate, rather miniature-like landscapes of woodlands or villages, probably during his stay in Italy from 1593 to 1595. Though still in many respects Mannerist, with a complexity of small parts making up the scenes, these landscapes were more closely based upon nature than those of his older compatriots Gillis van Coninxloo or Paul Brill, and exhibited a fresher feeling for atmosphere. Rubens's landscapes, such as *The Dairy Farm* (London, Buckingham Palace) of about 1620, *Summer* (Windsor Castle) of about 1620–5, or *Landscape*

70 PETER PAUL RUBENS (1577–
1640) *Albert and Nicholas Rubens,*
c. 1625. Oil on panel, 5′ 2″×3′
(158×92). Liechtenstein Collect-
ion, Vaduz

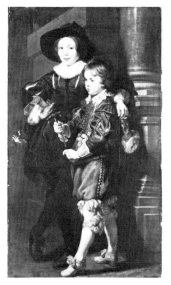

with a Quarry Waggon (Leningrad, Hermitage), while
owing a great deal to Brueghel, introduce a new grandeur
of format and a vitality which derived from his studies of
Titian.

Though they are never literal representations of actual
scenes, he did incorporate into some of them recognizable
features of actual spots, such as his own Castle of Steen
(in the marvellous painting in the London National
Gallery) or the valley of the river Thames in the back-
ground of the *Landscape with St George and the Dragon*
(Buckingham Palace) which he presented to Charles I.
In the sense of light, of space, of distance, of the vitality of
nature, and in the richness of contributory incidents,
Rubens's landscapes remain among the most remarkable
achievements of this branch of art – a unique blend of
northern naturalism and the great Venetian tradition.
Their structure, almost invariably based upon a system
of receding diagonals, as in the splendid *Landscape with a*
Rainbow (London, Wallace Collection) (*Ill. 71*), is as
conscious an artifice as the very different constructional
systems of Poussin or Claude, but it enabled him to
suggest a pictorial space on a much vaster scale, which
seems to continue indefinitely beyond the limits of the
frame.

Rubens must be considered the perfect type of the
Baroque artist. The organic flow of his line, the glow of
his colour, the textural variety and brilliance of his
surfaces, his marvellously corporeal sensuality, combined
with a sure feeling for character and emotional expression,
make him one of the most universal of artists. In addition
to all his paintings and designs for prints, he designed
several series of cartoons for tapestries – the six scenes of
the *History of Decius Mus* (Vienna, Liechtenstein
Collection), and the *Eucharist* series for the Archduchess
Isabella were both produced in the 1620s. He made
designs for silver, for sculptural reliefs, and for other
media, and in his last years he superintended the elaborate
festivities for the triumphal entry into Antwerp of the
Cardinal Infante Ferdinand on his succession to the
Governorship of the Netherlands, himself painting a
number of portraits and allegories for the occasion, and
sketching designs for triumphal cars, arches, etc.

A great part of his prodigious success was undoubtedly
due to his personal qualities. Even early in his career,
while in the service of the Duke of Mantua, he was

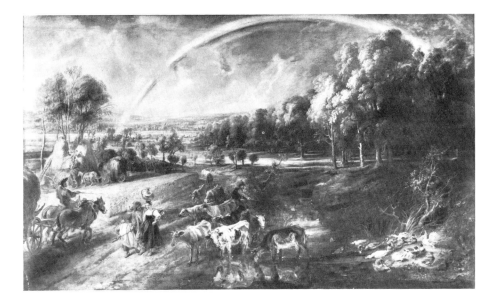

entrusted with a delicate diplomatic mission to Spain;
later, his diplomatic missions for the Archduchess
Isabella and for Philip IV were always discharged with a
probity which earned general respect and admiration.
His correspondence with Nicolas Claude de Peiresc,
with Pierre Dupuy in France; and with his favourite
pupil and assistant, the sculptor Lucas Fayd'herbe, show
him as a considerate and warm-hearted friend. The
portraits of his young second wife Hélène Fourment,
whom he married when he was fifty-three, and of her
children, reveal his capacity for the deepest, most
affectionate devotion. This is the quality which gives such
charm and warmth, for instance, to the half-length
portrait of Hélène in the Alte Pinakothek at Munich,
and to the earlier double-portrait of his sons by his first
marriage, *Albert and Nicholas Rubens*, in the Liechtenstein
Collection (*Ill. 70*).

Among Rubens's closest collaborators and assistants,
mostly specialists in still-life, animals, landscape, etc.,
were several very able painters. Frans Snyders and Jan
Fyt were the most important in still-life and animal
painting, and both also produced splendid large inde-
pendent paintings, full of Baroque exuberance and
sensuous delight. Rubens's dominant genius tended to
dwarf most of the other artists of his time, whether they
were portraitists like Cornelis de Vos, landscapists like

71 PETER PAUL RUBENS (1577–
1640) *Landscape with a Rainbow,*
1636–8. Oil on panel, 4′ 6″×7′ 9″
(137×237). By courtesy of the
Trustees of the Wallace Collection,
London

93

Lucas van Uden, or historical and religious painters like Pieter Soutman. Two artists of greater individuality than these, nevertheless, managed to assert their independence; namely Jacob Jordaens and Anthonis van Dyck (later Sir Anthony).

Jordaens had originally studied, like Rubens, under Adam van Noort, whose daughter he married in 1616. His early pictures, like *The Daughters of Cecrops finding Erichthonius* (Antwerp Museum) or the *Adoration of the Shepherds* (Stockholm, National Gallery), of 1617 and 1618 respectively, reflect Rubens's style; and from about 1618 onwards Jordaens seems to have been involved in Rubens's studio. Nearly twenty years later he was engaged under Rubens's direction in various projects, including paintings from sketches by Rubens for Philip IV's hunting lodge, the Torre de la Parada, but independent works from this period also exist. By 1640 he had established his own studio, and received a number of important commissions for Antwerp churches and for foreign princes and monarchs. His later paintings, however, such as the *Twelfth Night Feast* (Vienna, Kunsthistorisches Museum) (*Ill. 72*), exhibit a hearty bourgeois realism which is quite different from Rubens's more aristocratic manner, and is closer in spirit to the Dutchman, Jan Steen. Jordaens became a convert to Calvinism, and while his conversion did not prevent him from continuing to paint religious subjects for Catholic churches, it seems to have brought him into sympathetic relationship to the realism of the Dutch, especially the Caravaggesque tradition as represented in the work of Theodor Rombouts. Jordaens added to Rombouts's type of composition the naturalistic settings of bourgeois interiors, and an ebullient vitality which gains in force from the confinement of his pictorial space.

Van Dyck's temperament led him in quite the opposite direction. Trained in the first place under Hendrik van Balen, he was enrolled as a master in the Antwerp Guild in 1618, and then entered Rubens's studio. After assisting Rubens in the ceiling paintings for the Jesuit church in Antwerp in 1620, he went to England at the invitation of the Earl of Arundel, and was granted a salary by King James I. A work of about this period, *St Martin dividing his Cloak* (London, Royal Collection), is, as might be expected, very close in style to Rubens, with massive forms powerfully modelled. Most of the ensuing five or

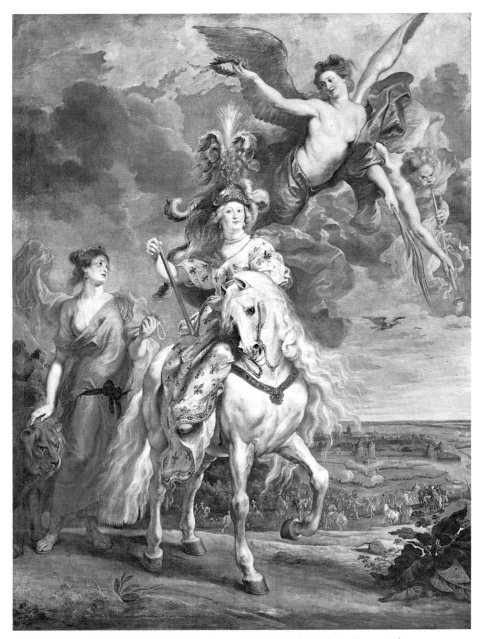

75 PETER PAUL RUBENS (1577–1640) *The Journey of Marie de' Medici, 1622–5. Oil on canvas, 14' 11"×9' 6" (394×295). Louvre, Paris*

the Virgin (Vienna) of 1629–30 is a beautiful example of this Italianate style, as also is *The Rest on the Flight into Egypt* (Munich). Van Dyck's mastery of tenderness and pathos is most effective in subjects like the *Pietà* (Munich and Madrid, Prado), *St Sebastian* (Leningrad, Hermitage), *St Jerome* (Dresden and Althorp, Earl Spencer), or, with a still softer, more poetic sensuality, in the lovely *Cupid and Psyche* (Windsor Castle), painted towards the end of his life, though early works, such as *Christ crowned with Thorns* (*Ill. 76*) or *The Taking of Christ* (both Madrid, Prado) are more robust and dramatic.

Van Dyck's impact produced a complete trans-formation in English painting. Before the accession of Charles I, several Netherlandish painters of some distinction had worked in England, notably Daniel Mytens from The Hague, about 1618, Paul van Somer, who arrived in 1616, and Cornelius Johnson (actually born in London of Flemish parents), whose known works date from 1617. Nevertheless, Van Dyck's elegance, inventiveness and fluency of execution introduced an entirely new set of standards. His influence dominated

76 ANTHONY VAN DYCK (1599–1641) Christ crowned with thorns, c. 1620. Oil on canvas, 7' 4"×6' 5" (223×196). Prado, Madrid

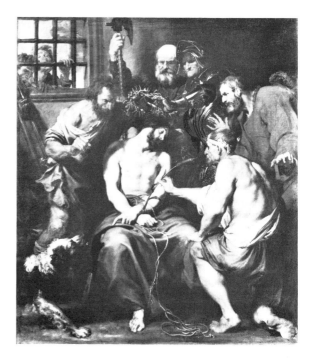

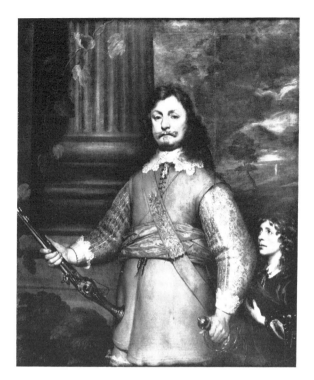

the next generation of portrait painters, especially Robert
Walker, the favourite painter of the Parliamentarians,
Michael Wright, William Dobson and Peter Lely.
Dobson was apparently trained under the decorative
painter and designer of tapestries Francis Cleyn; and his
technique as well as his temperament were quite different
from Van Dyck's. But his rich, painterly handling, the
strongly Venetian flavour of his textures, and the postures
of some of his figures would have been inconceivable
without Van Dyck's example. During the Civil War
he became the chosen painter of the Royalist party, and
his pictures express, perhaps better than any other docu-
ments, the tragic grip of that conflict. Some of them, for
example the *Unknown Officer with a page* (Knole, National
Trust) (*Ill. 77*), *Endymion Porter* (London, Tate Gallery),
or *Sir Charles Lucas* (Woodyates Manor), have a bluff
heartiness and directness of characterization, but another
side of Dobson's personality becomes apparent in the
full-length portrait called '*James, 3rd Earl of Northampton*',
(Castle Ashby, Marquess of Northampton), and in the

full-length *Henry, 2nd Earl of Peterborough* (Drayton). It
is as though these brave and gentle men are about to en-
gage in a battle which may bring them wounds, death or
ruin. Some of this poignancy is also present in the splen-
did *John, Lord Byron* (Tabley House), and in the triple
portrait-group of *The Artist, Sir Charles Cotterell and
Sir Balthasar Gerbier* (Albury Park). Many of Dobson's
pictures have what Oliver Millar has aptly called a
'cumbersome inelegance', with their crowded accessories,
thickly impasted flesh, and detailed military accoutre-
ments, but the painter's sensitivity to personality and
character gives them a reality of presence which can make
even Van Dyck's charm and elegance look a shade vapid.

Peter Lely, after a training in Haarlem, went to London
by 1647, possibly as early as 1641. His early portraits,
such as *The Children of Charles I* (Petworth, National
Trust), painted in 1647, are still dependent upon Van
Dyck, but by the middle of the next decade, with his
restrained and sensitive portrait of *Sir Thomas Lee*
(Leicester Art Gallery), he liberated himself from that
influence. Shortly before the Restoration of the monarchy
in 1660, however, the sobriety of this style gave way to a far
more flamboyant and Baroque manner, of which the *Two
Ladies of the Lake Family* (London, Tate Gallery) is a
readily accessible example. While the psychological
interest declines – with some notable exceptions – this new
manner permitted the development of Lely's special
gifts as a colourist. The brushwork becomes bolder and
freer, and brilliantly decorative colour-schemes give his
best works of this period a gorgeousness which few
painters of his time could match. Confirmed as court-
painter in 1662, he produced in the next decade or so his
best-known works, including the series of *Maids of
Honour* painted for the Duchess of York (Hampton
Court Palace), which are splendid in colour and in
variety of silken textures, but whose figures have an al-
most stereotyped languor of expression, and the far more
vigorous series of admirals and sea-captains painted for
the Duke of York (Greenwich, National Maritime
Museum), the best of which are the portraits of *Sir John
Harman, Sir Thomas Allin* and *Sir Jeremiah Smith*.

Perhaps Lely's historical significance depends mainly
on his transmission of something of the Van Dyck
tradition to the great portrait painters of the following
century. But in his colour, his use of landscape settings,

78 ANTHONY VAN DYCK (1599–
1641) *Frans Snyders, c. 1620–25.
Oil on canvas, 4' 8" × 3' 5" (142.5 ×
105.5). Copyright The Frick Col-
lection, New York*

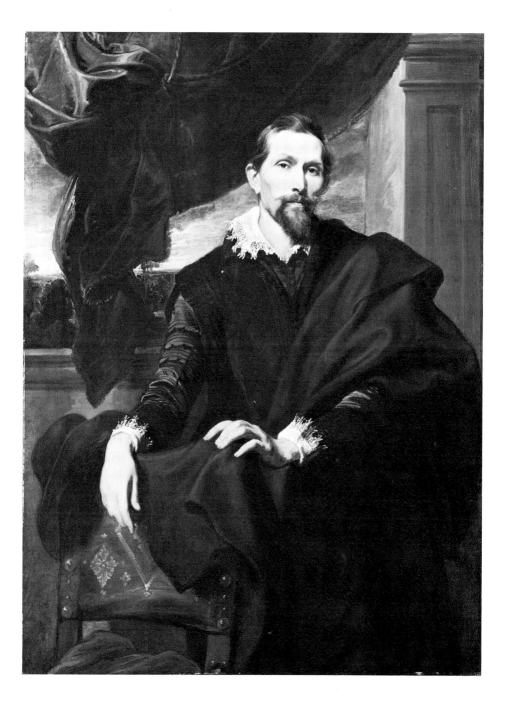

sculptural accessories, and in his occasional evocation of a pastoral mood (as in *Nymphs at a Fountain*, in the Dulwich Gallery), he moves in the direction of the Rococo. He anticipated Reynolds in the attempt to 'elevate' portraiture by incorporating motifs from 'higher' branches of art, as in his portrait of *Barbara, Duchess of Cleveland and her son* (London, National Portrait Gallery) (*Ill. 82*), the composition of which, one of his most accomplished and architectonic designs, alludes to the iconography of the Madonna and Child.

In Flanders itself, a few other painters of distinct originality arose, quite apart from the spheres of influence of Rubens and Van Dyck. The paintings of Brouwer and Teniers especially have a bourgeois character close to that of contemporary Dutch art. Adriaen Brouwer, who worked in Amsterdam and Haarlem early in his career, greatly influenced Dutch artists of the next generation. His typical subject-matter, derived from the tradition of Pieter Brueghel, concerned the lives of peasants – the everyday incidents of drinking, smoking, card-playing or quarrelling in taverns, the visits of the itinerant dentist or the surgeon, the games of skittles or bowls in the innyard. His little pictures, painted with a broad, free touch, convey the pathos and humour of such events, and the thick steamy atmosphere of the interiors. His handling of the brush may owe something to the influence of Frans Hals, but in his depth and intensity of humanity he occasionally approaches Rembrandt. The little painting of a *Boor Asleep* (London, Wallace Collection) (*Ill. 79*), blissfully dreaming, or the *Peasants quarrelling over cards* (Dresden), make it easy to understand why his works were admired and collected by Rubens.

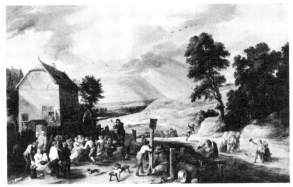

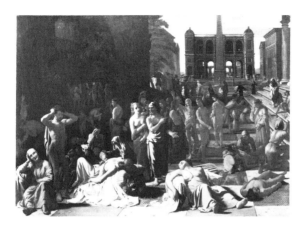

David Teniers represents another link between the
Flemish and Dutch schools. Active in Antwerp from
about 1632 to 1651, and subsequently in Brussels where
he was court painter and keeper of the Archduke's
picture collection, he may never have actually visited
Holland. Nonetheless, there are many similarities between
his work and Dutch painting. He painted almost all
kinds of subjects, but his scenes of peasant life, un-
doubtedly influenced by Brouwer, are the best known.
Though his figures lack the impassioned absorption
of Brouwer's, his range was greater. His *Rural Fête*
(Gemäldegalerie, Cassel) (*Ill. 80*) reveals his skill in
the mingling of figures, still-life and landscape.

Another painter of outstanding ability, Michael
Sweerts of Brussels, evolved in a quite different direction.
He was in Rome from 1642 to 1652–4, where he came
under the influence of Pieter van Laer, known as
Bamboccio. Sweerts, however, handled the typical genre
subjects with exceptional tonal sensitivity. His quiet
schemes of brown and pale grey, and his sense of stillness
occasionally recall Vermeer. His portraits, too, have a
gentle charm. At times, he was capable of a remarkable
essay in the early style of Poussin, like his *Plague at Athens*
(Cook Collection, on loan to Manchester City Art
Gallery) (*Ill. 81*). Such reflection of Roman classicism
was exceptional in Flemish Baroque painting. Sweerts
returned from Italy to Brussels, where he was involved in
the founding of the Academy in 1656. In 1658 he was
in Amsterdam, and three years later joined a religious
mission to India, where he died.

81 MICHAEL SWEERTS (1624–
64) *The Plague at Athens, 1647–52.
Oil on canvas, 4′×5′ 9″ (121×
175). Sir Francis Cook Bt and the
Trustees of the Cook Collection (on
loan to the Manchester City Art
Gallery)*

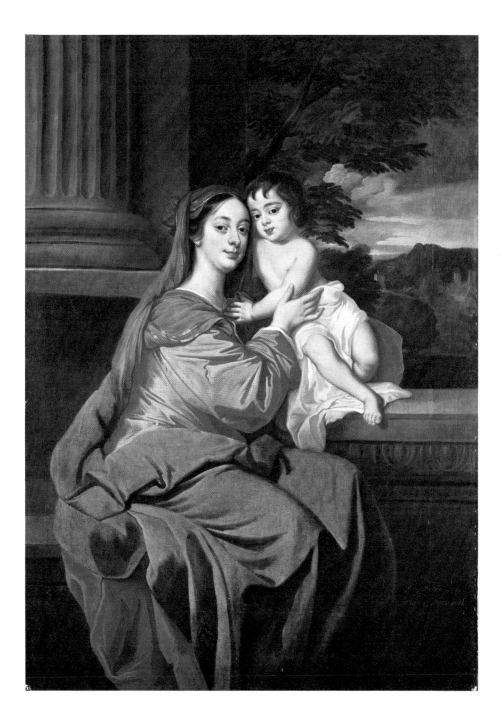

CHAPTER SIX

Dutch painting in the seventeenth century

Dutch art in the 17th century developed along different lines from Flemish art. Whereas Flanders was Catholic and ruled by Regents with monarchical powers, the northern Netherlands were predominantly Protestant, and the Union of Protestant States formed in 1579 conducted a long and eventually successful struggle against Spanish rule. The Twelve Years Truce signed in 1609 acknowledged the freedom of the states and abrogated the pretensions of the archdukes. Although war with Spain was resumed in 1621, the Peace of Münster in 1648 marked the complete triumph of the Dutch, and ushered in the period of greatest power and prosperity of the United Netherlands. The constitution was a complex one, but a great deal of power resided with the States-General and the States of Holland, consisting of delegates of the burghers of the principal towns. To a degree which was unprecedented even in Renaissance Florence, patronage of the arts rested with the bourgeoisie. Consequently art itself was secular and civic instead of religious and monarchic. When religious subjects were depicted, it was not their iconic significance which was stressed, but their humanity. Churches, however, were stripped bare of altarpieces and statues of saints. The most characteristic art-product of the period was the group-portrait. The companies of civic guards, the aldermen of the towns, the governors of academies, hospitals and guilds decorated their assembly rooms with celebrations of their collective authority. In the hands of such artists as Frans Hals, Bartholomeus van der Helst and Rembrandt, such group-portraits attained a dynamic quality expressive not only of their civic pride and local patriotism, but also of their participation in the newly enjoyed processes of democratic government. While giving full weight to the personalities of the figures, these pictures emphasize their collective character and responsibility.

82 PETER LELY (1618–80) *Barbara, Duchess of Cleveland, and her son. Oil on canvas, 5′ 9″×3′ 9″ (175.5×114.5). National Portrait Gallery, London*

It was in painting especially that the new social and
political set-up found its typical expression. The attitude
to the world was matter-of-fact, realistic and compre-
hensive. Every aspect of the objective world which con-
cerned them was recorded, in landscape, still-life,
portraiture, interiors and scenes of bourgeois, military
and peasant life, architecture, shipping, wild and
domestic animals and birds. No previous society had
recorded the circumstances of its life in such profusion
and with such passionate enjoyment.

To a considerable extent the chief towns preserved dis-
tinctive local characteristics. The mainly Catholic and
Jansenist Utrecht was especially individual. In the 1620s
Caravaggism was brought to it from Italy by Matthias
Stomer, Dirk van Baburen, Jan van Bylert and others,
reaching a climax in the work of Hendrik Terbrugghen
and Gerrit van Honthorst. In Haarlem the Mannerist
eclecticism of Hendrik Goltzius and his followers at the
beginning of the century gave way to the most splendid of
the Dutch schools of landscape painting, from Esaias van
de Velde to Jacob van Ruisdael, Meindert Hobbema and
Jan Wynants, as well as a school of portraiture dominated
by the massive personality of Frans Hals, and a school of
genre painting whose most gifted exponent was Adriaen
van Ostade. Delft in the middle of the century produced
the serene art of Jan Vermeer, Pieter de Hooch and
Emmanuel de Witte. Leyden, Dordrecht, The Hague
and other towns also produced their own distinctive
local schools. Nevertheless, there was considerable
movement of artists between centres, much cross-fertiliz-
ation and exchanges of influence. Amsterdam became
the metropolitan centre and meeting-place of styles, and
the interchange of artistic ideas and influences between
the Netherlands and Italy maintained its importance. The
richness and variety of these local schools, and the stimulus
of foreign styles provided the soil in which the seeds of
genius flourished.

One interesting result of the disappearance of court and
aristocratic patronage was the emergence of a new class of
artistic middlemen – the dealers. Instead of painting
mainly in response to specific commissions, artists
produced their works spontaneously, and offered them
for sale through the dealers. In spite of the phenomenal
spread of picture-buying among the middle classes,
however, supply outstripped demand and many painters

failed to earn a living from the practice of their art. Either
they died paupers, like Frans Hals, or they supplemented
their earnings from painting by some other calling – Jan
Steen, for instance, kept an inn – or they married wealthy
women, as did Adriaen van Ostade. It was probably the
severely competitive nature of the market which helped to
produce the striking tendency to specialization among
painters. Few artists succeeded in crossing the boundaries
of these specialisms in portraiture, landscape, shipping,
still-life, etc.

The first of the great masters was Frans Hals. Born in
Antwerp, he studied under the Flemish late-Manner-
ist painter Karel van Mander, who had settled in Haarlem
and founded there an academy in association with
Goltzius and Cornelis van Haarlem. Hals's surviving
early pictures, however, suggest that the principal
influence upon him in his formative years was that of
Anthonis Mor, court painter of the Spanish Netherlands
who died a few years before Hals was born. By 1616,
when he painted the first of his series of great portrait-
groups of the banquets of the Haarlem companies of
militia, *The Company of St George* (Haarlem, Frans Hals
Museum), the essentials of his personal style are already
visible. His predecessors in this kind of subject tended
to line up the figures in rows, but Hals employed sweep-
ing diagonal lines, vigorous and varied poses, to create a
dynamic effect which is unmistakably Baroque.

A revealing work of his early maturity, which used to
be regarded as a self-portrait, is the *Gentleman and his wife*
(Amsterdam, Rijksmuseum) (*Ill. 84*), painted about
1623. The joviality of these two smiling figures, seated
informally on a bank in their garden, and the brilliance
and ease of the painting of their costumes, show a delight
in material joys and prosperities which is in very marked
contrast with the aristocratic dignity, say, of Van Dyck's
Genoese portraits. But the closest precedent for this
picture, no doubt painted in celebration of a marriage,
is to be found in Rubens's *Self-Portrait with his first
wife, Isabella Brant* (Munich, Bayerische Staatsgemälde-
sammlungen) painted some fourteen years earlier. Rubens,
in fact, visited Hals in Haarlem in 1624, and the two men
may very well have been in contact at an earlier date; but
the stylistic tendencies of Hals's pictures in this period are
in some respects quite different from the Rubensian
Baroque. The vigorous compositional movements which

give vitality to his groups, such as the *Assembly of the Officers of the Company of St Adrian* (Haarlem, Frans Hals Museum), usually dated 1633 but possibly painted some nine years earlier, have almost no recessional function, but operate across the surface of his canvases. His treatment of space is hardly ever really Baroque; even in the great banquet scenes the amount of pictorial space actually represented is minimal, and most of his individual portraits are shown against plain backgrounds, close behind the figures. His system of lighting from one side, which owes a good deal to the Caravaggists, differentiates so sharply between full light and shadow that the effect is, rather paradoxically, to emphasize the surface pattern rather than the threedimensional mass. And his virtuoso freedom of handling, with broad, spontaneous and apparently almost casual strokes of the brush magically suggesting the various substances and shapes of the subject, helps also to emphasize this continuity of the painted surface itself.

Hals was undoubtedly fascinated by the instantaneous and fleeting expressions of his sitters' faces, whether in portraits or in genre subjects; but the popularity of certain works in which these superficial expressions are rendered with especial brilliance, such as the socalled *Laughing Cavalier* (London, Wallace Collection) and *La Bohèmienne* (Paris, Louvre), has tended to obscure his capacity for more subtle observation of character, which indeed gives his heads an astonishing variety and animation. A comparison of the heads in the last of his Civic Guard groups, *The Officers of the Company of St George* (Haarlem, Frans Hals Museum) painted in 1639, or of almost any examples of his individual portraits, such as the *Man with a Holly Sprig* (Toronto Art Gallery), dated 1626, the *Man holding gloves* (London, National Gallery) of about 1640, and the *Man with a glove* (Leningrad, Hermitage) of about 1650, is sufficient to show the fineness of his perception, whether of the ruthless opportunist, the kindly and rather saddened man of middle age, or the somewhat disillusioned sensualist.

In the later phases of his career, especially after 1640, Hals's style underwent a change. The boisterous swashbuckling mood of the earlier pictures, and their bright and varied colours, give way to a quieter, calmer, more dignified tone and a concentration upon black, with only a few subdued accents of colour. *The Regents of the St*

83 FRANS HALS (*c.* 1580–1666) *Portrait of a Man, c. 1660. Oil on panel, 12⅜″ × 10″ (31.6 × 25.5). Mauritshuis, The Hague*

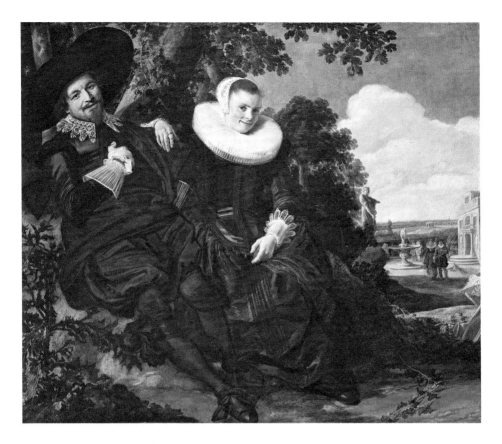

Elisabeth Hospital (Haarlem, Frans Hals Museum), painted about 1641, are gathered in serious debate around a table. Still more in the two groups of the male and female *Regents of the Old Men's Home* (Haarlem, Frans Hals Museum), painted about 1664, or in the *Portrait of a Man* (The Hague, Mauritshuis) (*Ill. 83*), also of the 1660s, the mood is tinged with a profound sadness. The figures, especially in the male group, seem isolated by their intensity of feeling, as if they were brooding on the inadequacy of human effort. These works of his old age challenge comparison even with Rembrandt's great works of the same period.

Rembrandt is usually and rightly regarded as the greatest of the Dutch masters, the greatest of all 17th century painters, perhaps the supreme master of portraiture, and one of the two or three greatest painters of the whole European tradition; yet it is by no means easy to explain exactly in what his greatness consists. In his early

84 FRANS HALS (*c.* 1580–1666) *A Gentleman and his wife (Isaac Massa and Beatrix van der Laen), c. 1623. Oil on canvas, 4′ 7″×5′ 5″ (140 × 166.5). Rijksmuseum, Amsterdam*

maturity, Rembrandt enjoyed a very high reputation, which for various reasons he lost before the middle of the century. He was neither an intellectual nor a theorist, and he left us no written guides, or reported conversations, which might help to define his aims and objectives.

Born at Leyden in 1606, he was enrolled in 1620 as a student at the university there, but soon turned to the pursuit of painting. After three years as a pupil of the landscape painter Jacob van Swanenburgh, he went to Amsterdam to study for six months under Pieter Lastman, and perhaps also for a short time under Jacob Pynas. Both Lastman and Pynas had spent some years in Rome, where they were influenced by Caravaggism, but, more importantly, they had both been in contact with the in-tense, dramatic and imaginative art of the German Adam Elsheimer. The influences reflected in Rembrandt's earliest works are predominantly of this Elsheimer school. *The Martyrdom of St Stephen* (Lyons, Musée), for example, Rembrandt's earliest dated picture, of 1625, is small in scale, densely packed with figures, minutely worked and finished, full of action and movement. In its somewhat claustrophobic lack of space it is reminiscent of Els-heimer's picture of the same subject now in the National Gallery of Scotland, and still essentially late-Mannerist in style. Within the next few years, Rembrandt was modifying this style by giving his figures more monu-mentality, and by surrounding them with ample space, using subtly controlled lighting to dramatize the attitudes and to unify the whole, as in *Samson betrayed by Delilah* (Berlin–Dahlem, Gemäldegalerie) of 1628. The Elsheimer influence, however, persisted until the middle 1630s even in much larger pictures, such as *Belshazzar's Feast* (London, National Gallery), *The Sacrifice of Abraham* (Leningrad, Hermitage), and *The Blinding of Samson* (Frankfurt, Städelsches Kunstinstitut). In order to achieve the vehement expressiveness and the drama which he sought, he accentuated the facial expressions to the point of grimace, giving very special attention to the physical action of the hands, as in *The Sacrifice of Abraham* (*Ill. 85*). Rembrandt was finding his own way to a kind of Baroque, by methods which were at times very similar to Caravaggio's. But in what should prob-ably be considered the masterpiece of his early years, *The Presentation of Jesus in the Temple* (The Hague, Mauritshuis), dated 1631, it is the more reflective and

poetic aspects of Elsheimer's style which triumph. The rich textures and the sparkle of light falling on the central group of figures are contrasted with the vast shadowed spaces surrounding the scene with a solemn stillness which was to be the leading characteristic of so many of Rembrandt's later works.

Following his removal to Amsterdam in 1631–2, Rembrandt entered upon the most brilliant and success-ful phase of his career. The work which established his reputation was *The Anatomy Lesson of Dr Tulp* (The Hague, Mauritshuis). The somewhat gruesome subject, already established for two generations in Netherlandish painting, expresses the keen interest which was felt in scientific research; but the most striking feature of the picture is the way the painter has used the figures' con-centration upon the dissection which is being demon-strated, to establish a vivid and dramatic pictorial unity. In a rather similar way Rembrandt used the incident of the woman passing a letter to her husband as a means of effecting a dramatic relationship between the figures in the double-portrait of *The Shipbuilder and his Wife* (London, Buckingham Palace) (*Ill. 86*), of 1633. Such compositions afford a fairly close parallel with Hals's banquet groups of the same period, in their search for a more intimate union of all the components of a scene. Most of Rembrandt's portraits of the 1630, however, are of single figures, usually shown at half or three-quarters length; and the manner of presentation, with only a few exceptions, is essentially simple. The forms are powerfully modelled; costumes and accessories, textures of clothing and flesh are richly rendered; attention is centred on the crucial points of expression, the head and hands; but there is no attempt, as in Hals, to fix a vivid momentary expression. Descriptive accuracy has been tempered with a sympathetic, indeed often an affectionate eye. The massive figure of the minister *Eleazar Swalmius* (Antwerp, Museum), seated rather like a pope by Titian, is clearly enjoying the discourse he is delivering, and *Maria Trip* (Amsterdam, Rijksmuseum, on loan from the Van Weede Foundation), though not beautiful, has an endearing look of intelligence and charm. The technical means by which Rembrandt conveys the characters of his subjects are never obvious. In the *Portrait of an old lady aged 83* (London, National Gallery), painted in 1634, the powerful impression of patience and resignation in

85 REMBRANDT (1606–69) *The Sacrifice of Abraham, 1635. Oil on canvas, 6' 4"×4' 4" (193×133). Hermitage Museum, Leningrad*

III

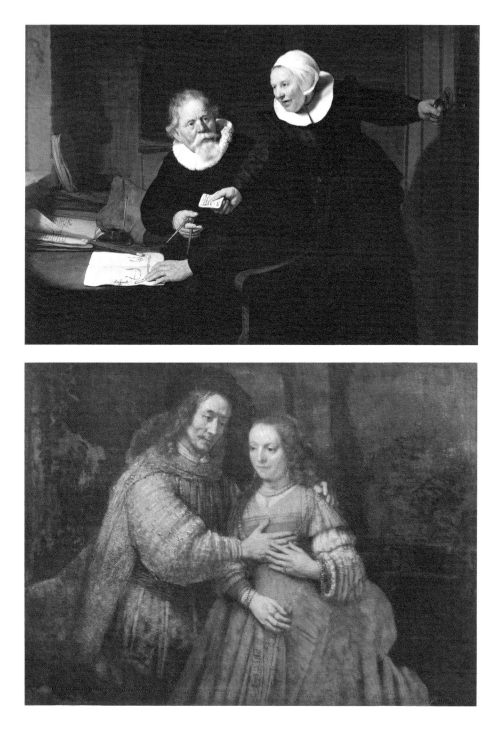

suffering is due primarily to the downward, abstracted gaze of the eyes, and the contraction of the muscles of the brow. In the next decade, Rembrandt came to rely more upon chiaroscuro than upon drawing and model-ling. In the portrait of *Nicolaas van Bambeeck* (Brussels, Musée Royal) of 1641, for example, the deployment of light serves to enrich immeasurably the impression created by the somewhat embittered expression of the mouth and eyes, and the tension of the hand holding the glove.

In the 1640s a change came over Rembrandt's style, and over his fortunes: the violence of some of his early subject-pictures gives way to calm and simplicity. These changes are usually regarded as being connected with the death in 1642 of his wife Saskia. But in fact, in *The Sacrifice of Manoah* (Dresden, Gemäldegalerie) (*Ill. 88*), which is dated 1641, he was already emphasizing an atmosphere of mystery and awe, and softening the chiaroscuro so as to bind together more intimately the figures and the space. In a drawing of the same subject (Berlin, Print Room) of two years earlier, the entire con-ception is still dynamic and full of movement.

But it was in 1642 that Rembrandt finished his last and most monumental work in the more dramatic style. The so-called *Night Watch* (Amsterdam, Rijksmuseum) (*Ill. 89*) gives an altogether new interpretation to the por-trait group of Civic Guards, normally represented, even by Hals, gathered round a table or standing at their place of assembly. In Rembrandt's conception there is general animated movement. The essential role of the rather stage-like space and the architectural background in controlling this movement has been obscured by some reduction of the original canvas at the bottom and both sides. The figures of the two chief officers are thus brought more towards the centre, the arch in the background – originally more central – no longer exerts its stabilizing effect, and the space seems too confined. Nevertheless, the picture still marks the transformation of the traditional group-portrait into something much more akin to an historical or genre subject-painting.

The borderlines between portraiture, Biblical, al-legorical and genre subjects become increasingly hard to define. In an early picture like the *Saskia as Flora* (London, National Gallery) of 1635, a balance between portrait-ure and allegory seemed to be held: one can easily under-

86 REMBRANDT (1606–69) *The Shipbuilder and his Wife, 1633. Oil on canvas, 3′ 9″×5′ 6″ (114.5 × 169). Reproduced by gracious per-mission of Her Majesty Queen Eliza-beth II*

87 REMBRANDT (1606–69) *The Jewish Bride, 1668. Oil on canvas, 3′ 11″×5′ 5″ (119.5×166.5). Rijksmuseum, Amsterdam*

113

88 REMBRANDT (1606–69) *The Sacrifice of Manoah, 1641. Oil on canvas, 7′ 11″×9′ 4″ (242×284). Gemäldegalerie, Dresden*

stand that this is Saskia posing in fancy costume as Flora. But it is possible that the element of allegory has been introduced in order to express an aspect of Saskia's own personality. We are faced with the same problem in *A Man with a large sword* (Cambridge, Fitzwilliam Museum), dated 1650. As in many other examples, the costume is fanciful; but is it actually a portrait, or a studio model posing for a subject-picture, and if the latter, what then is the subject? It is even more difficult to define the difference of emphasis between the picture now entitled *The Apostle Paul at his Desk* (Washington, National Gallery), and the *Man holding a Manuscript* (New York, Metropolitan Museum), of about 1657 and 1658 respectively. If the former belongs to the series of Apostles and Evangelists which Rembrandt painted about this time, may not the latter equally belong to the same series? Such questions are perhaps unanswerable in connection with one of Rembrandt's greatest pictures, the so-called *Jewish Bride* (Amsterdam, Rijksmuseum) (*Ill. 87*), which belongs to the artist's last years. The picture may represent an actual bridal couple, possibly Rembrandt's son Titus and Magdalena van Loo, or Isaac and Rebecca; the painting is equally valid on both levels, as an existing actuality and as an interpretation of the Biblical story.

In these late works, Rembrandt's technique attained an extraordinary boldness and freedom, but of a kind alto-gether different from that of Hals. It is not the deftness of

114

the virtuoso which he shows, but the passionate absorp-
tion of a man obsessed with the desire to express a vision.
He drives the paint about, piles one layer over another,
builds it up in brick-like slabs with impatient strokes of a
spatula, scratches at it with the handle of his brush. Local
colour almost disappears. No other paintings until the
late nineteenth century looked anything like this.

Among Rembrandt's drawings there is a considerable
number of marvellously observed studies of landscapes
from nature – like, for instance, the *View of the Amstel with
a man bathing* (Berlin, Print Room), or the *Cottage and trees
by a stream* (New York, Frick Collection) (*Ill. 90*) – but
his paintings of landscape, with two or three exceptions
only, are of imaginary scenes. They are filled by an
almost tangible atmosphere, and their heavy, threatening
skies and their generally dark tonality give them an
ominous, dreamlike character. Several examples contain
prominently placed architectural features, castles, bridges,
obelisks, churches, etc., and at least in some cases, such as
that of the *Landscape with a Castle* (Paris, Louvre), the

89 REMBRANDT (1606–69) *The
Night Watch, 1642. Oil on canvas,
13′ 9″×16′ 4″ (359×438). Rijks-
museum, Amsterdam*

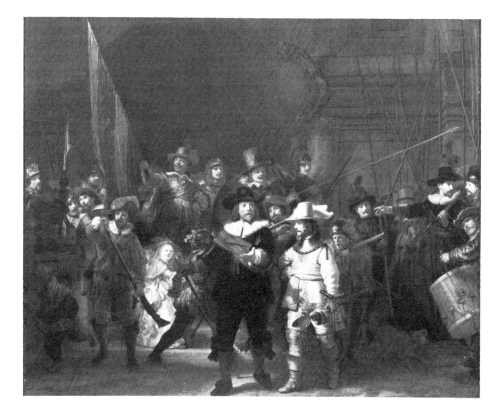

intention seems to be to evoke a vision of antiquity. In this respect, but in this only, they share something with the landscapes of Poussin and Claude. Rembrandt's anti/ quity generally suggests a biblical rather than a classical context. Apart from the work of Hercules Seghers, some of whose works Rembrandt owned, and who assuredly influenced him, and from that of a few of his pupils, Philips Koninck chief among them, who interested themselves in landscape, Rembrandt's landscape paint/ ings remain isolated in the history of art by the intensity of their romantic feeling. All the known examples belong to the middle period of his career, between 1636 and 1655.

It is fortunate that, as a result of the recognition by his contemporaries of the unique importance of Rembrandt's drawings, a very considerable number of them, from all periods of his life, have been preserved.

Rembrandt hardly ever regarded drawings as finished works but rather as a means of recording 'an instantaneous reaction to visual inspiration or impulsive expression of inner vision', as Otto Benesch has put it. There are, indeed, one or two portrait drawings evidently done in response to commissions, but these are exceptional, and as his drawings were done for his own private uses, no concessions were made to traditional or academic notions of form or style. He often worked at tremendous speed, in a variety of media, black or red chalks, pen and ink, washes applied with the brush or a feather, and occasion/ ally with admixtures of oil or gouache. His rhythms often convey the urgency of inspiration, but seldom any of the graces of controlled calligraphy. What these drawings provide is direct insight into the operation of a supremely creative mind. The way in which Rembrandt's imagin/ ation utilizes material from a direct study of nature, like the drawing of *A Naughty Child* (Berlin, Print Room) for the purposes of a painting of *The Rape of Ganymede* (Dresden, Gemäldegalerie), can be followed in the inter/ mediate stage represented by another drawing, also at Dresden. In some sketches, like the *Christ disputing with the doctors* (Paris, Louvre), one can see the artist's un/ certainty and changes of mind which leave the com/ positional problem still only partially resolved. But often, as with the *St Jerome reading in a landscape* (Hamburg, Kunsthalle), the subject is so completely realized that subsequent thoughts (in this case in an etching) can only blunt its impact.

Rembrandt used the etching needle with a lightness and rapidity which at times enabled him to work on copper almost with the spontaneity of a drawing. Yet many of the more elaborate and finished etchings are the product of as much consideration and as many changes of mind as important paintings. The freedom of his handling of the medium, and his ability to realize a complete ex-pression even within a small compass, place his etchings at the very pinnacle of achievement of graphic art.

In the latter part of his life, Rembrandt's work un-doubtedly lost the close *rapport* with public taste which he had enjoyed in the 1630s. Though he continued to receive commissions, not only from Holland but also from abroad, and his fame must have been spread widely by his etchings, the public could not follow him in his profound search for the spiritual essences of the biblical subjects which increasingly occupied him. Possibly his personal affairs caused enough scandal to isolate him socially from his bourgeois contemporaries. About 1645 Saskia's place in his household was taken by Hendrickje Stoffels, whom he was not in a position to marry because of a clause in Saskia's will. His irregular liaison with her

90 REMBRANDT (1606–69) *Cot-tage and trees by a stream, c. 1653. Pen, with brown ink and grey wash, 6⅜″ × 9″ (16 × 23). Copyright The Frick Collection, New York*

called forth the repeated admonitions of the church, but her faithful companionship and support during his financial crisis and enforced liquidation in 1656, when all his possessions, including his considerable art collection and his house were sold, must have made her death in 1663 all the more bitter a blow.

It was probably Hendrickje who posed for the life‑size picture of *Bathsheba* (Paris, Louvre) (*Ill. 91*) painted in 1654, which is among the most splendid of his later Biblical pictures. The subject had interested him for a long time. A small painting of 1632, and a more important one of 1643 (New York, Metropolitan Museum) both contain the old woman occupied in the care of Bathsheba's feet, but both represent an earlier stage in the story. The 1643 panel especially contains many distractions from the central figure; a second servant combs Bathsheba's hair; a bronze jug and bowl, and richly embroidered draperies surround her, while in the right foreground is a peacock, and in the left back‑ground a view of Jerusalem. In contrast, the Louvre picture is very still and quiet. The setting seems to be an interior, and all the illumination falls upon the principal figure, which completely dominates the space. Bathsheba holds King David's letter in her hand. The emphasis has

*91 REMBRANDT (1606–69)
Bathsheba, 1654. Oil on canvas,
4′ 8″ × 4′ 8″ (143.5 × 143.5).
Louvre, Paris*

been shifted from externals to the internal question in
Bathsheba's mind. Her acquiescence is expressed in her
whole relaxed posture. In spite of the erotic element in the
story, and Bathsheba's total nudity, it is thought and
feeling which predominate, not sensuousness.

Many of Rembrandt's late works, including the
marvellous *Jacob blessing Joseph's sons* (Cassel, Gemälde-
galerie) of 1656, similarly concentrate upon moments of
quietude, and all denote his attainment at this time to a
new spiritual level at which dramatic tensions are resolved.

Something of this can also be discerned in his *Self-
Portraits*, most particularly in the superb example at
Kenwood House, London, which is not dated, but must
belong to his last years.

The great series of about fifty self-portraits, from almost
every year of his activity, provide some of the most im-
pressive evidence of the nature of his approach to the
painting of people, which was remarkably objective in its
observation of the exterior, but directed always at the dis-
covery of the sitter's inner consciousness. The most
important of the portrait commissions of his last years,
The Syndics of the Cloth Merchants' Guild (Amsterdam,
Rijksmuseum) (*Ill. 92*), dated 1662, has given rise to
endless discussion by critics. All six men concentrate

92 REMBRANDT (1606–69) *The
Syndics of the Cloth Merchants'
Guild, 1662. Oil on canvas, 6′ 2″ ×
9′ 1″ (188 × 278). Rijksmuseum,
Amsterdam*

119

their attention towards the spectator, as if listening to a
question put to them from an unseen audience; the
bearded man on the left rises as if to answer, while the
chairman and his neighbour refer to the open book on
the table. But if these are the Wardens of the cloth-
samples, such an interpretation can hardly be correct, for
they did not hold public meetings. In fact, the inter-
relationships of the figures with each other and with the
spectator are the means of unifying the composition, and
if the spectator is left with a problem as to the exact
meaning of the scene, this residue of mystery must have
been felt by Rembrandt as no disadvantage.

The flattening of pictorial space, which is a notice-
able feature of the *Syndics*, is even more obvious in *The
Conspiracy of the Batavians* (Stockholm, National Gallery)
(*Ill. 93*), painted in 1661. When the scheme for the
interior decoration of the new Town Hall of Amsterdam
was being prepared towards the end of the 1650s, none of
the twelve large lunettes was allotted to Rembrandt. Only
after the death of his former pupil Govaert Flinck in 1660
did Rembrandt receive the commission for this painting.
What survives, however, is a mere fragment – the central
part of a composition now known only from preliminary
drawings. For some unknown reason the painting was
removed and cut down. Its subject is the revolt of
Claudius Civilis and the Batavians against Rome in A D
69–70, seen as an analogy and prototype of the Dutch
revolt against Spanish rule, and it concentrates upon the
moment of the solemn oath given upon drawn swords.
The figures are blocked out in overlapping patches of
colour, and so lit that their forms are flattened either by
receiving full light or by being silhouetted against it. In
its uncompromising directness and almost brutal strength,
this is the most heroic and monumental of all Rembrandt's
historical pictures, and in its original architectural setting
must have been one of the greatest masterpieces of
European painting.

Dutch bourgeois taste in the third quarter of the century
is more typically represented by the art of Jan Vermeer
than by that of Rembrandt. Whereas, however, Rem-
brandt's production of paintings, drawings and etchings
was massive, Vermeer's output was limited to a quite
small number of paintings. Born at Delft in 1632, he
entered the Guild of St Luke there in 1653. Of his
training nothing is known, though he was influenced

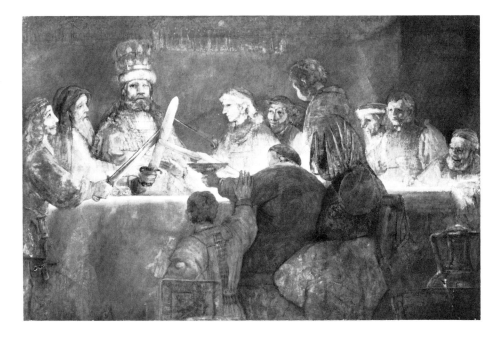

early in his career by Carel Fabritius, a pupil of Rem-
brandt's in the early 1640s, who had settled in Delft by
1650. Apart from two early paintings of religious or
mythological subjects, practically the whole of Vermeer's
works are devoted to quiet domestic interiors with
figures occupied with everyday matters, or to local
townscape. His interiors are filled with softly diffused
light which gently but precisely defines all the forms and
spaces. Still-life objects – fruit, pottery plates or jugs,
turkey carpets, or crusty loaves of bread – often near the
foreground, pick up the strongest light and reflect it
according to the varied textures of their surfaces, in bright
separate touches of impasto. Sometimes an open case-
ment window, as in the Lady reading a letter (Dresden,
Gemäldegalerie), or a mirror hanging upon the far wall,
as in A Lady at the Virginals (London, Buckingham
Palace), reflects a part of the scene, disrupting the image
or viewing it at an unexpected angle, and imparting a
subtle mystery. Of narrative, drama or incident there is
scarcely a hint. It is an ordered world of placid content-
ment. Unlike most of the painters of still-life, however,
such as Willem Kalf, Jan Davidsz de Heem, or Abraham
van Beyeren, Vermeer's interest is not centred in the
varied surfaces and textures for their own sakes, nor

93 REMBRANDT (1606–69) *The
Conspiracy of the Batavians, 1661.
Oil on canvas, 6′ 6″×10′ 3″(198×
313.5). National Gallery, Stock-
holm*

121

in the impression of exotic luxury produced by rich piles of silver, oriental plates and tropical fruits, but on the relationship of solid and space, light and shadow, line and form; perfect simplicity and harmony are established. Every detail counts, but, especially in the few paintings in which figures occupy the major part of the surface, of which the *Girl with a flute* (Washington, National Gallery) (*Ill. 94*) is perhaps the most beautiful, there is a summary and selective treatment of details. Vermeer's exquisite sensibility to tone and atmospheric space is demonstrated with equal felicity in his landscapes, such as *Street in Delft* (Amsterdam, Rijksmuseum) and the *View of Delft* (The Hague, Mauritshuis), which are brilliant, unassertive, and timeless masterpieces.

Two other Delft painters at times approached Vermeer's distinction. Pieter de Hooch was a more uneven artist, whose figures are always less solidly constructed than Vermeer's; but during his best years, from about 1655 to early in the next decade, his paintings, with their masterly spatial construction of domestic interiors and courtyards with mothers and children, have an un-

sentimental charm which reflects a more sociable temperament than Vermeer's. A typical example is *The Music Party* (Cleveland, Museum of Art) (*Ill. 95*). His later work, done in Amsterdam, was influenced by Rembrandt's former pupil Nicolaes Maes, himself a master of the effects of light and shadow in interiors. As a result, De Hooch's work gains in richness of colour, but the delicate and poetic simplicity which gives his Delft works their special quality is gradually lost.

Emmanuel de Witte came from Alkmaar, but studied and worked at Delft until about 1651, settling subsequently in Amsterdam. He painted scenes of market stalls, portraits, harbours and mythological subjects, but it is his church interiors that mark him as a painter of real distinction. Many other painters of architectural interiors, such as Gerrit Houckgeest, Hendrik van Vliet, Job Berckheyde, Pieter Jansz Saenredam or Anthonie de Lorme created harmonious compositions with beautifully related spaces and recessions, but only in de Witte's work

95 PIETER DE HOOCH (1629– after 1684) *The Music Party, 1655– 62. Oil on canvas, 3′ 3″×3′ 11″ (100×119). The Cleveland Mus eum of Art (Gift of Hanna Fund)*

do the patterns of sunlight and deep shadow express such stillness, solemnity and mystery.

The efflorescence of landscape as one of the major branches of painting was widespread and various in its manifestations in Holland during the 17th century; what the Dutch painters above all succeeded in adding to the landscape traditions was the sense of the unique spirit and character of a particular place. Early in the century at Utrecht Abraham Bloemart had elaborated, in a brilliantly decorative way, full of sharply defined details, the Flemish tradition of bucolic landscape which had descended from Pieter Brueghel, but this was still an art essentially Mannerist in style. The achievement of a new approach was due to painters born in the last fifteen years of the 16th century, Arent Arentsz, Hendrik Avercamp, Esaias van de Velde and Jan van Goyen. Instead of the accumulation of detail within a conventional com-positional structure, their pictures are filled with great open stretches of sky, water, or ice-covered rivers, rendered with a new sense of atmospheric effect. Aver-camp's winter scenes, peopled with crowds of brightly coloured little figures engaged in outdoor sports and amusements, often have a charming naïveté combined with a highly accomplished elegance of drawing and a pearly paint quality. From this style emerged about 1630 the figures of Jan van Goyen and Salomon van Ruysdael, whose work is poetic, and often charged with a pervasive melancholy. Their compositions are frequently of the greatest possible simplicity; the handling, especially in van Goyen, is free, with solid brush-strokes of almost monochrome brownish-green.

In the same generation, Hercules Seghers created a pro-foundly imaginative and emotional type of landscape, equally restricted in range of colour, but powerfully unified by atmosphere and chiaroscuro, developing the tradition of his master Gillis van Coninxloo and of Joos de Momper. The leading landscape painters of the middle decades of the century were not unresponsive to this emotional style, but they owed far more to the naturalistic vision of men like Jan van Goyen and Salomon van Ruysdael. In their hands, indeed, landscapes of actual places, without subordination to any other subject-matter, became the sole theme of painting. Aert van der Neer specialized in moonlight and winter scenes of an astonishing virtuosity in the rendering of the subtlest

nuances of lighting. Aelbert Cuyp of Dordrecht, who also painted portraits and animals, was much influenced by van Goyen and Ruysdael, but used a wider and richer range of tone and colour; and in his later work, under the influence of Claude Lorrain, he became the greatest of many Dutch painters who explored the effects of golden sunlight, and incorporated in their work motifs and compositional devices derived from the Claudian vision of Italian scenery. Philips de Koninck exploited the flat open scenery of the Netherlands in his panoramic views, rich in the natural chiaroscuro of sunlight and cloud-shadow. His landscapes have been considered clear indications of Baroque feeling for space – the view extends without interruption into the farthest distance, the spreading horizon and the movement of the sky seems to imply the continuation of pictorial space beyond the limits of the frame. His compositions are no longer en-closed but suggest a continuous and expansive world.

Dutch landscape in its fullest maturity, however, is best represented by Jacob van Ruisdael. Born and trained in Haarlem where he was enrolled in the Guild in 1648,

96 JACOB VAN RUISDAEL (1628/9–82) *Bentheim Castle, 1650–55. Oil on canvas, 3′ 3″ × 4′ (100.5 × 123.5). Cincinnati Art Museum (Gift of Mary Hanna)*

Ruisdael worked for a time abroad, in the region of
Germany bordering Holland, before settling in Amster-
dam in 1656. In his early years his typical subjects were
the dunes and woods around Haarlem, which he painted
in rich colour, conveying the weight and substance of
things, the vitality of trees and the movement of the sky.
During the period of travel, to which some of his most
impressive pictures belong, such as *Bentheim Castle*
(Cincinnati Art Museum) (*Ill. 96*), the effects are
more static, even monumental, and a mood of intense
seriousness, almost of foreboding, is often present. Im-
penetrable shadows, shattered tree-trunks or ancient
ruins convey the transience of life. His later mountainous
scenes with pine forests, rushing waterfalls and jagged
rocks perhaps reflect some influence from Allart van
Everdingen, who had travelled in Sweden, and they
afford a parallel to the wild landscapes of Salvator Rosa.
Broad views of the plains of Holland under majestic skies
possibly owe something to the style of Philips de Koninck;
winter scenes like the *Winter Landscape* (Amsterdam,
Rijksmuseum), or views of country towns or villages
under threatening clouds, like the *Windmill at Wijk*
(Amsterdam, Rijksmuseum) convey more vividly than
ever before a sense of the weather, the dignity, heroism and
pathos of nature.

Neither his brilliant follower Meyndert Hobbema, nor
any of the Italianate landscape painters, of whom Jan
Both and Nicolaes Berchem may be taken as typical,
possessed a fraction of Ruisdael's extraordinary power.

Of the prolific school of portrait painters – among
whom the brilliant Bartholomeus van der Helst and the
gentle Johannes Verspronck were the best – and of the
innumerable painters of still-life, animals, genre and
marines, it is hardly possible here to say anything. One
other painter of genius, however, must not be omitted:
namely Jan Steen. His works included biblical and
historical subjects, domestic interiors rather in the manner
of the Delft school, and a few landscapes; but his most
individual and inimitable works were his genre scenes.
Steen had been a pupil of Adriaen van Ostade, to whose
scenes of peasant and tavern life he was certainly in-
debted; but Steen's subject-matter is not, as a rule, con-
cerned with the peasantry but with the prosperous and
prolific families of town tradespeople and bourgeois.
His outstanding quality was his affectionate humour. His

97 JAN STEEN (1625/6–79) *The Feast of St Nicholas, c. 1660–4. Oil on canvas, 32¼" × 27⅞" (82 × 70.5). Rijksmuseum, Amsterdam*

occasionally crowded compositions abound with vitality. A picture like his *Feast of St Nicholas* (Amsterdam, Rijksmuseum) (*Ill. 97*), with its wealth of character and narrative incident, represents a view of the world which was to prove the foundation for a great deal of the more popular art of the 19th century, especially in Britain. In the hands of his contemporaries Gabriel Metsu and Gerard Terborch, interior genre scenes attained a greater refinement and delicacy, but these artists had little of Steen's exuberance.

The incredible artistic efflorescence of Holland in the middle decades of the century was, however, comparatively short-lived. A passion for high finish and polished surfaces, already apparent in the work of one of Rembrandt's most successful pupils, Gerard Dou, became obsessive in that of his pupil Frans van Mieris. And the most successful painter of the last decades of the century, Adriaen van der Werff, cultivated a porcelain-smooth treatment of flesh and an academic perfection of drawing which fail to conceal the banality of his mind.

127

98 GIACOMO VIGNOLA (1507–73) and GIACOMO DELLA PORTA (*c.* 1540–1602) *Façade of Il Gesù, Rome, 1568–75*

CHAPTER SEVEN

Baroque architecture and sculpture in Italy

The transition from the Mannerist style of the second half of the 16th century to the Baroque of the 17th century was less abrupt in architecture than in painting. The key building in the genesis of the Baroque church was Il Gesù (*Ill. 98*) in Rome, begun in 1568 by Giacomo Vignola, and completed in 1575 by Giacomo della Porta. As compared with Pellegrino Tibaldi's San Fidele at Milan (1569) and even Palladio's San Giorgio Maggiore at Venice (1566), the simple two-storied artic-ulation of the façade of the Gesù marks a return to order and a certain severity. The Gesù influenced churches of the succeeding generations in many ways, not least in its compromise between a centralized plan surmounted by a dome, and a longitudinal nave with side chapels rather than aisles; and in its adoption of the Albertian scheme for a façade topped by a pediment covering the three bays of the upper storey, while the transition to the five-bay ground storey is masked by large volutes.

These features are repeated in what is generally regarded as the first church of the Baroque movement, Carlo Maderno's Santa Susanna (*Ill. 99*), Rome, erected in 1597–1603, but the differences rather than the similarities are significant. In spite of the much smaller scale of Santa Susanna, Maderno used more powerful modelling of his façade to achieve an integrated effect. Moving from the outer corners inwards, each bay is stepped forward and increased in width, emphasizing the centre. This tend-ency towards reintegration and dynamic effect, so different from the tensions between component elements and the dispersal of interest from the centre outwards which was characteristic of the Gesù, was to reach its climax about half a century later.

A further stage in the transition towards the new style was marked by Maderno's nave and façade of St Peter's (*Ill. 105*), Rome, built between 1607 and 1612. The

99 CARLO MADERNO (1556–1629) *Façade of Santa Susanna, Rome, 1597–1603*

129

composition of the façade is highly complex, with a giant order of four columns to the central portico, a wide bay with giant pilasters at each end, and, between these and the central feature, two unequal bays on each side, the inner pair having columns and the outer pair pilasters half hidden behind the orders of the adjacent bays. Mannerist complexity is still more apparent in the arrangement of windows, doors and niches. The total effect is perhaps as much Mannerist as Baroque, and the increasing propensity for massive and bold forms is shown chiefly by the partial substitution of columns for the order of giant pilasters favoured by Michelangelo. In the interior, however, Maderno opened up the arches separating the side chapels from the nave, so as to create a space which flows freely through the whole vast width and length of the building.

Fundamentally, it was this idea of integrated space which led to the creation of the most characteristic effects of the full Baroque. At the church of SS. Martina e Luca in Rome, begun in 1635 and completed in 1650, Pietro da Cortona built upon the plan of a Greek cross with apsidal ends, the crossing surmounted by a dome. The interior thus asserts a powerful spatial unity. On the façade, the principal wall bends in a convex curve which seems to respond to the pressure of the interior, and to require the firm anchorage of the narrow piers at its ends, articulated with pairs of almost touching pilasters, with two further orders of pilasters tucked in behind them. A similar idea received strikingly dramatic treatment in Cortona's later façade of Santa Maria della Pace (*Ill. 100*), Rome, built in 1656–7, where a semi-circular porch provides an extension of the interior space, bursting out, as it were, through the door. This is all the more effective by contrast with the concave screen which appears behind the upper storey, and opens on to the stage-like area of the piazza.

This treatment of the wall as a pliable structure, responding to pressures of space, internal or external, also occurs in the works of Francesco Borromini during the same period; but his peculiar genius imparted to it a totally different character. The interior of his first church, San Carlo alle Quattro Fontane, in Rome, built 1634–41, is of a diamond shape with curving outline alternately convex and concave. The other parts of the plan, cloisters, vestries, staircases, etc., though ingeniously

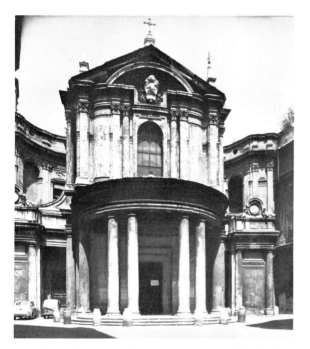

100 PIETRO DA CORTONA
(1596–1669) *Façade of Santa Maria
della Pace, Rome, 1656/7*

fitted into the restricted site, remain essentially distinct
from each other, as does the later façade, erected in 1665–7,
which echoes the curvature of the interior walls though
its upper parts are quite unconnected with them. But
inside the church the various stages of the structure, up
to the oval dome with its coffering of cross-shapes,
octagons and hexagons decreasing in size towards the
domed lantern at the top, are so interrelated as to create
the impression of a single cohesive space, charged with
energy, but controlled by the great columns and un-
dulating entablature of the ground storey.

Borromini's next church, Sant'Ivo della Sapienza
(1642–60), is built upon the plan of a star-hexagon, and
roofed with a dome of unprecedented shape, in which
vertical ribs separate semicircular lobes and convex-
ended triangles. This dome is set directly upon the walls,
without the interruption of drum or pendentives, no
doubt with the object of attaining the maximum possible
unity of the interior space. Externally, the design is of a
wilful fantasy. A concave façade of two storeys opens
upon the courtyard; above, what looks like an undu-
lating drum supporting a shallow dome belies the

131

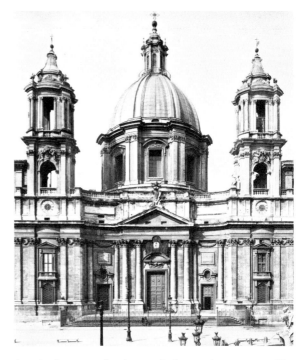

(1599–1667) *Façade of Sant'Agnese*
in Piazza Navona, Rome, 1653–7.
Completed by other hands in 1666

interior forms; and at the top the lantern is surmounted by
an extraordinary spiral. This unrestrained upward
energy, visible also in his tower of Sant'Andrea della
Frate (1653–65), was more successfully controlled in
what is undoubtedly Borromini's most monumental
building, the church of Sant'Agnese in Piazza Navona
(*Ill. 101*) (1653–7), where he took over from Carlo
Rainaldi. The façade, with its concave wall flanked by
twin towers, provides an admirable setting for the dome
upon its high drum, in the manner which had been in-
tended for St Peter's, but was only achieved here.
Borromini was himself displaced in turn as architect in
1657, and the project was completed by Rainaldi and
others who modified Borromini's intentions; but this
should not detract from his achievement, for the con-
ception has a triumphant unity and a sculptural complete-
ness which made it the model for many later churches.

We shall say more of Rainaldi later, but now we must
turn to the greatest genius of the age in architecture and
sculpture, Gian Lorenzo Bernini. Though born in
Naples, Bernini spent virtually the whole of his working

life in Rome, which his work did more than any other man's to transform into a Baroque city. Far more than Cortona's rich plastic sense, or Borromini's intricate geometric fantasy, the grandeur, pomp and majesty of Bernini's designs strike the essential keynote of the Roman Baroque. His career began in sculpture, the profession of his father. In a series of major works commissioned by Cardinal Scipione Borghese, Bernini created a new sculptural language. The still transitional *Aeneas and Anchises* (Rome, Galleria Borghese) of 1618–19 retains a Mannerist instability; but it also has a new realism in the representation of muscles, bones and sinews under the contrasted textures of the skin of the two figures, and the first signs of a new energy. It is above all this quality of energy which makes the *Neptune and Triton* of 1620 (London, Victoria & Albert Museum), the *Pluto and Proserpina* (*Ill. 102*) of 1621–2, *David* of 1623 and *Apollo and Daphne* of 1622–4 (all in the Galleria Borghese) so remarkable. The figures of Pluto, David and Apollo are all based upon antique statues, but their concentrated energy of action provides a close parallel to Annibale Carracci's figures on the Farnese ceiling. Bernini's sculptural style also has a pictorial quality. The Pluto and Apollo groups, and the David, though technically free-standing, imply a principal viewpoint from which the movements are most effective. All these movements are related within an imaginary pictorial plane, although there is a number of subordinate alternative viewpoints. The actions of the figures imply a much greater space than they actually occupy, and their 'spiritual focus' (in Wittkower's useful phrase) is projected outwards into this space, dissolving the boundary between the represented event and the viewer, and involving him directly in the emotions of the participants.

Bernini never again produced anything like these brilliant works of his youth. In 1623 Maffeo Barberini became Pope as Urban VIII, and almost immediately gave him the commissions for the restoration of the little church of Santa Bibbiana, and for the Baldacchino (*Ill. 103*) over the high altar and the tomb of St Peter under the dome of St Peter's. This Baldacchino is a unique blend of architecture and sculpture, constructed mainly of bronze, and partly gilt. Four twisted columns of a form traditionally associated with the Temple of Solomon at Jerusalem, and decorated with climbing

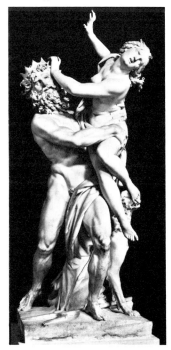

102 GIAN LORENZO BERNINI (1598–1680) *Pluto and Proserpina, 1621–2. Marble, over life-size. Galleria Borghese, Rome*

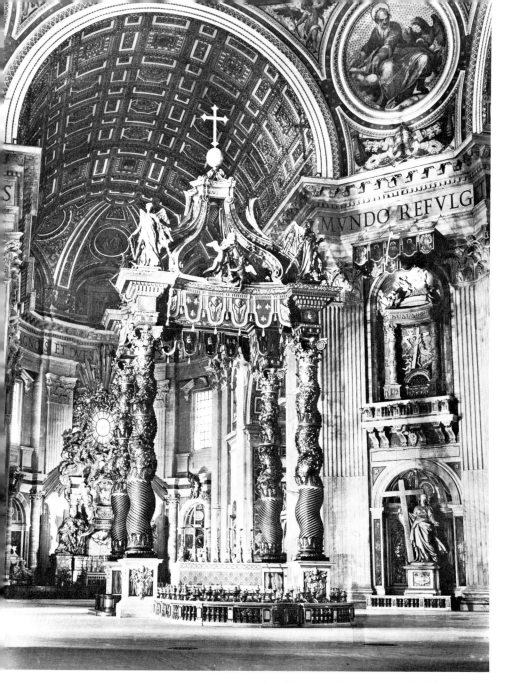

103 GIAN LORENZO BERNINI (1598–1680) *Baldacchino*, 1624–33. *Bronze*, *h. 85′*. *St Peter's*, *Rome*

plants, *putti* and the Barberini emblem of the bee, support a rich entablature from which hangs a bronze pelmet; above this, four large angels stand at the corners, four groups of *putti* holding arms and emblems are mounted in the centres of the sides, and between these figures four great scrolls rise to support a ball and cross at the top. This immense work, in which Bernini was assisted by many collaborators, needed its extraordinary scale in order to form an adequate feature in the centre of the vast space of the church. Its splendour and profusion struck a new note, which was to set the key for the later decorations throughout the church.

For fifty years Bernini was engaged on a tremendous series of major works in St Peter's – tombs for Urban VII and Alexander VII, balconies, decorations and altars for the side chapels and the nave, a relief over the door of the portico, the Cathedra Petri at the eastern end, etc. The statue of *St Longinus* (*Ill. 104*) in one of the four niches facing the Baldacchino is of colossal size - more than fourteen feet in height – and represents the saint at the moment of his conversion, with his arms outstretched diagonally as he simultaneously embraces the faith and the space of the crossing. The basically strong and simple design of a triangle, with the arms and the lance forming

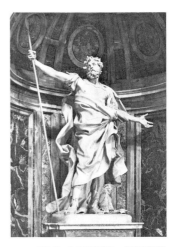

104 GIAN LORENZO BERNINI (1598–1680) *St Longinus, 1629–38. Marble, h. 14' (440). St Peter's, Rome*

105 GIAN LORENZO BERNINI (1598–1680) *Piazza San Pietro, Rome, begun 1656*

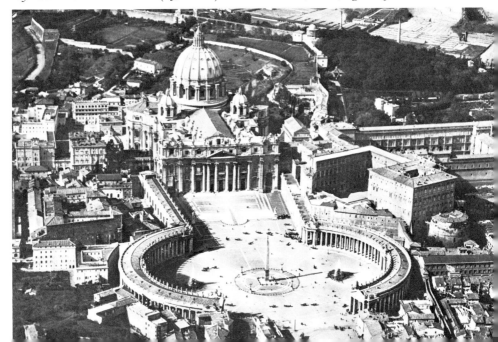

two sides and the hem of the garment the third, is en-
riched by the turbulent masses of drapery passing in great
folds across the body and falling in agitated curves from
the shoulder. More stably related to its base than any of
the earlier figures, this is the first masterpiece of the
sculptor's maturity, and of the Roman High Baroque.

But the grandest of all Bernini's additions to St Peter's
is the tremendous oval piazza (*Ill. 105*), begun in 1656.
Like the arms of St Longinus, the curving colonnades,
topped by an entablature, balustrade and rows of statues,
embrace the space where the faithful gather. A third arm
was to have completed the enclosure, but was never built;
nevertheless the conception expresses with the utmost
grandeur the dignity, majesty and motherhood of the
Church.

Bernini's various contributions to secular architecture
are not, on the whole, of an importance comparable
with his religious works, with two notable exceptions.
In the Palazzo Chigi he created what was to be the most
characteristic type of High Baroque façade, in which the
ground floor functions as a plinth for a giant order of
pilasters covering the two upper storeys, and with the
windows of the top storey treated in a light and almost
playful manner. Its influence throughout Europe was
immense. Secondly, the Scala Regia (*Ill. 106*), built in
1663–6, provided a ceremonial connection between the
old entrance corridor on the first floor of the Vatican
Palace and the portico of St Peter's. The space available
was narrow and converged towards the turn at the upper
landing, while the staircase itself was at right angles
to the line of approach from the portico, at the lower
landing. With masterly ingenuity, Bernini articulated the
whole flight with columns set gradually closer to the wall
and diminishing in size towards the upper end, so as to
produce an illusion of regular width. The turn of ninety
degrees at the lower landing provided the opportunity for
a spectacular combination of architecture and sculpture.
Opposite the entrance from the portico he placed a statue
of Constantine on a rearing horse, backed by a great
windblown drapery, dramatically lit from a window
above, towards which the Emperor turns his gaze in the
moment of revelation. The stairs rise up to the left of this,
the first set of columns being surmounted by a triumphal
arch enriched by flying angels blowing trumpets and
supporting the papal arms.

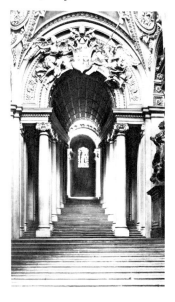

106 GIAN LORENZO BERNINI
(1598–1680) *Scala Regia in the
Vatican, 1663–6*

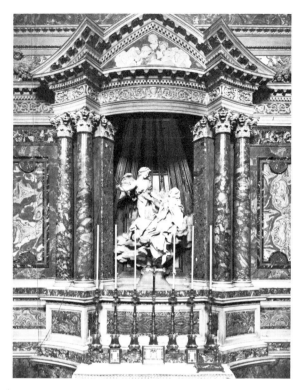

107 GIAN LORENZO BERNINI
(1598–1680) *The Ecstasy of St
Theresa, 1645. Marble, life-size.
Cornaro Chapel, Santa Maria della
Vittoria, Rome*

This inventive and dramatic use of light and movement
is paralleled in another supreme combination of archi-
tecture and sculpture, the Cornaro Chapel in the church
of Santa Maria della Vittoria. Above the altar, a convex
aedicule seems to swell from the wall, revealing within
the niche-like space so created a vision of St Theresa
(*Ill. 107*) swooning in ecstasy as the angel appears
hovering above her, holding the fiery arrow with which
her heart has been pierced. She seems to float weight-
lessly among her agitated robes upon a cloud, and light
floods down from a concealed source, surrounding the
group with its golden shafts. The impact of the trans-
cendental experience is reflected throughout the chapel:
in the vault, angels among clouds adore the Holy Spirit
amid a glow of heavenly light; in the frieze, flying *putti*
joyfully carry floral swags; and in a gallery at each side the
Cardinal Cornaro and others animatedly discuss the
event. The entire richly polychromed interior with
variegated dark marbles providing contrast for the white

137

sculptured figures, is a union of the three arts of archi-tecture, sculpture and painting, and marks the culminat-ing point of Bernini's achievement.

The more elaborate creation of a somewhat similar kind, the Cathedra Petri in the eastern apse of St Peter's, is less successful because its central image of the throne of St Peter as Christ's vicar cannot generate the same emotional charge as a figure, and because attention is divided between this image and the luminous dove of the Holy Spirit, painted on the window above.

Some of Bernini's most important architectural works belong to his final period. The three churches of Castel-gandolfo, Ariccia and Sant'Andrea al Quirinale (*Ill. 108*) in Rome were all begun between 1658 and 1662. They are small, and all are built upon centralized plans, respectively a Greek cross, a circle and an oval. The simplicity of their forms contributes to the unity of their interior spaces under domes set as directly as possible on the entablatures of the orders. The designs use sculp-tural decoration as a means towards the recreation of mystical emotion – most successfully in the case of Sant' Andrea, where the figure of the titular saint is seen ascending through the broken pediment over the altar, where his martyrdom is represented in the altarpiece. Externally also, Sant'Andrea is the most interesting of the three. The open arms of the exedra lead directly to the grand triumphal arch of the entry, the lines of the entablature of which continue round the curving sides of the church; below this, the line of the top moulding of the surrounding side-chapels, also visible from the approach, seems to protrude through the entrance, where it is supported by two columns, and where its form is echoed in the semicircular flight of ten steps. The high narrow shape of this entrance prepares one for the powerful up-ward accents of the interior. The motif of the semicircular porch, borrowed from Cortona's Santa Maria della Pace, is here given a new meaning and integration into the whole conception. All these churches are in a sense formal abstract sculpture of a kind which the modern eye has been prepared by recent art forms to appreciate.

The most private aspect of Bernini's sculpture is to be found in his portrait busts, though in fact some of them form features of monumental tombs in churches. They occur at almost all periods of his career, but are mostly concentrated in the early and middle phases, down to the

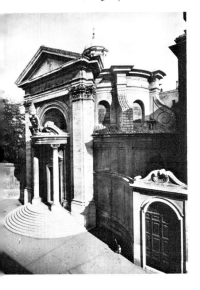

108 GIAN LORENZO BERNINI (1598–1680) *Sant'Andrea al Quir-inale, Rome, 1658–70*

early 1650s. The earliest examples, like that of *Pedro de Foix Montoya* in Santa Maria di Monserrato, Rome, made about 1621, are still entirely calm and static, with simple draperies and firm outlines, though with an expressiveness which already distinguishes them from the 'cold' style of a Mannerist sculptor like Pompeo Leone. By 1632, when he carved the *Cardinal Scipione Borghese* (Rome, Galleria Borghese), Bernini had decisively begun the process of Baroque animation. The head turns to one side, the eyes, with deeply incised pupils, have a lively intelligence, and light flickers over the surface of the robe to suggest movement. The process reaches its culmination in the portraits of *Francis I d'Este* (Modena, Museo Estense) of 1650–1, *Louis XIV* (Versailles) of 1665, and *Gabriele Fonseca* (*Ill. 109*) (Rome, San Lorenzo in Lucina) of about 1668–75. In these, all is movement. The heads of the duke and the king are turned, chins tilted upwards; the locks of their wigs cascade onto their chests, and draperies swirl out as if in a high wind. The expression of princely authority is superb. It is not surprising that these became the models for the grand Baroque bust for the remainder of the century. The *Fonseca* is a much more profoundly spiritual work; not isolated, but a part of the elaborate decoration of the Fonseca Chapel designed and supervised by Bernini, in which this rapt figure appears as donor.

At the opposite extreme, Bernini's most public sculptures are his fountains. Earlier Roman fountains had generally consisted of an accumulation of architectural or geometric forms. Bernini followed the Florentine tradition of figurative fountains, but in his *Triton Fountain* of 1642–3, in the Piazza Barberini, had already given this a new dynamic unity. Four dolphins support on their tails a giant shell which opens to reveal the squatting Triton holding above his head a conch through which he blows high a jet of water. The central feature of the *Fontana del Moro* of 1653–5, in the Piazza Navona, also consists of figure, shell and dolphin, but here the almost human sea-creature struggles upon a giant conch which rests precariously on its rounded side, with a dolphin spouting water through the gap between his legs, while he turns his head to look over his shoulder. The tremendous torsion of the figure gives this composition a validity from various viewpoints, and proves how effectively Bernini could design in this way. In this case he

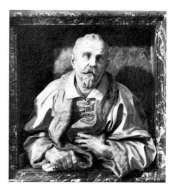

109 GIAN LORENZO BERNINI (1598–1680) *Gabriele Fonseca, c. 1668–75. Marble. San Lorenzo in Lucina, Rome*

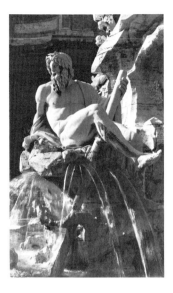

may have done so because the Moro fountain was essentially a refitting of an older one by Giacomo della Porta, whose original basin and the subsidiary figures seated on its rim were retained.

But the grandest of Bernini's fountains, also in the Piazza Navona, is the Fountain of the Four Rivers (*Ill. 110*) constructed in 1648–51. Its importance is as much due to its providing a focal point of suitable proportion for the vast elongated space of the piazza, one of the most magnificent pieces of Baroque urban planning, as to its superb sculptural richness. Basically, it consists of a rocky cave, with a palm tree and other vegetation growing around it, and supporting on the summit a great Egyptian obelisk, and on its four corners figures symbolizing four great rivers, the Danube, Nile, Ganges and Plate. A horse, a lion, a snake, an armadillo and other creatures, and the arms of Pope Innocent X, form subsidiary features, and the obelisk is topped by a dove, emblem of the Holy Spirit as well as of the pope's family. The variety of materials, travertine for the rock, animals and plants, white marble for the figures, granite in the obelisk, and originally gilding in the inscriptions, combine with its irregular outline and soaring movement to create the most spectacular of all Bernini's creations.

The ebullient vitality characteristic of the Baroque, its realism, richness and variety of texture, and its deliberate intention to stir the spectator's emotions, involve a constant risk of theatrical extravagance and vulgarity. Bernini avoided this danger, sometimes rather narrowly, by the intensity of his spiritual feeling, and the formal power of his compositions. The former quality is nowhere more impressive than in four of his late works, the *Daniel* and *Habbakuk* of 1655–61 in the Chigi Chapel at Santa Maria del Popolo, and the *St Mary Magdalene* and *St Jerome*, of 1661–3, in Siena Cathedral. The latter quality, always apparent in his draperies, and never more so than in those of such late works as the *Angels with the Crown of Thorns and the Superscription* carved between 1667 and 1671 for the Ponte Sant'Angelo, but now in Sant'Andrea della Fratte, may often be felt most strongly in details, such as the figure of Charity which forms part of the *Tomb of Alexander VII*, 1671–8, in St Peter's. Every part of the figure and drapery works, as artists say, in terms of form, light and shade, line and movement, both to express the character of the individual

figure, and to relate her to the heavily draped doorway against which she leans and to the rest of the composition. Bernini was certainly one of the greatest artists of the century, and one of the three or four greatest sculptors of the whole European tradition.

Italian sculpture was completely dominated by Bernini's influence; of the few artists gifted enough to withstand it, the most distinctive was Francesco Mochi who, even before Bernini, had evolved a style of energetic movement and direct expressiveness in strong contrast to the refined elegance of Giambologna and his followers. Mochi's two equestrian monuments of *Ranuccio* and *Alessandro Farnese* (*Ill. 111*) in the Piazza Cavalli at Piacenza (1612–20 and 1620–25 respectively) herald the Baroque era not only in their tremendous panache and energy, but also in the sensuousness of the modelling. Later, after contacts with Bernini, Mochi's *St Veronica* in St Peter's carried movement and expression to a degree so extreme as to seem almost frenzied, in the effort to achieve maximum emotional impact.

Of Bernini's contemporaries, the ablest were Alessandro Algardi and the Fleming François Duquesnoy, who worked in Rome from 1618 till his death in 1643. Both inclined towards a calmer and more classical version of Bernini's style. Algardi's brilliant portrait busts, such as the *Francesco Bracciolini* (*Ill. 112*) in the Victoria and Albert Museum, avoid the virtuoso differentiation of textures characteristic of Bernini's later style. Among the younger generation, the most distinctive talents belonged to Antonio Raggi, a pupil of Algardi, assistant of Bernini and collaborator of Gaulli in the interior decoration of the Gesù; and to the Maltese Melchiorre Caffà, whose highly pictorial relief of *The Ecstasy of St Catherine*, in the church of Santa Caterina da Siena at Monte Magnanapoli, Rome, with its background of variegated marbles, carried still further the melting emotionalism of Bernini's *St Theresa*.

In Italian architecture, the basic High Baroque principle of dynamic organization of forms and spaces was developed in various ways by other designers. Carlo Rainaldi, already mentioned, collaborated with Bernini and with Carlo Fontana in the twin churches of Santa Maria dei Miracoli and Santa Maria in Monte Santo, which close an imposing vista at one end of the Piazza del Popolo; but his most striking creation is the church of

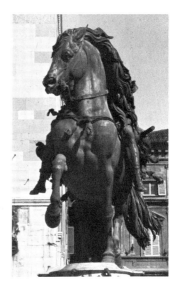

111 FRANCESCO MOCHI (1580–1654) *Alessandro Farnese, 1620–5. Bronze. Piazza Cavalli, Piacenza*

112 ALESSANDRO ALGARDI (1598–1654) *Francesco Bracciolini, c. 1633/4. Marble, h. 2′ 2″ (66). By courtesy of the Victoria and Albert Museum, London*

113 MARTINO LONGHI (the
Younger) (1602–57) *Façade of
Santi Vincenzo ed Anastasio, Rome,
1646–50*

Santa Maria in Campitelli, Rome, built in 1663–7. Its
high façade is modelled in powerful relief, with central
aedicules of the full storey height at both levels thrust
forward on free-standing columns, and visually supported
by similar single columns at the sides. The entablatures
and pediments above them dramatically break forwards
as well. Inside, the nave with its trio of chapels on each
side – a large one in the middle flanked by two smaller
ones – occupies a square, leading at the east into a domed
choir and an apsidal sanctuary. These spaces, however,
which on the plan look separate and only loosely related,
are united by the scenically arranged sequence of gigantic
Corinthian columns along each side, and by a brilliantly
contrived scheme of lighting, passing from the relatively
dark nave to the much brighter choir, and finally to the
darkness of the sanctuary. This is one of the most com-
pelling of all Baroque church interiors.

Martino Longhi the younger was responsible for an-
other of the outstanding church façades of Rome, that of
Santi Vincenzo ed Anastasio (*Ill. 113*), built in 1646–50.
This, indeed, is perhaps the most dynamic of all: its
triplicated pairs of columns, set successively forward to
frame the doorway and the central window of the upper
storey, appear positively to jostle one another.

In Venice, the outstanding architect was Baldassare
Longhena, whose masterpiece is the church of Santa
Maria della Salute (*Ill. 114*), begun in 1631 and finished
in 1687, five years after his death. Its individual blend of
elements derived from various sources, early mediaeval,
Renaissance and Palladian, nevertheless results in a
Baroque effect. The dome is raised on a high drum above
the octagonal nave, which is surrounded by ambulatory
and side chapels; the sanctuary, with its own dome resting
on spandrels and drum, has two large apsidal transepts;

143

and the choir, to the east of the high altar and largely screened by it, is rectangular. As in Rainaldi's Santa Maria in Campitelli, however, the separateness of these constituents is overcome by a superb scenic control of the vistas from the centre of the nave, or through the great west doors. Externally, the two principal domes with their lanterns, the campanile and the great scrolled buttresses carrying statues produce a skyline which is one of the most picturesque ever devised.

Longhena's great work, like the eccentric creations of Guarino Guarini, contained potent influences for the late Baroque and the Rococo of the 18th century, especially in Germany and Central Europe. Guarini, priest, philosopher, mathematician and dramatist, produced a number of buildings of a geometrical ingenuity that surpasses even Borromini's. After lecturing on philosophy and mathematics at Modena, Messina and Paris, he settled in 1666 in Turin, and in the remaining seventeen years of his life was responsible for a series of churches and palaces which made this city the leading centre of late Baroque architecture. At the church of San Lorenzo, built 1666–79, the plan consists of a long rectangular vestibule, an octagonal main hall with convex arched altar niches on the diagonal axes, and small apsidal bays under similar arches between them, an oval chapel to the east, surmounted by a circular dome, and a sanctuary of an elongated kidney shape. Such is the complexity of the treatment that it is virtually impossible to grasp visually the separate geometry of the principal spaces; instead, the longitudinal vista to the east assumes predominance. In this respect Guarini has something in common with Longhena. But the predominance of this eastward vista is in turn surpassed by the tremendous vertical accents of the domes. The solid structures of the Roman Baroque domes are replaced here by a cage-like linear system of ribs, with concave in-fillings between them, pierced with windows of a variety of shapes or left entirely open. Guarini's ideas seem to have been developed from Hispano-Moresque buildings such as the great mosque at Cordova, but the transformation of this mediaeval system by means of light was entirely due to his own genius.

Guarini's Cappella della Santa Sindone (*Ill.* 115), built in 1667–90 between the choir of the cathedral and the royal palace of the house of Savoy in Turin, has a still

more extraordinary dome – if, indeed, that is the correct term by which to describe it. Above the circular ground-floor structure, already built before Guarini took over as architect, three pendentives pierced with oval windows rise to a circular cornice. On top of this is a sort of drum with six large round-headed windows separated by aedicules containing rather Borrominesque niches; but above these, everything is totally unprecedented: the conical structure, consisting of successive zones of seg-mental arches, each springing from the centres of the arches below, produces an extraordinary lace-like effect, since these arches are opened with no less than seventy-two windows. The small central area is covered by a twelve-pointed star-shaped saucer dome with a dove in the middle, from which the light appears to radiate down-wards. This chapel is too eccentric a creation to be typical of the late Baroque; nevertheless, in its spatial effects, its use of light, and its tendency to avoid effects of mass and weight, it has some definitely late Baroque characteristics.

On the other hand, Guarini's Palazzo Carignano in Turin, erected in 1679–92, was a principal source for the later evolution of great palaces. The concave-convex-

115 GUARINO GUARINI (1624–83) *Interior of the dome, Cappella della Santa Sindone, Turin Cathedral, 1667–90*

145

concave curves of its main front, between flat wings, are almost devoid of any sense of mass, though they in fact reflect externally the forms of the two symmetrical curving staircases leading up from the foyer to the great oval salon on the first floor, which has been called the most spectacular late 17th century grand salon in Italy. It rises two full storeys in height to a pierced ceiling, above which is a second suspended reflector ceiling inside a lantern of the same plan and dimensions as the floor of the salon, producing an effect of astonishing lightness. The sequences of dark and light, narrow and open spaces leading up to the brilliance of the salon, indeed play an essential part in the whole effect, which leaves the solemnity of the early Roman Baroque far behind.

116 JACQUES LEMERCIER *(1580/85–1654) Church of the Sorbonne, Paris, begun 1635*

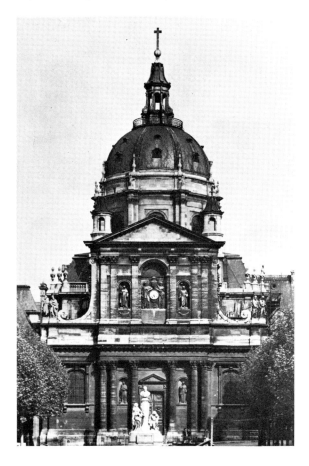

CHAPTER EIGHT

Baroque architecture and sculpture outside Italy

In France, architecture in the 17th century very clearly reflects the influence of the Roman Baroque, yet the greatest of the French architects achieved in their buildings something that was quite distinctive. One of the earliest, finest and most characteristic of French Baroque churches is the church of the Sorbonne (*Ill. 116*) by Jacques Lemercier, commissioned in 1635. In plan, it is con- servative in comparison with Roman examples, but the western façade, with its bold and irregularly placed six columns, its high aisle windows, and its trio of round- headed niches in the upper storey, has a powerful dynamism, carried on in the ribbed dome, topped by a lantern with a conical roof and high cross. In general, however, what is striking, especially in the upper storey of this façade, is the restraint, precision and refinement of the treatment.

The approximately contemporary Sainte-Marie de la Visitation, also in Paris, by François Mansart, built 1632–4, is more Baroque in plan, with a central circular domed space and three oval chapels; but the external walls reveal nothing of this at street level, except for the enormous segmental pediment above the main entrance, which carries the eye up to the dominant feature, the un- ribbed dome of oval profile rising on its tall and boldly buttressed drum to a high lantern, *flèche* and cross. The dramatic quality of this exterior expresses great power and assurance, but also a rigorous restraint.

François Mansart never went to Italy, and the inde- pendence of his style is even more evident in his secular buildings, such as the *châteaux* of Blois and Maisons, built respectively in 1635–8 and 1642–6. In both, he continued to use the high pitched roofs and tall chimneys of the previous century, but the spatial planning of the interiors shows a new force and freedom, especially in the great domed staircase with its oval gallery at Blois.

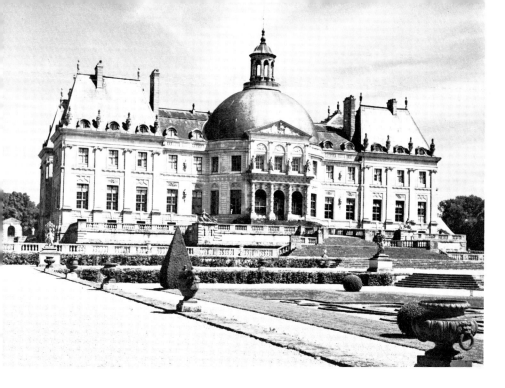

117 LOUIS LE VAU (1612–70)
Château of Vaux-le-Vicomte, 1657

Development on these lines was carried a stage further by Louis Le Vau in the *château* of Vaux-le-Vicomte (*Ill. 117*), built for Nicolas Fouquet, minister of finance to Louis XIV, in 1657–61. The grand staircase and great oval-domed salon occupy the entire central portion of the design, linked by intermediate rooms to the four corner pavilions with steeply pitched roofs. On the garden façade, this oval salon thrusts boldly through the line of the wings, and, corresponding to this projection on the entrance front, the portico is flanked by concave walls which reveal some distinctly Roman influence. In his Collège des Quatre Nations, begun in 1662, Le Vau became still more decisively Roman, employing on a grandiloquent scale motifs derived from Pietro da Cortona and from Sant'Agnese in Piazza Navona. A decisive turning point away from Roman influence came in 1665, when Louis XIV invited Bernini to Paris to design the eastern parts of the Louvre, which the king intended to rebuild. His proposals for a great square in the Roman style, with giant orders of detached columns on both the outer and the courtyard façades, were rejected and the design actually carried out was by Claude

Perrault, who, although he adopted certain features of Bernini's designs, especially the flat balustraded roofline, and the plan without markedly projecting wings, gave his building an elegant precision which, like almost all the detail, is distinctly French.

The greatest achievements of French architecture and planning, however, followed the removal of the court and government to Versailles in 1682. Building at Versailles had been begun under Louis XIII by Lemercier; Le Vau had made some additions in the 1660s, and was succeeded in 1678 by Jules Hardouin Mansart, great-nephew and pupil of François. The younger Mansart was responsible for the Galerie des Glaces, the chapel and the two wings. The scheme which eventually evolved was enormous in scale, involving garden prospects over two miles in length designed by André Le Nôtre, and a series of buildings – galleries, pavilions, courts, wings and orangery – for which responsibility was shared between a number of architects, while the interior decoration was mainly in the hands of Charles Le Brun. The Baroque classicism of Versailles, as represented for example by Mansart's Grand Trianon (*Ill. 118*) of 1687, is remarkably pure, calm and lucid as compared with the Italian late Baroque. The long low lines and straight façades of the Trianon, its pale limestone and rose-pink marble, have a harmonious delicacy which is more classical than Baroque. Only in the interiors, such as that of the Galerie des Glaces, with its great curved ceiling covered with

118 JULES HARDOUIN MAN-SART (1646–1708) *Grand Trianon, Versailles, 1687*

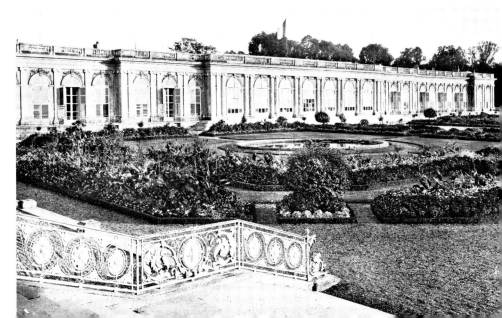

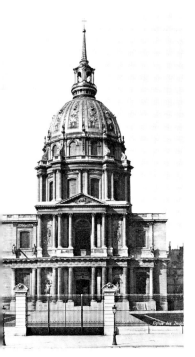

119 JULES HARDOUIN MAN-
SART (1646–1708) *Church of Les
Invalides, Paris, 1680–91*

paintings by Le Brun, and its glittering walls of mirrors alternating with candelabra, does the more sumptuous aspect of the Baroque find scope.

The change from power to lightness which marks the late phase of the French Baroque reached its culmination in the Royal Chapel at Versailles, built by J. H. Mansart in 1698–1710. The simplicity of the longitudinal aisled plan with an apsidal eastern end concentrates attention on the high, brilliantly lit space above, articulated with round-headed arches between slender piers on the ground floor, fluted Corinthian columns at the first floor gallery level, and a high clerestory above the cornice. Windows at all three levels display the exquisite detail and pro-portions of the forms and ornament in every part of the interior. But the best-known example of Mansart's ecclesiastical architecture is the church of Les Invalides (*Ill. 119*) in Paris, built in 1680–91. Its plan of a Greek cross with very short arms and an oval chancel is centred upon the circular domed crossing, with four chapels in the corners, entered through small arched openings, and virtually excluded from the principal interior space. Thus far the effect is of an almost Bramantesque classicism. But the central space is given a tremendous upward impulsion by the high drum and inner dome, opening in the centre to reveal a second dome lit by concealed windows – a decidedly Baroque spatial effect. Outside, the dominance of this dynamic central feature is even greater, for both the domes seen from inside are false ones, and the actual roof, supported on a timber structure, rises above a double-tiered drum to a high lantern and *flèche.* The drums alone are as high as the two storeys of the main structure, and to the top of the lantern is three times its height. The western façade too combines a scholarly correctness with dynamic emphasis by means of advances in three stages towards the central portico, and by the free rhythmical spacing of the columns.

The influence of the Roman Baroque was rather slow to reach Spain, and when, from about 1630 onwards, a form of Baroque developed in the Iberian peninsula, it tended to be quite different from either the Italian or the French forms. Philip III's principal architect, G. B. Crescenzi, was indeed an Italian; but his most famous work, the Pantheon of the Kings in the Escorial, belongs to the Mannerist tradition. Juan Gomez de Mora, in his Bernardine church at Toledo, used a dome of elliptical

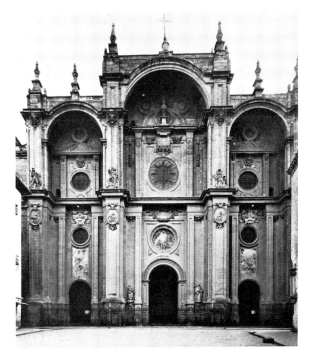

plan, and about the middle of the century a number of
churches with circular or oval plans and central domes
began to be built. The most influential example was
Pedro de la Torre's Chapel of San Isidro in Madrid,
finished in 1669, where the octagonal drum and dome
rise above a box-like rectangular structure, articulated
with twin giant pilasters at each corner. There are no
Italianate dynamic masses here – the style is more one of
surface and line. Similarly, Alonso Cano's façade of
Granada cathedral (*Ill. 120*), designed in 1664, and
usually regarded as one of the masterpieces of Spanish
Baroque, is quite independent of Italian influence. Its
triple round-headed arches, its thin, sharply drawn and
intricate system of pilastered decoration, its circular
windows, oval reliefs and almost Gothic pinnacles over
the centres of the arches, are already nearer to the Rococo
than to the Baroque of Cortona or Bernini.

The characteristic Spanish complex surface decoration,
running riot over structures to which it bears little or no
relation, became increasingly dominant in the later part
of the century. This tendency, already apparent in the west

151

front of Jaen cathedral by Eufrasio Lopez de Rojas, 1667,
reached a climax in the work of José de Churriguera and
his brothers. Churriguera's masterpiece, the fantastic
great gilded retable (*Ill. 121*) of the church of San Esteban
in Salamanca (1693) reveals the powerful influence of
Bernini's Baldacchino in St Peter's; but the foliage en-
twining the 'Solomonic' columns has acquired new
energy and excitement, dwarfing the figures of saints and
angels. This style was then applied to exteriors such as
that of the courtyard of the Jesuit College in the same city.
Though in the hands of his many imitators the effect was
apt to be merely one of frenzied exuberance, Churriguera
himself, and his brother Alberto who designed the splen-
did Plaza Mayor of Salamanca, preserved the mass and
underlying rhythms of the true Baroque.

In Portugal, architecture remained on the whole sober
in style throughout the 17th century; but in Latin
America the cathedrals of Mexico City, of which the
interior was completed in 1667, Puebla (consecrated
1649), Lima, Cuzco, Cordoba (Argentina) and Bogotà
(Colombia), established a rich and decorative Baroque
style, largely based in its later developments upon the
Churrigueresque, which was to flourish in the Spanish
and Portuguese colonies for the next hundred years.

Flemish architecture very quickly responded to the
new ideas from Italy. An early example of a centrally
planned and domed church which is already almost
Baroque is that at Scherpenheuvel, built in 1609 by
Wenzel Cobergher. The Jesuit church of St Michael at
Louvain (*Ill. 123*), built between 1650 and 1670 by
Guillaume Hesius, is perhaps the finest of the fully
Baroque churches, based upon Roman models and rich
in plastically conceived decoration, though somewhat
top-heavy and less unified than its Roman sources.

The church with a centralized ground-plan would
have suited very well the requirements of Protestant wor-
ship in Holland, with the pulpit rather than the altar
placed in the focal position. In fact, a number of small
churches of this type were built. The most important is
the New Church at Haarlem by Jacob van Campen,
built 1645-9; but it is also characteristic of Holland that
this has a very un-Baroque appearance. Its lucid interior,
constructed upon the plan of a Greek cross within a
square, has a classical clarity and logic. Similarly, the
almost exactly contemporary New Church at The Hague

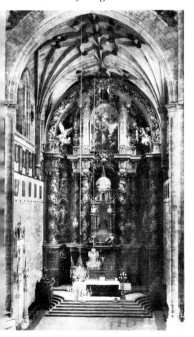

*121 JOSÉ DE CHURRIGUERA
(1665-1725) Retable, San Esteban,
Salamanca, 1693. Gilded polychrome
wood, over 90' high*

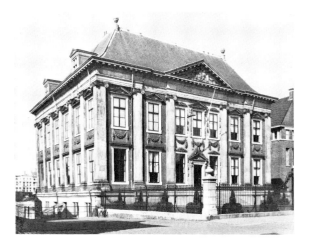

by P. Noorwits and B. van Bassen, built 1649–56 on a
more complex plan of two interlocking squares with six
semi-octagonal bays, looks from the outside rather like a
late-Gothic structure firmly encased within a classical
order of giant pilasters, only the belfry and a series of urns
and knobs on buttresses and roofs adding touches of
Baroque extravagance. But for the most part, the Dutch
contented themselves with stripping the ornaments from
their great Gothic churches and rearranging the interiors
as amphitheatres with all the seats turned towards the
central pulpit. Unlike the Flemish pulpits, the Dutch
ones were usually plain boxes with flat panelled sounding-
boards above. The Baroque spirit made itself felt in these
interiors only in organ-cases and occasional elaborately
carved bench-ends, and outside in steeples with a suc-
cession of usually octagonal storeys and a variety of orders,
balustrades, bulbous forms and finials.

The Dutch preference for restraint and classical order is
still more apparent in secular architecture. The master-
piece of the period is the Mauritshuis (Ill. 122) at The
Hague, built by Jacob van Campen and Pieter Post, and
begun in 1633. Compared with the enormous Italian and
French palaces it is almost miniature in scale, its two
storeys contained within a giant Ionic order of pilasters
carrying modest triangular pediments on the longer
façades only. A series of swags between the upper and
lower windows is almost the only concession to the
ornamental. Proportion and emphasis are managed with

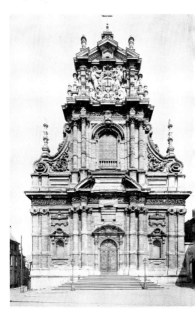

notable skill and subtlety. Van Campen's most ambitious
building, the Town Hall in Amsterdam, built in 1648–
55, is less attractive. Its five main storeys arranged in two
tiers each of two storeys, standing upon a low basement,
and its principal façade of twenty-three bays, stretch the
capabilities of the system a little beyond its proper limits,
while the big domed lantern-cupola over the central
pavilion strikes a slightly incongruous note.

Later in the century, under French influence, a richer
and more ornate manner affected a number of *châteaux*,
now mostly destroyed. The best surviving building in
this style is the Royal Library at The Hague by Daniel
Marot; but this belongs in fact to the 18th century, and,
especially in its interior decoration, with elaborate
plasterwork in Marot's distinctive manner, marks the
transition between the Baroque and the Rococo.

In England, architecture in the 17th century went
further in both directions, Palladian and Baroque, than
the Dutch. The designs of Inigo Jones for the Queen's
House at Greenwich, begun in 1615, and for the Ban-
queting House of Whitehall Palace (*Ill. 124*), built
1619–22, are based strictly upon Palladian examples
which Jones had studied in Italy. Their purity and
restrained simplicity were, generally speaking, in advance
of the taste of the society in which he worked; but his
followers John Webb and Sir Roger Pratt successfully
continued to work in the Palladian manner, while their
contemporary Hugh May practised in a style influenced
by Jacob van Campen, as can be seen from his best-
known building, Eltham Lodge, of 1664. A more
Baroque spirit, however, made an early appearance in
the work of Sir Balthasar Gerbier, a friend of Rubens.
His York Watergate, London, built in 1626, with its
heavily rusticated masonry, curved pediment carrying
the massive arms of the Duke of Buckingham, and lions
couchants resting on the cornice, closely parallels the sort
of antique-Roman-cum-Baroque architecture represented
in Rubens's pictures.

Both Jones's Palladianism and the Baroque exercised
potent influences upon the greatest English architect of
the period, Sir Christopher Wren. Baroque influences,
however, reached him via France. He was in Paris in
1665 when he met Bernini, and no doubt other architects
concerned with the new projects for the Palais du Louvre,
and saw *châteaux* built by Le Vau and Mansart. As one

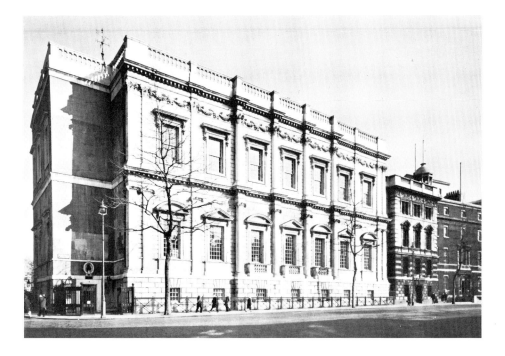

of the three Commissioners appointed to consider the
rebuilding of the city of London after the disastrous fire of
1666 (the others were Pratt and May), and as Surveyor-
General of the King's Works from 1669, Wren enjoyed
a central position in a highly productive period. His first
architectural work, Pembroke College Chapel, Cam-
bridge, built 1663–5, is both severely restrained in its
principal forms, and richly ornamented. His fifty-two
rebuilt city churches exhibit a great variety of ingenious
ground-plans, necessitated by their often cramped and
awkward sites. In several instances, such as St Benet
Fink, St Mary Abchurch and St Swithin, he used
centralized plans of oval, square or octagonal form, to
provide preaching-halls focused upon the pulpit. Galleries
were often included to increase the accommodation,
emphasizing the arena-like effect, as for example at St
James Piccadilly and St Bride Fleet Street. The master-
piece among them, from the point of view of planning, is
St Stephen Walbrook, which cleverly combines the idea
of nave and aisles with that of a Latin cross with a large
cupola over the crossing, the whole being contained
within a rectangle no larger than sixty by eighty-three
feet. These, however, and his many brilliant secular

*124 INIGO JONES (1573–1652)
Banqueting House, Whitehall, Lon-
don, 1619–22*

155

works, which include masterpieces like the libraries of Queen's College, Oxford and Trinity College, Cambridge – surely among the most beautiful rooms ever designed for this purpose – are all surpassed in importance by his grandest effort, St Paul's Cathedral (*Ill. 125*). Conceived upon a vast scale intended to rival St Peter's in Rome, its plan represents a compromise between Wren's own wish for a centralized design and the clergy's desire for a longitudinal church. Over the intersection of the transepts he raised an immense dome, the drum of which carries on the outside a colonnade like that designed by Bramante for St Peter's. The western façade is articulated with two orders, Corinthian below and Composite above. Though all the parts are designed with an antique Roman severity, they are combined with a Baroque vigour and sense of drama. Though from certain viewpoints the almost hemispherical form of the great dome, and the long continuous horizontal lines of the cornice and balustrade produce an effect of mass and equilibrium which is strongly classical, the distant western prospect, with the steeples flanking the western front, and the great dome with its lantern, ball and cross rising triumphantly between them, is certainly Baroque.

Baroque also, and planned on a grand and spacious scale, is the great series of buildings comprising Greenwich Hospital, begun in 1696, where the long colonnades, in spite of their straightness, testify to the influence of Bernini's Piazza in front of St Peter's.

The two leading architects of the next generation, in the first quarter of the 18th century, Nicholas Hawksmoor and Sir John Vanbrugh, developed still further, in some of their works, Wren's Baroque tendencies. Vanbrugh, soldier and dramatist, was an inspired amateur in architecture. The general conceptions of Castle Howard, Yorkshire, built 1699–1712, and of Blenheim Palace (*Ill. 126*), 1705–20, were doubtless his; but especially at the latter much of the detail, particularly of the towers, was due to Hawksmoor, who had been in Wren's office since 1679, and his principal assistant from the middle of the next decade. But whereas Vanbrugh's work at its most personal presents a powerful grouping of masses and a variety of spatial effects and ornament, Hawksmoor's characteristic works, his London churches of St Anne Limehouse, St Mary Woolnoth, Christ Church Spitalfields and St George-in-the-East, have a sharp-edged,

125 SIR CHRISTOPHER WREN (1632–1723) *St Paul's Cathedral, London, 1675–1712*

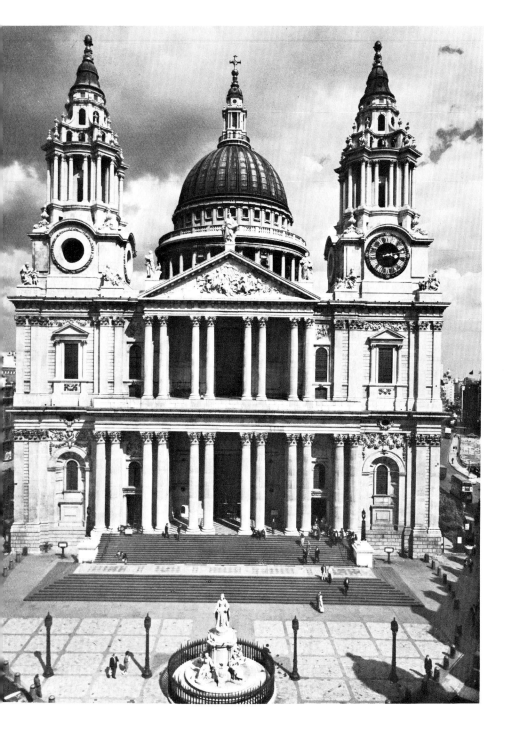

gaunt and forthright geometric quality, often uningratiat'
ing on first encounter, which nevertheless bears the stamp
of a highly original imagination. Like Vanbrugh's,
Hawksmoor's work at different periods of his career
varies considerably in its superficial stylistic character.
Some of his designs for Oxford colleges, for example the
quadrangle of All Souls, and the western towers of
Westminster Abbey, are dressed in Gothic clothes; but
his strong sense of light and shade and his characteristic
powerful sculptural forms, are easily perceptible in all his
works, whether in mediaeval, antique or plain modern
dress. One of his most mature designs, the Mausoleum at
Castle Howard (*Ill. 127*), has an impressive monumental
solemnity. Its antique Roman appearance was achieved
not by slavish imitation of ancient models – the close
setting of the columns in the circular peristyle is in fact
so unprecedented in antiquity as to have called forth
protests from the scholarly Lord Burlington – but by the
use of that rarest gift among architects, a genius for
expression.

In Germany and the countries of Central Europe, due
very largely to the ravages of the Thirty Years War and the
struggles against the pressures of the Turks in the east and

126 SIR JOHN VANBRUGH
(1666–1726) *Blenheim Palace,
Woodstock, 1705–20*

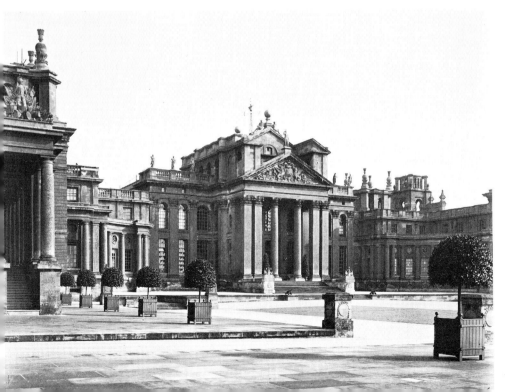

the French in the west, new architectural movements
arrived very late. Some of the most influential buildings,
such as the church of St Michael and the Theatine church
in Munich, were direct copies of Italian models. In the
north, Netherlandish Mannerism remained the pre-
dominant style. Only after the decisive defeat of the Turks
at the Siege of Vienna (1683) did a genuine resurgence of
architecture become possible. A generation of great
architects born in the period between 1656 and 1687
reached their maturity in the last years of the 17th century;
and their masterpieces, built in the next thirty years with
the collaboration of brilliant sculptors and painters, were
of such originality as to shift the artistic centre of Europe
decisively northwards. But of these architects only the
oldest, Johann Bernhard Fischer von Erlach, may
properly be included in the Baroque: all the others belong
essentially to the Rococo, and will therefore be more
appropriately discussed later. Fischer von Erlach is also
reserved for later treatment, since it would create a false
impression to detach him from his younger contem-
poraries.

In French sculpture, Roman Baroque influences were
strong, but so also, in the second half of the 17th century,
was a classicism purer than any in Italy. François and
Michel Anguier had worked for some years in Rome, the
latter under Algardi; Bernini himself had produced a
rather unsuccessful bust of Richelieu in 1640–1, a splen-

159

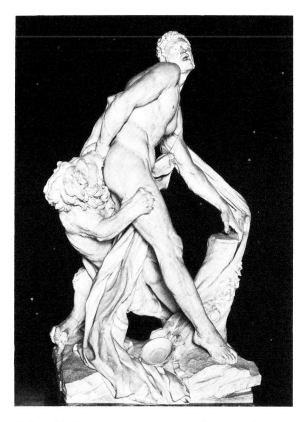

128 PIERRE PUGET (1620–94)
Milo de Crotone, 1671–83. Marble,
h. 8′ 11″ (271.5). Louvre, Paris

did marble bust of Louis XIV, as well as the unfortunate
equestrian statue of the king which was not liked and
was ultimately erected, transformed into Marcus Curtius,
in a far corner of the gardens at Versailles. Pierre Puget,
one of the outstanding talents of the time, was in Italy
from 1640 to 1643, where he was profoundly influenced
by Bernini. His statue of *Milo de Crotone* (*Ill. 128*) (Paris,
Louvre), made 1671–83 for Versailles, is powerfully
modelled and dramatic in a style not far removed from
that of Bernini's *David*. Most of Puget's work was done
in his native area of Provence, and exercised little
influence on national taste. In the next generation
Antoine Coysevox, much employed at Versailles, seems
to have been influenced by Bernini or Algardi in his
portraits, such as the statue of *Louis XIV* (Paris, Musée
Carnavalet) or the busts of *Le Nôtre* (*Ill. 129*) (Paris,
Eglise Saint-Roch) and *Le Brun* (London, Wallace

Collection). His style has an unmistakably Baroque flavour in such works as the monument to the Marquis de Vaubrun in the Château de Serrant, but his earlier work was more classical. The most classical of French sculptors was François Girardon, the close collaborator of Le Brun, especially in the group of *Apollo tended by Nymphs* (Versailles).

Flanders produced at least three Baroque sculptors of distinction: François Duquesnoy, who worked in Rome from 1618 to 1643 and contributed the colossal figure of *St Andrew* to the central crossing of St Peter's, where it stands opposite Bernini's *St Longinus*. It is more static and less emotional than the Bernini, but the pose and even the draperies reveal the inescapable power of Bernini's example. More independent, and much more purely classical, is Duquesnoy's life-size figure of *Santa Susanna* in Santa Maria di Loreto, Rome. Secondly, Duquesnoy's pupil Artus Quellinus the elder produced his best work for Amsterdam Town Hall. It is always vigorous, but a little inclined to be coarse-grained. Lucas Faydherbe, an architect as well as a sculptor, worked in a style closer to Rubens than to Bernini. But perhaps the most distinctive products of Flemish Baroque sculpture are the somewhat formless rustic extravaganzas made by Hendrik Verbrugghen and by Michel Verwoort as pulpits for Sainte-Gudule at Brussels, and for Antwerp and Malines cathedrals.

Meanwhile, England produced only one sculptor of really distinguished gifts, namely Grinling Gibbons, much of whose career was spent in carving in wood highly naturalistic ornaments for interiors, most frequently domestic, but including also the choir stalls and organ-case in St Paul's cathedral. His best bronze is the rather classical statue of *James II* (*Ill. 130*) (London, Trafalgar Square) wearing Roman armour.

Otherwise, it was only in Spain that a quite independent style emerged, in the polychrome wood sculptures of religious subjects which were made to be carried in street processions. A number of artists worked in this medium, notably Gregorio Fernandez of Valladolid, Juan Martinez Montañes of Seville, Alonso Cano (already mentioned as painter and architect) of Granada, and Pedro de Mena of Malaga. Their emotional realism verged at times on the sentimental and theatrical, but just avoided these perils by virtue of an intense religiosity.

129 ANTOINE COYSEVOX (1640–1720) *Bust of Le Nôtre, c. 1700. Marble, life-size. Saint-Roch, Paris*

130 GRINLING GIBBONS (1648–1721) *James II, 1686. Bronze, just over life-size. Trafalgar Square, London*

CHAPTER NINE

Rococo painting in France and Italy

The transition from the Baroque to the Rococo involved no distinct break in continuity, but rather a change of emphasis from the grandiloquent and splendid to the light and delicate. Generally lacking either the intense religious emotion and drama of the Baroque, or the intellectual rigour of Poussin's classicism, the Rococo aimed above all to please.

If any single work of art may be regarded as the perfect embodiment of the Rococo spirit, it is the painting which Antoine Watteau presented to the French Académie Royale as his diploma work in 1717, following his election to membership five years before. *Le Retour de l'Ile de Cythère (Departure from the Island of Cythera)* (*Ill. 131*) (Paris, Louvre) was unusual as a reception piece. Normally, unless he were content with election in the

'lower' categories of portraiture, still-life, landscape or genre-painting, an artist would submit to the Académie a painting of some subject from ancient history, myth-ology or religion. Watteau's picture contains no myth-ological, historical or allegorical personages except the little flying *putti*; it contains, indeed, no figure to whom even a name can be given. Most of the young gallants and their ladies do not even reveal their faces, which are turned towards the distance. The legendary Ile de Cythère was a land of bliss, a haven of perfect, tender and gentle love. Watteau's immediate source was a song introduced as an interlude in a play by Florent Carton Dancourt called 'Les Trois Cousines', written in 1698 and performed for the first time in 1700:

Venez dans l'Isle de Cythère
en pèlerinage avec nous ;
jeune fille n'en revient guère
ou sans amant ou sans époux ;
et l'on y fait sa grande affaire
des amusements les plus doux.

The picture belongs to the category of the *Fête galante*, whose origins go back to Giorgione's *Fête Champêtre* and which included works by Pierre Pourbus in the 16th century and by Rubens in the 17th. Whereas in Rubens's *Garden of Love* (Madrid, Prado) however, the eroticism is hearty and exuberant, in Watteau it is tender and nostalgic. In place of Rubens's robust and energetic courtiers, Watteau gives us graceful creatures, all refine-ment and charm. The rhythm of the composition, instead of embracing everything, as in Rubens, in a single powerful and ebullient movement, unbroken in its sweep by the subordinate interplay of the couples, consists of a gently rising and falling cadence in which each pair of figures marks a separate phrase.

Watteau was of Flemish origin, born at Valenciennes, where he first studied with an obscure painter before going to Paris. There he worked in the studios of Claude Gillot and Claude Audran, the latter of whom was curator of the Palais du Luxembourg, where Watteau saw Rubens's great paintings of the life of Marie de' Medici. The influence of Rubens upon him was pro-found, but the differences between them are even more important than their resemblances. Watteau's settings,

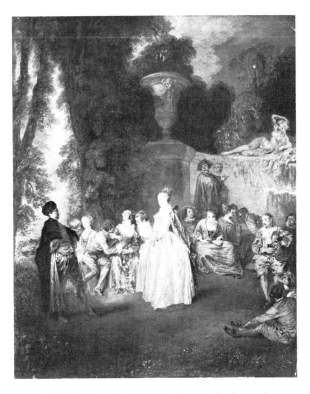

especially in such pictures as *Fête in a Park*, or the ex-
quisite smaller version of the same composition, called
Les Champs Elysées (both London, Wallace Collection),
reveal very clearly their Rubensian parentage, but the
figures are disposed in little groups, scattered among the
trees; the spaces between them have become as expressive
as their contacts. The special grace of this smaller, softer
rhythm reached its most perfect expression in the later
version of *L'Ile de Cythère* (Berlin–Dahlem Museum),
where the undulating line circles round the canvas
towards the groups gathered about the boat from which,
like a descant, a loop of little cupids flies upwards,
fluttering in the air, in a typical intricate Rococo rhythm.

In Watteau's delicious *Fête Vénitienne (Ill. 132)* in the
National Gallery of Scotland, the figures form two fes-
toons on either side of the girl in the centre, while a third
curve, echoing these, links the vase in the centre back-
ground with the recumbent nude statue on the fountain.
In such statues, which Watteau introduced into almost

all his more elaborate compositions, the erotic sensuality which in the real figures is veiled by courtly silken cos/ tumes and exquisite gestures is expressed overtly. The statue in this picture defines the theme, and to emphasize its significance, a figure points to it. Sometimes the sculp/ tures seem, indeed, more real than the human figures; and some of Watteau's most delicate and evocative drawings from life were used for them. On occasion he transformed them back again into living flesh, but that of gods and mythological beings, as in the *Jupiter and Antiope* (Paris, Louvre), where we may recognize in Antiope the figure on the fountain in *Les Champs Elysées*.

The type of *fête galante* established by Watteau was imitated by many other artists. His closest follower was his pupil Jean Baptiste Joseph Pater, who also came from Valenciennes. Nicolas Lancret, a pupil of Gillot only a little after Watteau, also imitated his manner. But such painters very seldom achieved the refinement, the subtle psychological relationship between the figures, or the gentle melancholy which distinguishes the work of the master.

The other leading figure in French Rococo painting was François Boucher. A pupil briefly of François Le Moyne, he studied for four years in Italy, where he was much influenced by Paolo Veronese. From his return to Paris in 1731, and especially under the patronage of Madame de Pompadour, Boucher set the fashionable style of French decorative painting. He lacked Watteau's romantic delicacy, but should not be underrated. He too owed to Rubens his conception of the ideal feminine form, as may be seen in *The Judgment of Paris*, one of four decorative canvases painted in 1754 for Madame de Pompadour's boudoir in the Hotel de l'Arsenal, and now in the Wallace Collection. Boucher's eroticism is explicit, at times almost blatant, and it is not surprising that this series should have been removed as indecent in the next reign. Boucher's Venuses, Dianas and Nymphs seem to promise the most voluptuous pleasures, but they also reveal most clearly the limitations of his quality as an artist, for they seem incapable of any deeper human relationship. Boucher's genius lay principally in the extraordinary decorative facility of his designs. The rising and intersecting diagonals of *Cupid Captive* (*Ill. 133*) create a light, gay rhythm which is kept close to the plane/ surface of the picture by a clever spatial deformation in

133 FRANÇOIS BOUCHER (1703–70) *Cupid Captive, 1754. Oil on canvas, 5' 5" × 2' 9" (164 × 83). By courtesy of the Trustees of the Wallace Collection, London*

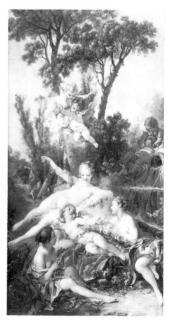

134 MAURICE-QUENTIN DE LA
TOUR (1704–88) *Self-portrait, c.*
1737. Pastel on board, 21¾″ × 18⅛″
(55.5 × 46). Toledo (Ohio) Mus-
eum of Art (Gift of Edward Drum-
mond Libbey, 1955)

135 JEAN-BAPTISTE-SIMÉON
CHARDIN (1699–1779) *La Pour-*
voyeuse, 1738. Oil on canvas, 18⅜″
× 14¾″ (46.5 × 37.5). National
Gallery of Canada, Ottawa

the upper parts, in the interest of decorative effect. He was hardly less a master of high-keyed decorative colour.

The merits and limitations of the French Rococo style are exceptionally clear in the work of one of the leading court portrait painters, Jean Marc Nattier, who almost invariably used a peculiarly pure and brilliant blue in the costumes of his female subjects, in contrast with the rose-pink of their flesh, with draperies of dull green and crimson, and accessories of silver, glass or gilt wood. His surfaces have an extraordinary softness, approaching closely to the effect of pastel, which enjoyed its greatest popularity as a medium for portraiture in the middle decades of the century. The ladies always look seductively beautiful and charming, though in a somewhat standard-ized way. Nattier avoided the exposition of any profound traits of character. On the other hand, no portraits could more effectively take their places in the ensemble of a Rococo interior.

It is, indeed, in the decorative arts that Rococo delicacy and fantasy found their principal outlet. The figured and watered silks of costumes and furnishing fabrics, the porcelain vases, table-ware and ornamental figures made at Sèvres, Vincennes and other centres all over Europe, the furniture of swelling *bombé* shapes decorated with marquetry and ormolu, the girandoles and mirror frames composed of scrolls, foliage, rockwork, shells, glimpses of landscapes with ruins, and birds, assembled with astonishing skill, extravagance and illogicality, in spite of their inherent absurdity have an exquisite charm. The fashion lasted a long time – in the decorative arts, at least, until about 1780. Although it was repudiated by the more rational and severe taste of the Revolutionary generation in the last decades of the century, Rococo decorative art produced many indis-putable masterpieces, among them the figures modelled by Franz Anton Bustelli and Johann Joachim Kaendler for the royal porcelain factories at Meissen and Nymphen-burg in Saxony.

Not all French art in the first three-quarters of the 18th century, however, shared this aristocratic elegance and cultivated frivolity. Among portrait painters two es-pecially stand out for their explorations of individual character and expression: Jean Baptiste Perronneau and Maurice Quentin de la Tour. The latter's many *Self-Portraits*, of which there is a particularly striking example

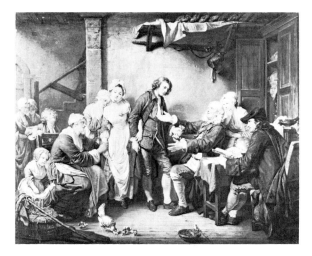

in the Toledo Museum of Art, Ohio (*Ill. 134*), have an unmannered directness and candour which are refreshing among so much artificiality. But the outstanding exponent of the antiRococo quality of simplicity and the quiet routine of everyday bourgeois domesticity was Jean Baptiste Siméon Chardin (*Ill. 135*). Though his art no doubt owes a great deal to the 17th century Dutch tradition, it is nonetheless entirely French in the exquisite delicacy of his painting.

To those who know Chardin's paintings only through the medium of reproductions it may seem curious that he should be considered a greater painter, when his subject matter was so limited and so similar to that of Pieter de Hooch or a dozen other Dutch artists of the 17th century. The paintings themselves, however, at once reveal the exceptional richness and subtlety of his handling of the medium. His vibrant surfaces, apparently painted with such directness and simplicity, are the result of scrupulously applied successive layers of touches. His treatment of form, too, depends upon the most delicate gradations of tone within the lights. His subjects offer a naturalism almost entirely without overtones of didacticism, condescension or satire, but this restricted world is pervaded by a luminous calm; everything is orderly, harmonious and well cared for. The pots shine, the plain costumes are freshly laundered, everything is in its proper place as part of a smoothly running routine. His figures completely accept their places in society.

In a much less subtle way, Jean Baptiste Greuze in the
next generation also expressed the morality of a bourgeois
or respectable peasant way of life, but with an insistence
on sentiment and narrative which Chardin eschewed.
His most popular picture, *L'Accordée de village (Ill. 136)*
(Paris, Louvre), exhibited in 1761, is a typical one. Its
subject is a betrothal party in a farmhouse parlour.
Though the individual figures are sensitively drawn, the
sentiments which they express are overstated and un-
convincing. The picture, intended to provide an example
of rural felicity, is a sermon addressed to the ambitious
and over-sophisticated city dwellers on the virtues, as
maintained by Rousseau and Wordsworth, of the
country life, in proximity to Nature. If the picture failed
in its objective, the reason was its lack of real insight into
the way of life represented as ideal. It imposed a false and
sentimental ideal upon an inadequately studied reality.

The twinges of social conscience experienced by
Greuze find no place in the art of the last of the French
Rococo masters, Jean Honoré Fragonard, which remains
unalterably dedicated to love. He had first studied with
Chardin and then under Boucher. At the age of twenty-
four he went to Italy, where he admired the work of
Tiepolo and studied antiquities. From 1761, when he
returned to Paris, until the Revolution, he produced
pictures in the Boucher tradition, but with a warmer
palette, and an increasingly free and bravura style of
handling. His landscapes were distinctive; his trees seem
to fill the space with cascades of foliage; and in spite of
the sunlight, his atmosphere is steamy and humid. But a
typical picture such as *Love Letters (Ill. 137)* (New York,
Frick Collection), one of a series finished in 1773, com-
missioned for Madame du Barry's pavilion at Louvecien-
nes, has exactly the 'scented and frivolous air' which his
patrons had appreciated, though for some unknown
reason this series was not accepted. The Rococo taste was
already declining, and the commission was transferred to
the Neo-Classical painter Joseph Vien. In a more positive
way Fragonard marks the end of a phase. In a number of
small, freely executed sketch-like canvases, and in
drawings, his technique seems to respond to an irresistible
torrent of inspiration. The astonishing dexterity and
passion of his brushwork departs so radically from the
neat and fastidious execution of Boucher, or of his own
early works, as to anticipate Delacroix and occasionally

*137 JEAN HONORÉ FRAGONARD
(1732–1806) Love Letters, 1773.
Oil on canvas, 10′ 5″×7′ 1″ (317.5
×217). Copyright The Frick Col-
lection, New York*

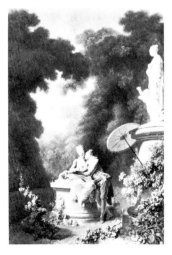

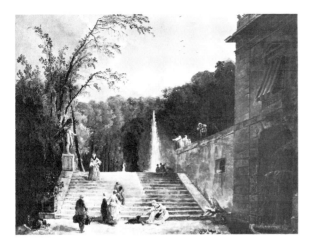

even Daumier; he passes beyond the Rococo into the
beginnings of Romanticism. But this development was
too early. Ruined by the Revolution which destroyed the
patronage upon which he relied, but which he neverthe-
less supported, he was reduced to poverty and forced to
accept employment as a curator in the museums service.
He died in 1806 in obscurity, almost in oblivion.

Landscape played a significant part in the art of
Watteau, Boucher and Fragonard, but it was an artificial
landscape of parks, gardens and arcadian rusticity. The
two best French painters of the period who specialized in
landscape ventured a little closer to reality. Claude Joseph
Vernet devoted himself especially to views of seaports
and harbours in a style strongly influenced by Claude
Lorrain, or occasionally in the more dramatic vein of
Salvator Rosa. Even in the series of *The Ports of France*
which he painted for Louis XV, he reveals as much
awareness of his great predecessor as of the scene before
him. Hubert Robert was an artist of greater originality.
He spent the years from 1754 to 1765 in Italy, where he
knew and was much influenced by Giovanni Paolo
Pannini and Giovanni Battista Piranesi. The paintings
of Roman ruins which formed the greatest part of his
output after his return to Paris certainly owe much to
Pannini. In 1761 Robert was in the south of Italy and
Sicily with Fragonard, whose more tender style also
influenced his development. The red chalk drawings
which both artists made at that time are almost indis-

tinguishable, and in some of Robert's most beautiful canvases, such as *L'Escalier dans le parc de St Cloud* (*Ill. 138*) (Floors Castle, Duke of Roxburghe), the style is a combination of picturesque antiquarianism and the spirit of the *fête champêtre*. Characteristically, his diploma picture on election to the Academy in 1766 was *A Capriccio of the Ripetta at Rome* (Paris, Ecole des Beaux Arts), but in later years, especially during the 1780s when large scale demolitions of old houses and bridges and new planning developments were in progress in Paris, he recorded the scenes with a sharply observant eye, as in *The Demolition of the Houses on the Pont-au-Change*, in the Musée Carnavalet.

Italy in the 18th century was still divided into a number of states, but the complex political pattern had become simplified to some extent. Only the papal states, Venice and Genoa were of real importance, apart from the dominions of the Bourbons who ruled Naples and Sicily, the house of Savoy which ruled Piedmont and Sardinia from Turin, and the house of Lorraine which succeeded the Medici in Florence. Weakened economically by the loss of trade resulting from the diversion of shipping routes to the Far East via the Cape of Good Hope, and by the almost complete erosion of the Italian empires in the Levant, the Italian states were further undermined by a series of dynastic wars, and by the struggles of which these formed a part against Austrian and French en-croachments. Cultural life was focused in the five cities of Genoa, Naples, Rome, Turin and Venice. Even these great cities, and especially Venice, had become more dependent on the tourist trade than on their own industry and commerce. It was the great age of the Grand Tour, when every gentleman from northern Europe who aspired to the status of a man of culture and education, spent a season in Italy, culminating in the Carnival at Venice. The glorious days of Italian art were nearing their end, but the prestige and influence of the great Italian artists still extended throughout Europe.

The greatest achievement of 18th century Italian painting was the creation of a Rococo style of mural decoration. The way was prepared by Sebastiano Ricci, a brilliant and facile decorator who adapted Veronese's style to modern tastes by introducing a still lighter and more luminous palette, rhythmic brushwork and more fashionable slender figures. He painted his most im-

portant works in the Schönbrunn Palace in Vienna, and in London, where he carried out decorations in Burling-ton House and in the apse of Chelsea Hospital Chapel, but failed to secure the commission for the decoration of the interior of Wren's great dome at St Paul's. His paintings are attractive, but have elements of superficiality and pastiche. A more serious talent was that of Giovanni Battista Piazzetta, who settled in Venice in 1711 after studying under Giuseppe Maria Crespi in Bologna. His altarpieces preserved the sombre tones of the 17th century Bolognese school, but with a heightened emotionalism and an apparent facility of execution which belied the slow and laborious preparations which lay behind them. He received only one commission for an important ceiling decoration, for the dome of Santi Giovanni e Paolo, which he carried out on canvas; but the brilliance of its spatial illusionism, no longer dependent upon architectural perspectives, was to prove a major source of inspiration for the greatest painter of the next generation, Giovanni Battista Tiepolo.

Tiepolo's art presents a glorious and luminous, splendidly theatrical view of saints, madonnas, myth-ological and historical heroes and heroines. It is an operatic world full of absurdities and unrealities, but the light airy rhythms of his compositions, their superb vitality, the brilliance of his colour, the virtuosity of his brushwork, conjure up an ambience of enchantment. His Madonnas, as for instance the one in the superb *Immacu-late Conception (Ill. 139)* in the Prado in Madrid, have the same air of assurance and condescension which we recognize in the top fashion models of today. However artificial, this world is imagined and expressed with an irresistible panache.

Tiepolo enjoyed and exploited his unsurpassed tech-nical facility. By the time of his first important decorative commission, for the Archbishop's Palace at Udine, painted between 1725 and 1728, he had already developed a palette of extraordinary high-keyed brilliance. In certain of his schemes, such as the ceiling of the Gesuati church in Venice, painted about a decade afterwards, and in the gorgeous ballroom decorations of the Palazzo Labia, painted about 1740–50, which is the most perfect marriage of painting and architecture achieved anywhere in Italy in the 18th century, he employed architectural perspectives in the manner of Andrea Pozzo to create the

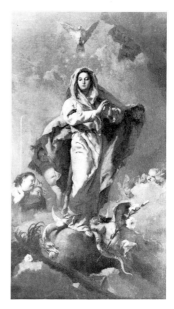

139 GIOVANNI BATTISTA TIE-POLO (1696–1770) *The Immacu-late Conception, 1769. Oil on canvas, 9′ 2″×5′ (279×152). Prado, Madrid*

171

illusion of receding space. In these architectural parts his collaborator was Girolamo Mengozzi-Colonna. But in some of his most delightful creations, for instance the ceiling fresco of *Emperor Frederick Barbarossa* (*Ill. 140*) in the Kaisersaal of the Residenz at Würzburg, painted in 1750-2, or in the ceiling of the throne room of the Royal Palace at Madrid (1762), the impression of vast and limpid space does not depend upon such devices. To avoid the disadvantage of the single predetermined view-point, from which alone such a method can achieve its full effect, Tiepolo depended solely upon the use of *de sotto in su* foreshortenings in groups of figures disposed around the edges of his compositions, or floating upon clouds, and flying in the clear central spaces, with no more than fragmentary and scattered architectural motifs. These groups have only a loose connection with one another, but their movements generate an exhilarating sense of illimitable space. This mobility is reinforced at Würzburg by the irregular ogival curves which frame the ceiling fresco, and by the stucco *putti* who carry up loops of drapery to reveal the subjects painted above the cornice. These subjects are ostensibly concerned with the Marriage of the Emperor Frederick Barbarossa, which took place at Würzburg in 1156, but Tiepolo is quite un-troubled by any concern for historical accuracy. His sense of suitable splendour demanded, above all, a suggestion of 16th century Venice, but with the addition of bizarre and opulently attired Orientals, and an abundance of allegorical and celestial beings.

Tiepolo's moment of greatest triumph was his election in 1754 to the presidency of the newly-founded Venetian Academy. About three years later he was engaged on the frescoes of the Villa Valmarana near Vicenza – his most purely theatrical scheme, devoted to themes from Homer, Tasso and Ariosto. After further works at Udine, Verona and the Villa Pisani at Strà, he travelled in 1762 to Madrid. Having painted three ceilings in the Royal Palace, he stayed on, making sketches in anticipation of further commissions, and painting seven altarpieces for Aranjuez. Though these last works are among his most intensely emotional, with an almost expressionist agi-tation in the brushwork, they met with a reception that was anything but appreciative. Factions at court favoured the more Neo-Classical style of the German Anton Raffael Mengs, who received the commission to replace

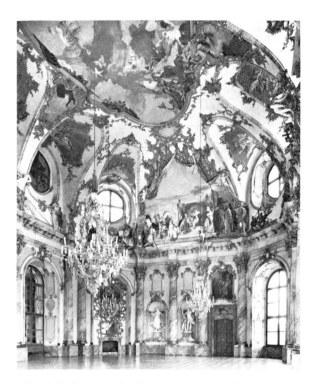

Tiepolo's altarpieces by his own. The triumphant empire
of the Venetian Rococo was almost at its end.

That empire had extended over almost all of Europe.
England had been visited by Giovanni Antonio
Pellegrini, Sebastiano and Marco Ricci, and Jacopo
Amigoni (not a Venetian by birth, but by adoption),
who had also worked in Germany and Spain; Pellegrini
had painted also in France and Germany; Francesco
Fontebasso in Russia. But the almost equally brilliant
school of decorative painters centred at Naples found
more adequate employment at home. Not that they ever
attained anything approaching the luminosity of Tiepolo's
colour. Francesco Solimena, however, developing from
the basis of Luca Giordano's style, with backward
glances also at Gaulli, Preti and even Raphael, achieved a
great virtuosity in the arrangement of complicated com-
positions containing scores or even hundreds of figures,
and his reputation was truly phenomenal. He decorated
many Neapolitan churches, some of his best works being
in the Chiesa del Gesù Nuovo, painted in 1725.

All the most distinguished Neapolitan decorative painters of the next generation had been Solimena's pupils. Sebastiano Conca was employed in Rome from 1706 for many years, and his position there was supreme after the death of Carlo Maratta, whose influence led Conca to a somewhat tamer style than his master's. He was joined in Rome in 1723 by Corrado Giaquinto, who thirty years later succeeded Amigoni as court painter in Madrid. Unlike Conca, who had moved in the direction of classicism, Giaquinto developed in the direction of the Rococo. His looser style of composition and execution was characteristic of the court circles at Turin, where he worked for a time, and where the court painter was Claudio Francesco Beaumont, of French origin, but trained in Rome under Trevisani.

The Turin manner represents the nearest approach of Italian painting to the French Rococo. The youngest of Solimena's notable pupils, Francesco de Mura, who also worked for a time at Turin, carried on the Neapolitan Rococo to its end in the 1780s.

A very different art, more responsive to the spirit of calm, rational and objective observation of the phenomena of the real world, which was characteristic of the age of Enlightenment in the northern countries, developed in Venice, and to a lesser extent in Rome. Significantly finding his principal market among the English Grand Tourists, Antonio Canaletto evolved a style of archi⁄tectural view⁄painting in which descriptive accuracy in perspective and typical incident was the primary concern. Like the 17th century Dutch townscapes of Jan van der Heyden, and possibly influenced by them, Canaletto's views were achieved with the aid of the *camera oscura*. He aimed at a pictorial documentation of the most notable buildings and vistas of the city, and also of the chief social events of the Venetian scene, its regattas, religious and state ceremonies and processions. The spirit of Canaletto's art is prosaic, but to say no more of it than that would be to do it less than justice. The same spirit animated one of the most scrupulous as well as influential of the Grand Tourists, the Frenchman Maximilian Misson, whose *New Voyage to Italy*, first published in 1695, was trans⁄lated into English and went through five editions by 1739. Misson had what he called a 'universal curiosity'; he admitted that "tis true [a Traveller] ought not to fill his Journal with insipid observations; but there is hardly

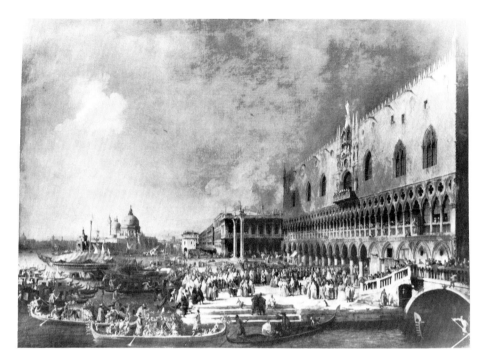

anything on which an exact and ingenious person is not capable of making reflections'. The search for facts, the exercise of a sturdy commonsense, the desire that his readers should 'instruct themselves carefully in every thing; and . . . passionately seek all possible means for their instruction; and greedily embrace the same, when found', has all the eagerness and enthusiasm of the spirit of early scientific enquiry.

Canaletto's enquiries were pursued with no less passion, though recorded in the cool, crisp and precise manner so well exemplified in *The Reception of Count Sergi, The French Ambassador* (*Ill. 141*), in the Hermitage at Leningrad. In his later work, after his visits to England, where he worked from 1746 till about 1755, some of the verve of his earlier period was lost, and his execution became hard and mannered. Paradoxically, Canaletto's work included also a number of *capricci* or *vedute ideate* – imaginary scenes usually showing well-known buildings in fanciful juxtaposition, or in invented settings. In this mode, however, he was surpassed by others, especially by Pannini and by Francesco Guardi.

141 ANTONIO CANALETTO (1697–1768) *The Reception of Count Sergi, The French Ambassador, c. 1740. Oil on canvas, 8′ 6″×6′ (259×181). Hermitage Museum, Leningrad*

175

Canaletto was pre⁄eminently a painter of Venice. In his views of Rome and, with the exception only of the two sparkling views of *The Thames from Somerset House Terrace* (Goodwood, Duke of Richmond and Gordon) painted on his first arrival in London, in his English views also, some indefinable quality in the *genius loci* eluded him. His brilliant nephew and pupil Bernardo Bellotto, on the contrary, was at his best abroad. Leaving Venice in 1747, he became painter to the Elector Frederick Augustus II of Saxony, who was also king of Poland. In the Saxon capital of Dresden he painted a number of remarkable pictures before the outbreak of the Seven Years War in 1756 put an end to the brief flowering of that court culture. After two years as court painter to the Empress Maria Theresa in Vienna, he returned to Dresden, painting in Munich on the way, only to find the city almost destroyed, and his own house gone. Frederick Augustus died in 1763; the finances of the state were ruined, and Bellotto was reduced to accepting a modest position as teacher of perspective in the Academy. In 1767 he left for Warsaw, where in 1768 he became court painter to king Stanislav Augustus and enjoyed a position of unique importance in the cultural revival of his reign. Bellotto is often regarded as a mere emissary of his uncle's style. In fact, however, his mind had much greater rich⁄

142 BERNARDO BELLOTTO (1720–80) *Warsaw seen from the suburb of Praga, 1770. Oil on canvas, 5′ 8″×8′ 9″ (172.5× 268.5). National Museum, Warsaw*

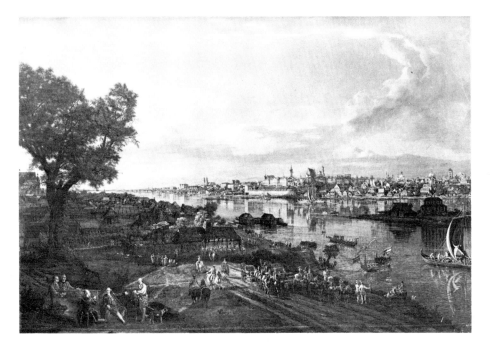

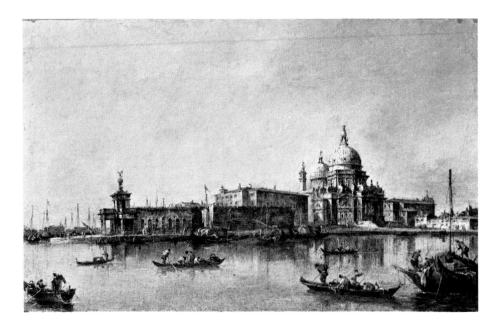

ness and scope. Bellotto stood further back from his subjects, so that the streets, squares and market places surrounding his buildings, the lively activity, and the whole intricate panorama of life in a great city are unfolded before us. In a few masterpieces, indeed, as in *Warsaw seen from the suburb of Praga* (*Ill. 142*), painted in 1770 and now belonging to the National Museum in Warsaw, the entire city is shown in clear relationship to its great river Vistula and to its surroundings. Bellotto's figures have a vitality and expressiveness, as well as an occasional touch of wit, which Canaletto's seldom aspire to. The liveliness of his brushwork is not excelled by that of any landscape painter of his time. Only the fact that his finest pictures are all in Warsaw prevents him from being recognized as one of the greatest masters of the 18th century. He, and not Canaletto, is the supreme exponent of that universal curiosity commended by Misson.

From the considerable number of painters of landscape and architecture who flourished in the age of the Grand Tour, three others must be distinguished. Many of the works of Gian Paolo Pannini, a Roman counterpart to Canaletto, are devoted to the architecture of ancient and modern Rome, sometimes in a straightforward topographical manner, sometimes in the form of *capricci*. But his most brilliant canvases, such as *The Visit of Charles III*

143 FRANCESCO GUARDI (1712–93) *Santa Maria della Salute and the Dogana, c. 1750. Oil on canvas, 12⅞″×20⅜″ (32.5×52). Birmingham City Art Gallery*

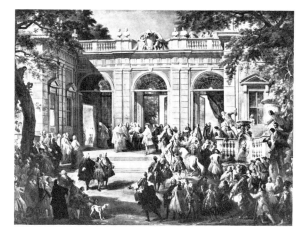

144 GIOVANNI PAOLO PANNINI
(c. 1692–1765/8) *The Visit of
Charles III of Naples to Pope
Benedict XIV, 1746. Oil on canvas,
4′×5′ 8″ (123×173). Capodi-
monte Museum, Naples*

of Naples to Pope Benedict XIV at the Palazzo Quirinale
(*Ill. 144*) (Naples, Capodimonte Museum), record social
or diplomatic occasions of special importance or pagean-
try. A precise draughtsman, he was also able to convey
atmosphere, and to compose his figures in an ac-
complished way.

In another medium, the prolific Roman engraver
Giovanni Battista Piranesi combined the archaeologist's
passion for accurate observation with a love of grandeur,
mystery and fantasy which he expressed most notably in
his series of imaginary prisons, the *Carceri d'Invenzione*,
which herald the age of Romantic imagination.

The strangest figure of all, however, is that of Fran-
cesco Guardi. Trained under his elder brother Gianan-
tonio, he seems during most of his career to have been a
member of a Venetian studio which produced un-
ambitious pictures of religious and poetic subjects,
mythologies, battle-pictures and townscapes, often
shamelessly copying the compositions of other artists,
including Canaletto and Giovanni Battista Piazzetta.
His Venetian *vedute* (*Ill. 143*) seem to have been bought in
large numbers by visiting foreigners; but he remained
quite obscure until after his brother's death in 1760. Not
until he was seventy-two years old did he become a
member of the Venetian Academy. Though the subjects
of his Venetian scenes are similar to Canaletto's,
Guardi's concern was not with objective description of
architectural structures, but rather with the vibrating
light and atmosphere. His compositions were charged

with such intensity that the whole perspective framework
is shaken, and even buildings tilt out of the perpendicular,
to give an almost dreamlike quality to his vision. Guardi's
brush excitedly flickers over the canvas to produce a
luminosity which already anticipates Impressionism.

Alessandro Magnasco, the most interesting Genoese
artist of the early 18th century, painted fantastic land-
scapes, often full of hermits, penitent monks in frenzied
states of prayer and self-mortification, or encampments
with bandits quarrelling over booty. They are executed
in an agitated manner, with exaggerated chiaroscuro and
gloomy colours. Similar qualities, though of a less
extreme kind, may be seen in certain of the landscapes and
storms at sea by Marco Ricci. The rational spirit of the
Enlightenment seems as remote from these as does the
pursuit of the pleasures of love.

There was, indeed, plenty of varied talent in 18th
century Italian painting, and this in itself is significant of a
new age, seeking for different ways of realizing the
potentiality of the individual. While the Bolognese
Donato Creti at one stage of his career painted elegant
little scenes of young ladies and their gallants, rather in the
French taste, his fellow townsman Giuseppe Maria
Crespi applied to religious subjects, genre scenes and
portraiture a depth of human feeling which involved a
complete rejection of the academic formulae of the
preceding period, and a return to the intense chiaroscuro
of the early Guercino. Crespi's sense of form, however,
and the freedom of his touch, as well as the simplicity of
his subjects from common life, are far from Baroque
confidence and assertion. His profound and reflective
mind seems full of questioning about the nature of man,
his actions and his consciousness of the divine. His series
of *The Seven Sacraments*, in the Dresden Gallery, are
among the most personal and original religious works of
the time. If he remains a marginal figure, it is not because
he lacked genius, but because he was too intensely
individual to exert much influence, except upon the
young Piazzetta.

On the other hand, the work of the Venetian Pietro
Longhi, who also concerned himself with genre, but of
upper-class ladies and gentlemen and their servants en-
gaged in keeping themselves properly attired and amused,
is not too distant from the world of Lancret or Hogarth.
Longhi had none of Crespi's gift for poignant stillness,

145 PIETRO LONGHI (1702–85)
*La Toilette. Oil on canvas, 1′ 11″ ×
1′ 7″ (59.5 × 47.5). Accademia,
Venice*

Lancret's sense of gallantry, or Hogarth's acid satire. He was not devoid, however, of a certain gentle humour, as in *La Toilette* (*Ill. 145*) (Venice, Accademia), where the tired and bored maidservant holding the mirror stares vacantly at nothing, and the old woman bringing in the coffee tray is ignored by all the others and looks with faint astonishment at her mistress. The very limitations of his ambition perhaps make him a more typical figure of the period than Crespi.

146 WILLIAM HOGARTH (1697–1764) *Marriage à la Mode, scene II. Shortly after the Marriage,* 1745. *Oil on canvas, 27½″ × 35¾″ (68.5 × 89). By courtesy of the Trustees of the Tate Gallery,* London

CHAPTER TEN

Rococo painting in England and Germany

The variety of styles current on the continent during the first three quarters of the 18th century also existed in Britain, which for the first time made a major contribution to the European tradition. The pure Rococo of Watteau and Boucher produced no more than minor echoes in the work of such men as Philippe Mercier and Bartholomew Dandridge. On the other hand, a number of late Baroque decorative painters from France and Italy were much employed in England. Antonio Verrio, Gianantonio Pellegrini, Antonio Bellucci, Sebastiano Ricci, Jacopo Amigoni, Louis Laguerre and others were engaged on projects in palaces, town and country mansions, some of them on a major scale. The leading English mural and ceiling painter, Sir James Thornhill, owed almost everything to their example; all the same, his most important undertaking, the frescoes in the dome of St Paul's Cathedral, is rather more restrained and classical than Ricci's might have been. Even in the preliminary drawings, such as that for *St Paul before Agrippa* (*Ill. 147*) (London, British Museum), the sobriety of composition is evident, in spite of the nervous and spirited calligraphy of the pen strokes, and the late Baroque framework. This quality corresponded to something inherent in British taste, which never surrendered to the more extreme forms either of the Baroque or of the Rococo.

This restraint is most distinctly felt in the portraiture of Sir Godfrey Kneller, who had succeeded to Lely's supreme position in this branch of painting. A German, trained in Amsterdam, he had practised briefly in Italy before arriving in England in 1674. Some of his earlier works show a typical Baroque delight in rich colours and textures, but after 1700 his style was purged of these qualities. Draperies tended to be treated far more abstractly, the colour moved towards a brown monochrome,

147 SIR JAMES THORNHILL (1675/6–1734) *St Paul before Agrippa. Pen and ink over black chalk with a sepia wash on brown paper heightened with white, 15″ × 9⅞″ (38 × 25). British Museum, London*

181

and the effects depended principally upon a broad, free technique with the brush, and a highly simplified drawing style. His reputation has undoubtedly suffered severely from the great unevenness of quality among the vast numbers of portraits that issued from his studio, many of them largely or even entirely the work of assistants; but at his best he was among the ablest portrait painters of his time. His *Sir Isaac Newton* (*Ill. 148*) (London, National Portrait Gallery), painted in 1702, has a probity, intelligence and directness which set a high standard for British portraiture throughout the century. Just how un/Baroque it is may be seen by comparison with Rigaud's roughly contemporary *Prince Wenzel von Liechtenstein* (*Ill. 64*) (Vienna, Liechtenstein Collection); despite Rigaud's brilliance of colour and the superb execution of the details of costume, his picture looks fussy, pompous and flamboyant beside Kneller's.

Essentially the same appreciation of a severe and chastened style was expressed by the philosopher, the third Earl of Shaftesbury, who demanded in art 'a simple, clear and united view . . .' and abhorred anything 'gaudy, luscious, and of a false Taste', just as he derided the vanity of the artist who boasts 'that by his Genius alone, and a natural rapidity of Style and Thought, he is able to carry all before him; that he plays with his business, does things in passing, at a venture, and in the quickest period of Time.' Such an attitude explains the resistance which the Rococo was to encounter in Britain; but Shaftesbury's demands for a pure classical style were not to be realized in painting for another generation.

The most important painter of the second quarter of the century, William Hogarth, represented a different point of view altogether. After an apprenticeship to a silver/smith, Hogarth began his career as an engraver and book/illustrator; but by about 1725 had turned his hand to small/scale portraits and conversation pieces, which he continued to produce at intervals almost throughout his life. His special genius, however, lay in the direction of satire. From 1720 onwards he had published individual satirical prints, but in 1731–2 he painted a series of six pictures of *A Harlot's Progress* (destroyed), also publishing a set of engravings from them in 1733. The story was of his own invention, inspired no doubt by such literary models as the novels of Daniel Defoe, whose *Moll Flanders* had appeared in 1722. The moral of his story

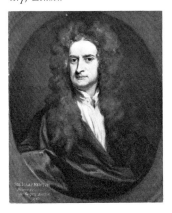

148 SIR GODFREY KNELLER (1646/9–1723) *Sir Isaac Newton, 1702. Oil on canvas, 24½″ × 29½″ (62 × 73.5). National Portrait Gallery, London*

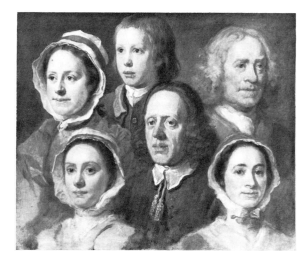

was directed with the greatest seriousness and intensity at a
number of very precisely defined targets. In this, and in
his later series, *A Rake's Progress* (London, Sir John
Soane's Museum), published in 1735, *Marriage à la Mode*
(*Ill. 146*) (London, Tate Gallery), published in 1745,
Industry and Idleness, engraved from drawings preserved
in the British Museum, and published in 1747, *The Four
Stages of Cruelty*, published in 1751, etc., he satirized the
idle and degenerate aristocracy, the rich and ambitious
city merchants, aping the ways of their superiors, the
gin-sodden urban proletariat (making its first appearance
in pictorial art), the crafty quack doctors, mincing French
dancing-masters, Italian opera singers, somnolent lawyers,
thieving prostitutes and corrupt politicians with which
18th century London society seems to have been laden.

Elements of Hogarth's subject-matter and of his com-
positional vocabulary have been traced to sources in
Dutch 17th century art and to contemporary French
engraving and illustration. He visited Paris twice, and
employed several French engravers, but his satirical
purpose had no real parallel on the continent, and both
his realism, and the breadth of his interest in society, set
him in a unique position. He belongs to the Rococo in
the liveliness of his touch with the brush, and in his fond-
ness for the serpentine curve which, in his *Analysis of
Beauty* (1753), he identified as 'the line of Beauty', but
these other qualities put his art into a special category.

He succeeded in freeing himself from servitude to
patrons and dealers by relying for his income mainly on
the sale of engravings published by himself, and pro-
tected by the Copyright Act of 1735 which he was
largely instrumental in getting passed. The most original
aspects of his style are certainly connected with the fact
that he expressed the attitudes of a new audience, the
middle classes, whose special virtues of industry and
enterprise he clearly exemplified.

Hogarth's unusually keen sense of his audience also
significantly affected the style of his portraiture. One of
his most ambitious single portraits, of the philanthropist
Captain Coram (London, Foundling Hospital), painted
in 1740, which was destined for a place of honour in the
charitable institution which he founded, is an adaptation
of the French Baroque of Hyacinthe Rigaud. But the
portrait of *George Arnold* (Cambridge, Fitzwilliam
Museum), of only a year or two earlier, presents this
businessman entirely without trappings, with no pretence
at fashionable elegance, but rather with the vitality,
assurance and simplicity of the self-made man. Still more
strikingly, one of the most vivid examples of Hogarth's
portraiture, the canvas with heads of his own servants
(*Ill. 149*) (London, Tate Gallery), presumably painted
for his own pleasure, shows them with the greatest
possible directness as isolated fragments, but with a
profound humanity.

In one aspect of his work, however, Hogarth seemed to
look backward rather than ahead, that is, in his efforts in
historical painting in the Grand Manner, at which he
was not very successful. His *Paul before Felix* (London,
Lincoln's Inn) and *Moses brought to Pharaoh's Daughter*
(London, Foundling Hospital) are based in style upon
Raphael's cartoons, and his *Sigismunda* (London, Tate
Gallery) of 1759, which was intended to prove that an
English painter could do as well as the continental 'old
masters' then being avidly collected, often under false
attributions, by the connoisseurs, was prompted by a
picture by Francesco Furini, then regarded as a Correggio.

For a time, however, in the middle decades of the
century, a Rococo manner made a strong impact in
Britain. The decorations of the pleasure ground at Vaux-
hall Gardens, for which Francis Hayman was largely
responsible, the silverware of Paul de Lamerie, the porce-
lains made at the factories of Bow, Chelsea and Wor-

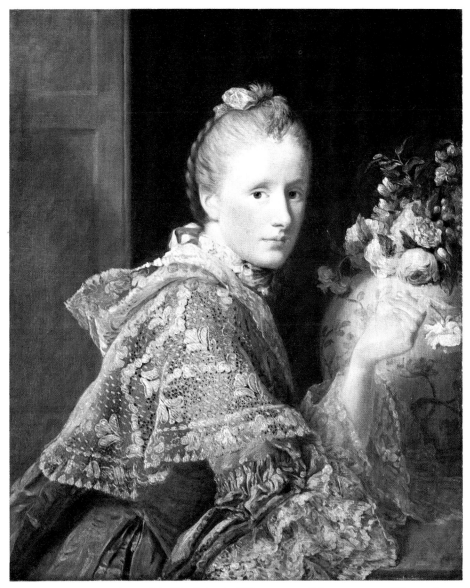

150 ALLAN RAMSAY (1713–84) *The Painter's Wife, c. 1755. Oil on canvas, 29¼″ × 24⅜″ (74 × 61). National Gallery of Scotland, Edinburgh*

cester, all helped to propagate an English version of the Rococo. In painting, perhaps the style of the Scottish-born portraitist, Allan Ramsay, who had studied in Italy with Francesco Imperiali and Francesco Solimena, but whose drawing and colour seem more French than Italian, best represented this phase of taste. His beautiful portrait of *The Painter's wife* (*Ill. 150*) (Edinburgh, National Gallery), very French in style, reveals him at his best. The portraits, especially those in pastel, by John Knapton, Arthur Pond and Francis Cotes, show a fondness for colour harmonies of pale blue and rose, while the conversation pieces of Arthur Devis, with their cool, airy colour and their slightly doll-like figures, have the same fragile grace as early Chelsea porcelain figures.

The relationship to the Rococo of the two greatest painters of the second half of the century, Reynolds and Gainsborough, is more complex and difficult to define. In his youth, when he was in London between 1740 and 1748, Gainsborough was in close contact with the circle of Gravelot, Hayman and the St Martin's Lane Academy which was at the centre of the English Rococo. The backgrounds of some of his early conversation pieces are very Watteau-esque, and the charmingly rustic figures of young lovers in some of his early landscapes, such as the two which he painted in 1755 for the Duke of Bedford (Woburn Abbey), are even more so. But Gainsborough always favoured a more naturalistic and less artificial mode. By close study of the landscapes of Jan Wynants and Jacob Ruisdael he achieved, very early in his career, in the so-called *Great Cornard Wood* (London, National Gallery), the effect of a particular place, intimately known and rendered in loving detail.

But his later landscapes are mostly derived from imagination rather than from particular places. Those of his London period, after 1774, acquire more and more the character of poetic improvisation and reverie, often concentrating on the qualities of early morning or late evening light. Sometimes they are elegiac in mood, as in *The Watering Place* (London, National Gallery), sometimes gently pastoral, as in *Upland Hamlet* (New York, Metropolitan Museum), occasionally cold and windy, as in the *Coast Scene* (Duke of Westminster); at their most impressive they are solemn, lonely and awe-inspiring, as in *Mountain Valley with Sheep* (Edinburgh, National Gallery). The depth and seriousness of their subjective

feeling puts these pictures at a great distance from the
Rococo. The mountain landscapes of Gainsborough's
late years may have been inspired by the scenery of Wales
or the Lake District which he visited on tours, but the
places are transformed by recollections of Gaspard Dug-
het, and sometimes provided with hill cities which look
Italian rather than English. One of the most splendid and
convincing of all his late landscapes, *The Market Cart* (*Ill.*
151) (London, Tate Gallery), perhaps refers in some de-
gree to a real scene, but this painting's great distinction lies
in its poetic feeling, in the gentle cadence of its downward
moving rhythms contrasting with the soaring majesty of
the great trees. It is only half a step from this to the
mature works of Constable and the full tide of the
Romantic movement.

In portraiture also, Gainsborough moved from the
Rococo charm and fragility of such early works as *Mr and
Mrs Andrews* (London, National Gallery) to the ex-
pression of much deeper qualities. During his years in
Bath, from 1759 to 1774, he seemed often to be interested
mainly in establishing the sitter's status and dignity, in a
way influenced by Van Dyck, but his preoccupation
with movement – both the characteristic movements
which reveal the personality of the sitter, as in the vivid
portrait of the actor *James Quin* (Dublin, National
Gallery), and the compositional movement set up by the
leading lines of the design, as in the unconventionally
posed *Mrs Philip Thicknesse* (Cincinnati Art Museum)
– helped him to convey an effect of lightness in his
figures. They move gracefully and easily within the
pictorial space, in a distinctly Rococo way. A charming
example is *Countess Howe* (*Ill. 153*) at Kenwood House,
and a later one, very possibly influenced by Lancret's
portrait of *Mademoiselle Camargo dancing*, which he could
have known through the engraving by Laurent Cars, is
the portrait of the ballet dancer *Madame Baccelli* (Swinton
Park, the Countess of Swinton). Moreover, Gains-
borough's unique freedom of handling – what he called
'the movement of the pencil' – contributed to the creation
of rhythms as light and delicate as those of Watteau or
Fragonard. On the other hand, many of his later portraits
reveal quite different qualities. *George Drummond* (Oxford,
Ashmolean Museum) pauses reflectively on a country
walk; *Mrs Robinson* (London, Wallace Collection) sits
on a mossy bank absorbed in sober thought, and *Mrs*

187

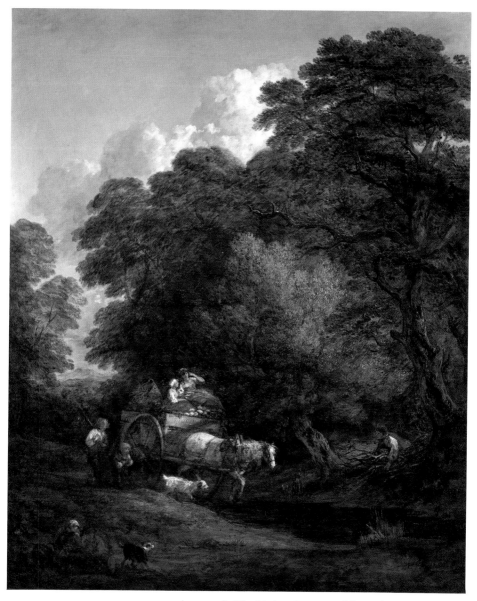

151 THOMAS GAINSBOROUGH (1727–88) *The Market Cart, c. 1786/7. Oil on canvas, 6′ × 5′ (184 × 153). By courtesy of the Trustees of the Tate Gallery, London*

152 THOMAS GAINSBOROUGH (1727–88) *Mary, Countess Howe, c. 1765. Oil on canvas, 8′ × 5′ (259 × 152.5). London County Council, Iveagh Bequest, Kenwood House*

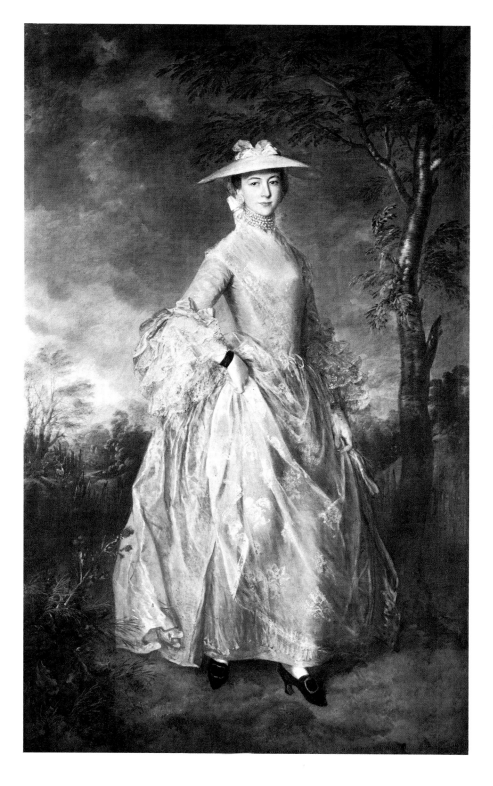

Sheridan (Washington, Mellon Collection), in a similar
pose, becomes one with the surrounding scene, her hair
and scarf blowing in the wind. This sense of communion
with Nature already expresses a distinct Romanticism.
Gainsborough's range of expression is considerable, and
he was equally capable of conveying the look of keen
intelligence and concentration on the face of his friend the
composer *Carl Friedrich Abel*, in the splendid picture in
the Huntington Art Gallery at San Marino, California.

The 'fancy pictures' of Gainsborough's last years, as
Ellis Waterhouse has remarked, are often like 'close-ups
of the smaller figures which had previously appeared in
his landscapes . . . the rustic inhabitants of an ideal
Arcadia.' Their colouring, especially in an example like
Haymaker and Sleeping Girl (Ill. 153) (Boston, Museum
of Fine Arts), is as high-keyed as a Fragonard, nostalgic,
and quite unrelated to the real world of agricultural
labour. Perhaps no one would quarrel with the applica-
tion of the Rococo label to such a picture. But the pathos
of *Peasant Girl gathering sticks,* in the University Gallery at
Fredericton, New Brunswick, or of *Cottage Girl with dog
and pitcher* in Sir Alfred Beit's collection at Blessington,
partakes of a different ethos – that of Rousseau and *The
Man of Feeling,* the novel by Henry Mackenzie, pub-
lished in 1771, which in English literature marked the
beginning of the age of sentiment, a phase of early
Romanticism. The notion of the superior moral qualities
of the peasant's life, to which Rousseau gave such clear
expression, and the cultivation of the language of the
heart, so characteristic of writers as different from one
another as Goldsmith, Sterne, the young Goethe, and
Bernardin de Saint Pierre, and of painters as various as
Greuze, Gainsborough and George Morland, provide
strong links between the worlds of the Rococo and early
Romanticism.

Gainsborough's great contemporary and rival Sir
Joshua Reynolds is usually thought of as a classicist.
Certainly, his theories of art, eloquently expressed in the
Discourses which he delivered to the Royal Academy
during the long period of his presidency, from 1769 to
1790, continually emphasize the basic Neo-classical
doctrine that the artist should represent not common
nature, but an ideal beauty freed from all 'accidental
deficiencies, excrescences and deformities of things'. The
noblest kind of art, he taught, was History painting in

153 THOMAS GAINSBOROUGH
(1727–88) *Haymaker and Sleeping
Girl, c. 1785. Oil on canvas, 7′ 4″ ×
4′ 9″ (223.5 × 144.5). By courtesy
of the Museum of Fine Arts, Boston,
Mass.*

the Grand Style. Since circumstances obliged him to earn his living by portraiture, he tried to elevate this comparatively servile trade by incorporating into the portrait some elements of the ideal. He began to apply this notion in the 1750s, when his full-length portrait of *The Hon. Augustus Keppel* (Greenwich, National Maritime Museum) placed the subject in the pose of the *Apollo Belvedere*. The effect of this picture is nevertheless not in the least classical; on the contrary, the Titianesque setting of a rocky shore with stormy sea and sky, and the dramatic lighting, create a distinctly Romantic effect. A few years later, he gave *Elizabeth, Duchess of Hamilton and Argyll* (Port Sunlight, Lady Lever Art Gallery) a more successfully semi-historical or allegorical character: the composition is restricted to a shallower and more relief-like space; the lady wears her peeress's robe of ermine over a sort of classical gown; she leans on an apparently classical marble relief of *The Judgment of Paris*, and is accompanied by a pair of doves, attributes of Venus. In the process, unfortunately, much of this noted beauty's real personality is lost. Still later, and especially during the seventies, Reynolds frequently represented his female sitters in character as Juno, Hebe, St Cecilia, Venus and so on. Such pictures have been described as belonging to Reynolds's classical phase, but his 'classicism' is far from pure. In one of the most superb examples of this period, *Jane, Countess of Harrington* (Ill. 154) (San Marino, California, Huntington Art Gallery), the subject does not personify any goddess, but her garments, the architectural accessories, and the relief-like limits of the composition may be called Neo-classical. On the other hand, the complex patterns of curves in the draperies, the ostrich feathers in her hair, and the gesture of her hand are in the Baroque tradition, while the background landscape with its windy sky is already Romantic.

154 SIR JOSHUA REYNOLDS (1723–92) *Jane, Countess of Harrington*, 1777. Oil on canvas, 7′ 9″× 4′ 9″ (235 × 145). Henry E. Huntington Library and Art Gallery, San Marino, California

In one of his greatest 'classical' pieces, *Three Ladies adorning a Term of Hymen* (London, National Gallery), painted in 1774, the principal curves of the composition create an unmistakably Rococo rhythm, and traces of the influence of the Rococo spirit can be detected elsewhere. For instance, his portrait of *Mrs Lloyd* (Rushbrooke Hall, Lord Rothschild) inscribing her lover's name on a tree, is almost identical in conception with Fragonard's *Le Chiffre d'Amour* (London, Wallace Collection). Most strikingly, in a number of his later portraits of ladies,

191

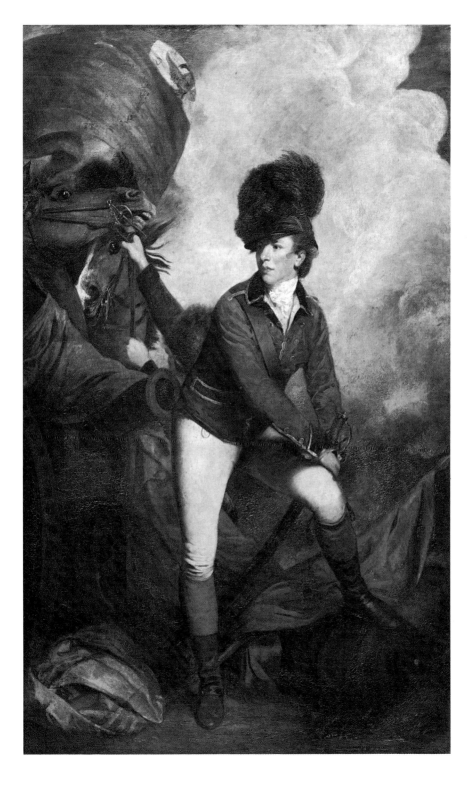

culminating in the splendid *Lady Jane Halliday* (Waddesdon Manor, National Trust) of 1779, his concern with lightness and movement is hardly less marked than Gainsborough's.

Fortunately, Reynolds painted many pictures which in no sense conform to his own theories, but present the personalities of his sitters in an intimate and straightforward way, without any attempt to suppress the peculiarities of their features or of contemporary costume. Outstanding among these, which occur at all periods of his career, are the *Joseph Baretti* (Holland House, Earl of Ilchester), and the charming *Lavinia, Viscountess Althorp* (Althorp, Earl Spencer), whose exquisite beauty seems as fresh today as in 1782 when she was painted.

In the last decade of his career, Reynolds tended to drop the 'classical' idealization of his subjects for a more Romantic conception. There are some memorable portraits, of great variety: *Mrs Robinson* (London, Wallace Collection) is seen in profile, gazing into a distance consisting almost entirely of sky; *Henrietta, Countess of Bessborough* (Althorp, Earl Spencer) seems to be plotting some witty piece of mischief; and *Lady Caroline Price* (Bath House, Lady Ludlow) is an image of perfect, demure and cool selfpossession. Although his portraits of soldiers and naval commanders rather exaggerate their Romantic vigour and heroism, as in the dashing *Colonel Bannastre Tarleton* (*Ill.* 155) (London, National Gallery), or in the grim and determined *Admiral Lord Rodney* (St James's Palace), Reynolds was also capable of conveying the refined sensibility of his young friend *Sir George Beaumont* (Pride's Crossing, Massachusetts, Miss Helen C. Frick), or the introspective gloom of the old lawyer *Joshua Sharpe* (Cowdray Park, Viscount Cowdray). He was at his greatest, in fact, when he forgot his theories, and was entirely absorbed in the study of the person in front of him.

There are many British artists of the 18th century who are worthy of discussion even in this brief survey, but the others, men like Richard Wilson, George Stubbs, Joseph Wright, Henry Fuseli and George Romney, have even more tenuous connections with the Rococo than Reynolds and Gainsborough, and are best left for a more appropriate context.

The Germanic countries unquestionably produced some of the most resplendent examples of Rococo paint

155 SIR JOSHUA REYNOLDS (1723–92) *Colonel Bannastre Tarleton, 1782. Oil on canvas, 8′ 3″ × 4′ 9″ (221 × 145). By courtesy of the Trustees of the National Gallery, London*

ing, in great palaces and especially in churches. But these
are so essentially a part of the complex union of the arts of
architecture, sculpture and painting that the appropriate
place in which to discuss them is in the last chapter, of
which architecture is the principal theme. In any case,
these developments belonged almost exclusively to the
Catholic south, and had no counterpart in the north. So
far as easel paintings are concerned, the most important
centre was Berlin, where French influence was domi-
nant. A number of French painters settled there,
including Antoine Pesne and Amedée van Loo; while
some of the ablest German artists, such as the engravers
Johann Georg Wille and Georg Friedrich Schmidt
moved to Paris. A great deal of this sort of interchange
occurred, which perhaps explains why the northern
parts of Germany produced comparatively little of
distinctive character. One of the leading Berlin portrait
painters was J. G. Ziesenis, who was of Polish origin,
but whose style was based upon French examples.
Anton Raffael Mengs, later to become one of the
leaders of Neo-Classicism, painted portraits in Dresden
in his youth; they are highly accomplished works, but
there is nothing definably German about them; and
in any case his significant work was all done in Italy or in
Spain. Another Pole, Daniel Chodowiecki, who had
been educated in France, became a prolific, charming and
influential illustrator of books, with a keen eye for the
atmosphere and details of domestic life. And Anton
Graff, of Swiss origin, was the portrait-painter most alert
to individual personality. The most purely German artist
of the period was Johann Tischbein, whose portraits
and conversation pieces reflected the growing importance
of the middle classes. But none of these men, except
Mengs, who belongs to the next period, can be con-
sidered major figures in a European perspective.

CHAPTER ELEVEN
Rococo architecture and sculpture

In its purest form, the Rococo was a style of interior decoration, rather than a language of architectural forms and ideas. All the same, the spirit which inspired the intricate, elaborate and elegant fantasies of rocaille decoration had its consequences also in terms of the design of structures. The decorative vocabulary was French in origin. In the numerous Parisian town houses built in the early decades of the century, in provincial *châteaux*, and even in the buildings erected by Jacques-Ange Gabriel for Louis XV and XVI at Versailles, small and intimate rooms, fitted with numerous mirrors and gilt-edged panels, and surrounded with fine ribbon-like framing terminating in C or S-shaped scrolls became fashionable. The Dutch-born decorator Gilles-Marie Oppenord, the architects Germain Boffrand and Juste-Aurèle

156 GABRIEL GERMAIN BOF-FRAND (1667–1754) *Hôtel de Soubise, Paris, c. 1735–40*

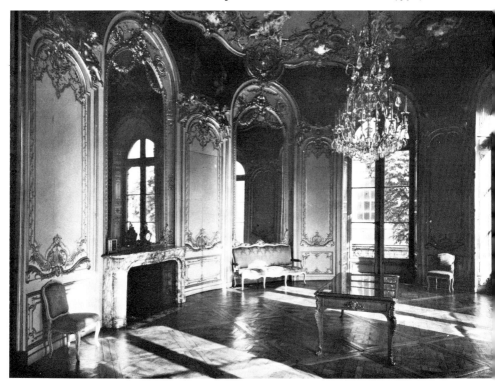

Meissonier contributed most to the development of this style, of which the finest examples are perhaps Gabriel's bedroom for Louis XV at Versailles and Germain Boffrand's interiors of the Hôtel de Soubise (*Ill. 156*) in Paris. The rooms are complicated in shape, rendered still more indefinable by the mirrored reflections, and by the way in which the ornament spreads from wall to ceiling, from doorcase to surrounds, blurring the structural boundaries. Surfaces are alive with activity. Naturalistic plant forms sprout from fragments of fantastic rocky landscape; water falls in cascades or gushes up in fountains; little *putti* or monkeys play with birds; trophies of arms or musical instruments, fruits, flowers or heaps of dead game are scattered incon-sequentially. All is charming illogicality and gaiety.

By the 1730s this style had spread through much of Europe. François Cuvilliés's Amalienburg at Nym-phenburg dates from 1734–39, and the most delightfully colourful of all Rococo schemes is the room from the palace of Portici, now in the Museo di Capodimonte at Naples, decorated with chinoiseries of gaily coloured porcelain from the designs of Giuseppe and Stefano Gricci in 1754–9.

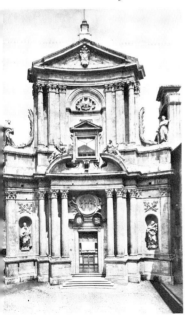

157 CARLO FONTANA (1638–1714) *Façade of San Marcello al Corso, Rome, 1682–3*

To see 18th century architecture, however, primarily in terms of this sort of decoration would be to misunder-stand the real tendencies of architectural thought. It would also give to France a central and dominating position which she did not entirely deserve, for although Italian art was approaching the end of its period of glory, and some of the most superb and original creations of the Rococo belong to the Germanic countries, it was still Italian architecture which, in the first half of the century, provided the essential points of reference. The tendency towards elaboration of ornament, which was inherent in the late Baroque, and which ran riot in the Rococo, was opposed by many adherents of a more ordered and rational style. Alongside Rococo fantasy, the first half of the cen-tury saw many signs of a continued tradition of classicism which prepared the way for the Neo-Classical revival of the end of the century.

In the last years of the 17th century the leading architect in Rome was Carlo Fontana. Although immensely skil-ful and productive, he lacked the highest qualities of architectural imagination. Nevertheless, his studio was of crucial significance since it was the training ground for

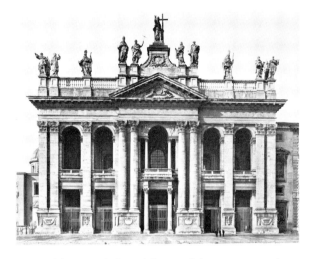

158 ALESSANDRO GALILEI (1691–1737) Façade of San Gio-vanni in Laterano, Rome, 1733–6

many of the most influential men of the next generation, including Gibbs, Hildebrandt and Pöppelmann. Fon-tana's façade of San Marcello al Corso (*Ill.* 157), Rome, built in 1682–3, typifies the tendencies of his style. Based to some extent on Pietro da Cortona's Santa Maria della Pace, it lacks the dynamic power of the earlier work. Whereas Cortona contrasted convex forms in the façade itself with a concave wall behind, in Fontana's church the entire façade is concave. In place of Cortona's robust and simple Tuscan Doric columns in the porch, Fontana used elegant Corinthian ones. A characteristic touch is the substitution of martyr's palms as brackets at the sides of the upper storey in place of the massive volutes of the High Baroque. The whole effect has become lighter, more precise, more decorative.

During the first twenty years of the century very few buildings of consequence were erected in Rome; but when activity revived in the second quarter, the tend-encies already apparent in Fontana became more pro-nounced, in such works as Gabriele Valvassori's Palazzo Doria-Pamphili, Ferdinando Fuga's Palazzo della Consultà, Filippo Raguzzini's Santa Maria della Quercia, and the church of Santa Croce in Gerusalemme by Domenico Gregorini and Pietro Passalacqua. By far the most important building of this period, however, was the new façade of San Giovanni in Laterano (*Ill.* 158), for which a competition was arranged in 1732, won by Alessandro Galilei. His façade, erected in 1733–6, is one

197

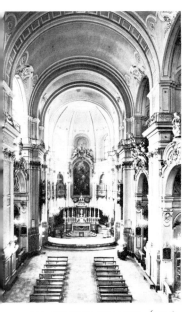

159 FILIPPO JUVARRA (1678–
1736) *Chiesa del Carmine, Turin,
1732–5*

of the most voluminously discussed works of 18th
century architecture, and one of the most difficult to
characterize briefly. Galilei undoubtedly took his cue
from Maderno's façade of St Peter's, repeating the giant
order encompassing two storeys, the central pedimented
feature, and the round-headed openings in the upper
storey, but the effect he achieved is quite different. This is
due above all to the different proportions, higher in
relation to its width than St Peter's. Galilei raised his
giant order on immense decorated plinths; he omitted
Maderno's mezzanine and attic storeys, and enlarged the
openings on the upper floor level so as to impart a strong
upward rhythm, carried on above the entablature by an
irregularly spaced row of colossal statues, mounted on a
high balustrade, the central one of Christ with the Cross
being raised still further on an entirely unclassical curved
pedestal.

The most original architectural developments in Italy,
however, took place not in Rome but in and around
Turin. Guarini's genius was so exceptional that for a
generation after his death in 1683 he seemed to have no
real followers. Filippo Juvarra, born in Messina in 1678
and trained in Rome under Carlo Fontana, proved to be
a worthy successor. With an incredible ease and fluency,
he produced immense quantities of designs for buildings,
town plans and developments, theatrical scenes and decor-
ative works of almost every conceivable kind. As
principal architect to the king from 1714 on, he enjoyed
an unrivalled position and was in great demand by other
European monarchs. Juvarra's buildings seem at first
glance to be in a variety of different styles, according to the
demands of the particular site and function. His Palazzo
Madama at Turin is an adaptation of Versailles; his
churches of Santa Cristina and Sant'Andrea at Chieri
are based upon Roman examples; and this flexibility and
mastery of many architectural tongues is an essential
aspect of his virtuosity. But his originality may be fairly
judged from three works: two churches and one hunting
lodge. The interior of the Chiesa del Carmine (*Ill. 159*),
Turin, built in 1732–5, marks the arrival of a new epoch.
There is a wide nave with three chapels on each side, but
above the high arches leading to the chapels, and in
place of a clerestory, Juvarra introduced another series of
high arched openings giving on to a deep gallery. The
nave is flooded with light through the gallery windows,

and the chapels receive light also from the gallery through oval openings in their ceilings. Space and light flow continuously through the entire interior, the most brilliant focus being in the apsidal sanctuary, provided with its own dome and lantern on the same level as the vault of the nave. The apparent lightness of the structure and the success of these spatial devices make the Carmine the most original Rococo church in Italy.

Juvarra may have been indebted to buildings north of the Alps for some of the ideas which he used at the Carmine. In the case of his grandest ecclesiastical master⁄piece, the Superga outside Turin, built in 1717–31, there can be no doubt that the great monastic churches of Ettal and Melk affected the methods by which he achieved an integration between the church and the monastic buildings behind it. The church itself has a centralized plan under a high drum and dome, but the exterior proportions take into account the entire bulk of the monastery, into which the church is embedded, its wings and twin campanili covering the whole end of the massive rectangular block. The enormous pedimented tetrastyle portico and the immense height of the dome are related, not to the size of the church, but to that of the complete ensemble.

In the secular field, Juvarra's masterpiece is the royal hunting⁄lodge of Stupinigi (*Ill. 160*), built 1729–33. This 'lodge' consists of a great oval domed central salon, brilliantly and lavishly decorated, with four radiating wings, of which two continue, with two turns through

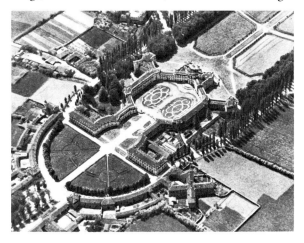

160 FILIPPO JUVARRA (1678– 1736) *Palazzo Stupinigi, near Turin, 1729–33*

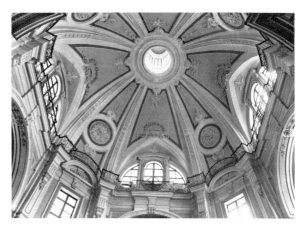

161 BERNARDO VITTONE
(1704/5–70) *San Michele, Rivarolo Canavese, 1759*

angles of sixty degrees, to enclose an immense principal courtyard, and instead of meeting to form a hexagon, turn a third time in the reverse direction to form a second-ary court. The external spaces, including a variety of staircases, connect with interior spaces at many points, and are just as important. Despite its scale, the effect is not one of massiveness. The dome is carried on elegant piers standing free from the walls, with space and light circulat-ing around them both on the ground floor and on gallery level. The brilliant painted decoration is characteristically set off against a white background.

Juvarra's pupil, Bernardo Vittone, whose best works were done in the middle decades of the century, united Juvarra's use of flowing space with Guarini's complex structural systems. Unfortunately, along with his brilliant gifts, he possessed an awkward and irritable temperament, so that he never enjoyed anything approaching Juvarra's success, and almost all his buildings, the most interesting of which are churches, are in minor Piedmontese towns. From his earliest work, the sanctuary church of Vallinotto (1738–9), to late examples such as the Assuntà at Riva near Chieri (1766–7), his plans exhibit an elaborate geometrical inventiveness. They are usually of a Greek cross design inscribed within a circle or an ellipse. The walls at Vallinotto run in serpentine curves round a series of elliptical apses, and, as at Santa Chiara, Bra (1742), appear to be inadequate supports for the dome. Vittone's domes, however, are conceived almost solely as internal features, concealed externally by walls and low-pitched roofs. Inside, they give the effect of nearly weightless

canopies, their surfaces broken up by great arched openings, windows and lantern, and by various types of ribs.
Even the pendentives of the nave dome at Santa Maria in
Piazza, Turin (1751–68), and the ringcornice surmounting them, are interrupted by great cutouts of more
than semicircular form, producing a looping, dancelike
rhythm. At San Michele, Rivarolo Canavese (*Ill. 161*)
(1759) he used delicate wroughtiron balconies running
round the base of the dome in a series of broken lines and
curves, and everywhere he repeated small motifs in
relief, of rosettes, pendants, inverted swags and ribbons,
shelllike forms and foliage, with paintings usually confined to relatively small areas. Of all the Rococo architects, Vittone most frequently brings to mind analogies
with the contemporary music of Vivaldi, Scarlatti,
Pergolesi, Piccinni and others; this is no accident, since
in his writings on architecture, published in 1760 and
1766, he claimed a relationship between architectural
proportions and harmonic intervals.

Luigi Vanvitelli's work occupies a much more central
position in the European development than Vittone's.
He worked in a number of central Italian cities, including
Rome, before being summoned in 1751 to Naples by
Carlo III, in order to build the enormous royal palace at
Caserta, his masterpiece, and the last great palace of the
Baroque and Rococo era in Italy. Its plan, of an immense
rectangle divided midway into four courtyards, is

162 LUIGI VANVITELLI (1700–
73) *Grand staircase in the Palazzo
Reale, Caserta, begun 1752*

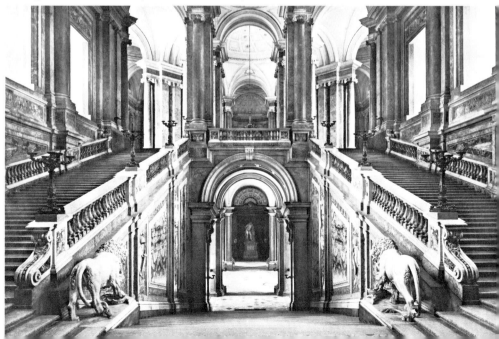

basically simple, but from three internal octagons, diagonal vistas open upon the courtyards. The climax of the design is provided by the great staircase (*Ill. 162*) rising from the central octagon, dividing into two upper flights at a landing, and ascending to an upper octagon with a spirally coffered dome, and vistas in every direction. It is a stage-set on a grandiose scale for the pageantry of Neapolitan court life. Vanvitelli was himself a prolific designer of theatrical scenes, but the style of his concep-tions must owe a good deal to the most successful and influential family of Italian theatrical designers, the Galli di Bibiena, whose services were sought by all the courts of central Europe. Vanvitelli's style is a transitional one between the late Baroque tradition and the Neo-Classical revival. If Caserta looks backwards in rivalry with Versailles, it is also planned with a geometric rigour which belongs to the age of the Enlightenment. In its vistas, its use of continuous interconnected spaces, its scenographic devices of screening arches, and its concern with effects of light, it is still in the line of descent from the Baroque; but in the simplicity of its exterior (it was originally to have had a high central dome and corner towers which were never built), and in the severity of its decoration it heralds the age of Neo-Classicism, to which, in fact, the surviving furnishings and decorations mostly belong.

We cannot leave Italy without a mention of the importance of exterior staircases, such as those which ascend to the impressive churches of Noto and Modica in southeastern Sicily, rebuilt on hilltops after the destruction caused by the earthquake of 1693. The most justly re-nowned of such staircases is, of course, the Spanish Steps in front of Santa Trinità dei Monti in Rome, by Fran-cesco de Sanctis and Alessandro Specchi – a graceful composition of contrasting curves both in the steps and in the balustrades of the landings. Their light rising rhythms, punctuated by the oval fountain at the bottom and the obelisk at the top, are a perfect expression of the Rococo delight in spatial flow.

Although the Baroque reached the countries of central Europe only after 1683, it found an interpreter of remarkable power in J. B. Fischer von Erlach. Trained first as a sculptor, and then as an architect in the Roman studio of Carlo Fontana, he developed a style in which a sculptural use of mass, and an admiration for Roman

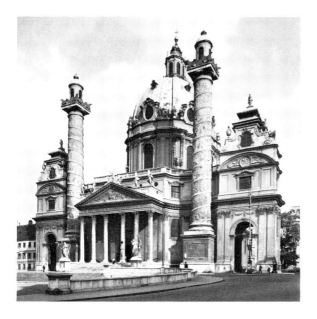

163 JOHANN BERNHARD FISCH⟨
ER VON ERLACH (1656–1723)
Karlskirche, Vienna, 1715–33

antiquities are equally evident. As court architect in
Vienna from 1704, he was called upon to design build⟨
ings of an imperial grandeur which is still Baroque. His
qualities and deficiencies are apparent in his greatest work,
the Karlskirche (Ill. 163) in Vienna, commissioned by
the Emperor Charles VI in 1716 after the city had re⟨
covered from an epidemic of the plague. It is easy to
criticize this building for the lack of integration between
its elements, and for an over⟨emphatic pomp. The
immensely wide façade, with its portico inspired by the
Pantheon, its concave wings with two colossal historiated
columns imitated from Trajan's in Rome, and the two
triumphal arches carrying rather peculiar towers at the
ends, is connected with the nave only in the centre, behind
the portico. All the elements of the plan, indeed, seem to
be based upon different geometric figures, yet everywhere
there is a striking force of conviction, especially in the
dome on its high drum. Externally the grouping of the
forms is picturesque and highly effective. Fischer's
secular buildings, the façade and grand staircase of the
Stadtpalais, the Schönbrunn palace, and the Hofbiblio⟨
thek (the last two completed by his son, Joseph Emanuel),
are no less important, and claim a place among the
grandest examples of late Baroque architecture.

203

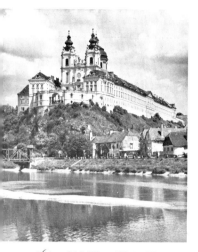

Fischer's greatest rival was the Italian-born Johann Lukas von Hildebrandt, also trained under Carlo Fontana. While serving as a military engineer with Prince Eugene's army in Piedmont in 1695–6, he must have had an opportunity of studying Guarini's work; and Hildebrandt's best-known church, the Piaristen-kirche in Vienna (designed in 1698 but built 1715–21 and later altered) is planned on a Guarinesque system. The complex interplay of convex and concave forms gives an undulating effect to the interior walls. Whereas Fischer's architecture seems to result from an additive process, Hildebrandt's is the product of a dynamic spatial sense; and it is really Hildebrandt who provided the starting point for the splendid development of the Rococo in central Europe.

The most original of Hildebrandt's palaces is the Upper Belvedere (*Ill. 165*) in Vienna, built for Prince Eugene between 1700 and 1723. The long façade of twenty-seven bays is composed of a high central block of three wide bays, set back behind an arcaded portico of entirely unclassical design, leading into the staircase hall; on each side of this are slightly lower blocks of five bays with attic storeys and pitched roofs behind an elegant balustrade; beyond these again are two lower wings of four bays, and at the ends two domed octagonal pavilions. The unity of the whole, however, is attained by the continuous line of the main entablature and cornice, by the rhythmic fenestration, and by the flattening of the elements into surface decoration.

Jakob Prandtauer, with whom the Austrian Rococo became fully naturalized, was a man of a very different type from these highly educated court architects. Trained as a mason, he was in his forty-second year when he entered the field of architectural design. His masterpiece is the great abbey and church of Melk (*Ill. 164*) on the Danube, built in 1702–24. The site, on a high ridge above the river, provided a wonderful opportunity to which Prandtauer rose magnificently. The two long

164 JAKOB PRANDTAUER (1660–1726) *Abbey and church, Melk, 1702–24*

165 JOHANN LUKAS VON HILDE-BRANDT (1668–1745) *Upper Belvedere, Vienna, 1700–23*

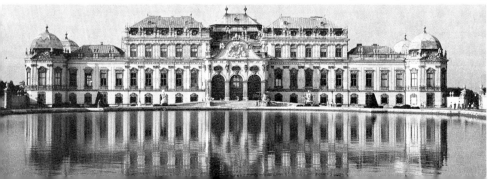

wings of the monastic buildings end towards the river in pavilions linked by a low curved gallery to form a court, at the rear of which rises the church, with its twin campanili and high dome. The interior, however, was completed and decorated by other artists; and for the culmination of the Rococo church interior we have to turn to the Germans.

The extraordinarily brilliant flowering of Rococo church art in Germany was in the main the achievement of about half-a-dozen artists born in the last decades of the 17th century. Their works are without parallel elsewhere in the frothy exuberance of their interior decoration, in which the arts of architecture, sculpture and painting are completely fused, and in the ingenuity of their spatial planning. The monastic church of Weltenburg (*Ill. 166*) in Bavaria, built in 1717–21 by Cosmas Damian Asam, is a transitional work, still comparatively simple in plan. It consists of an oval nave with chapels in niches on the diagonals and in the centres of the long sides, an oval vestibule, and an oblong choir and sanctuary. The Berninesque forms are reinforced by the deep, rich colouring, but the effect of the interior is dominated by the sculpture, which is presented with consummate theatrical skill. In the focal position on the high altar, against a frescoed background and lit by concealed windows, is an equestrian group of St George killing the dragon, by Egid Quirin Asam, the architect's brother. As the light strikes its gilt and silvered surface, the group appears like a radiant vision, riding into the church. The effect is heightened by the fact that the dragon and the rescued princess are painted in bright naturalistic colours. On either side, and a little in front, between enormous twisted columns, stand figures of St Martin and St Maurus. The latter gazes ecstatically at the vision, while the former – perhaps the supreme masterpiece of German Baroque sculpture – makes a grand gesture towards the congregation. The whole ensemble seems charged with intense religious fervour.

Several of the greatest of the South German church builders of the 18th century were trained in other crafts than architecture. Cosmas Damian Asam was a fresco painter; Dominikus Zimmermann a stuccoist. The latter's two most famous churches, the small country pilgrimage churches of Steinhausen (*Ill. 167*) in Upper Swabia, and Die Wies near the Austrian border south-

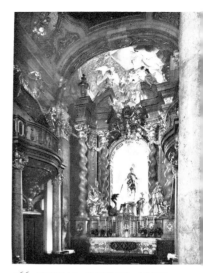

166 COSMAS DAMIAN ASAM (1689–1739) *Abbey Church, Weltenburg, 1717–21. High altar by Egid Quirin Asam (1692–1750), 1721–4*

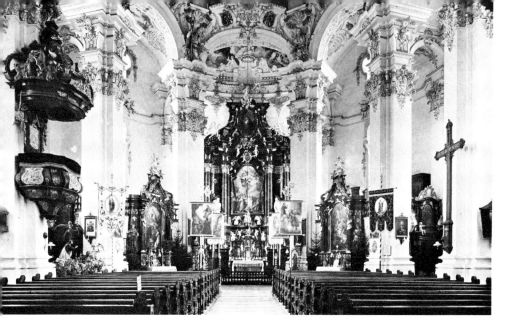

167 DOMINIKUS ZIMMERMANN
(1685–1766) *Pilgrimage Church,*
Steinhausen, c. 1727–35

west of Munich were built respectively in 1727–35 and
1746–57. Neither is very remarkable externally; only in
the interiors is Zimmermann's genius apparent. In both
cases the principal feature of the plan is an oval, which at
Steinhausen forms the entire interior except for the
sanctuary, which is a smaller transverse oval. The wide
ambulatory, through which the pilgrims circulated,
passes behind slender piers supporting the vault. Between
them, the arches rise on top of the interrupted entablature,
admitting a flood of light from two tiers of windows. Over
these arches, a fanciful stucco balustrade dances a sort of
minuet round the vault, frescoed by Johann Baptist
Zimmermann, the architect's brother, and representing
the four Continents and a host of angels paying homage
to the Virgin among clouds. It is a kind of celestial *fête
champêtre*, with a formal garden around the Fountain of
Life in the central position above the High Altar. Asam's
massive forms, depth of colour and tricks of lighting
have here given way to a more evenly lit and brighter
effect, in which the emphasis is rather upon the activity of
light, line and surface.

Of the many churches in the fully developed Rococo
style, designed by Johann and Kilian Ignaz Dientzen-
hofer, Johann Michael Fischer and others, Balthasar
Neumann's Vierzehnheiligen (*Ill. 168*) may serve as an
example. The façade is of surprising height, with two tall

campanili and two principal storeys each with two rows
of windows, thin pilasters and a central aedicule with a
pediment resting on two columns. The exterior is so
restrained that the visitor is unprepared for the astonishing
experience of the interior, into which light floods through
windows on three levels, back-lighting the series of piers
with coloured scagliola columns and pilasters which
support the vaults. On each side, every bay between these
piers is of a different form, some seeming to advance into
the central space, others to withdraw from it, and the
piers themselves twist and turn. Everything seems to be in
motion. Lengthwise, the plan is centred upon the shrine
of the fourteen saints, midway between the door and the
high altar, in the largest oval space. The first portion of the
nave and the choir and sanctuary are two smaller
longitudinal ovals, but as one passes the shrine, the
circular spaces of the transeptal chapels become visible.
Where this system of lengthwise ovals meets, at the
crossing and between the first and the central parts of the
nave, there is a superimposed system of transverse ovals,
further complicated in the nave by a pair of small
longitudinal side chapels. The regular diagonal pattern-
ing of the floor gives no assistance in understanding the
structural system; and the vaulting in fact contradicts it,
inasmuch as the main vaults of the nave and choir extend
over the crossing, leaving it with no vault of its own, but
instead a pair of arches curving in three dimensions to

168 BALTHASAR NEUMANN
(1687–1753) *Pilgrimage Church,
Vierzehnheiligen, near Bamberg,
1743–72*

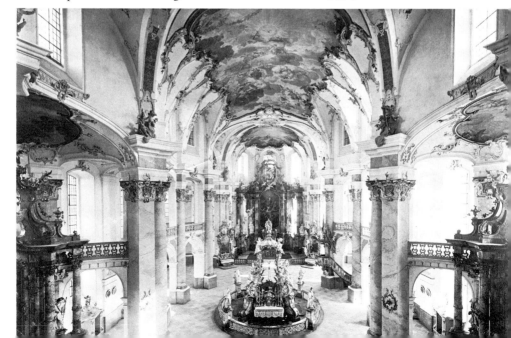

make delicate contact in the centre. The ceilings are painted with frescoes within elegantly curved mouldings surrounded with exquisite Rococo scrolls in stucco. The sculptures of the central shrine, pulpit and high altar were executed by the brothers Johann Michael and Franz Xaver Feichtmayer from designs by Neumann's pupil Jakob Michael Küchel. They exhibit an elaborate fantasy which has few parallels in church art. The total effect of the interior is of a series of connected spaces, with no element wholly autonomous.

In its last phase, the German Rococo church tended to lose this spatial flow, as in Johann Michael Fischer's church at Rott-am-Inn (1759–63), which, however, is distinguished by its outstanding decorations, in painting by Matthäus Günther, and in sculpture by Ignaz Günther (*Ill. 169*), whose painted and gilt wood figures, with their attenuated forms, their expressions of devotion, ecstasy or religious anguish, and their fluttering draperies, are related both to the mediaeval tradition of peasant art and to the Rococo world of aristocratic fantasy.

The union of the arts is a feature also of Rococo palaces. Nowhere have architecture and sculpture been more happily integrated than in the Zwinger (*Ill. 170*) at Dresden by Matthäus Daniel Pöppelmann. Augustus the Strong, Elector of Saxony, got Pöppelmann to erect a temporary wooden ceremonial amphitheatre for the occasion of a state visit in 1709. Wishing to replace it with a permanent structure, he sent Pöppelmann off to Vienna and Italy to gather ideas. The building which resulted, however, is of complete originality. Essentially, the Zwinger is a vast open-air arena surrounded by a series of two-storeyed pavilions linked by single-storeyed galleries, and entered through gateways of open two-storeyed structures crowned with onion-shaped domes. Because the galleries were intended to house the Elector's art collection, painting does not join company with the sister arts; but the exuberant sculptured decoration proliferates, ignoring all structural logic. Walls as such scarcely exist. In the pavilions, piers, columns, pilasters and caryatid herms are thickly clustered, in contrast with the galleries, which are practically all windows; the balustrades which top the galleries give way on the pavilions to fantastic accumulations of coats of arms, figures, gigantic masks and urns; the segmental pediments are broken, and the parts sometimes reversed. Perhaps no

*169 IGNAZ GUNTHER (1725–75)
St Kunigunde, Rott-am-Inn, 1761–3*

building has ever so marvellously conveyed an effect of richness and gaiety.

The French influence, which Pöppelmann so completely avoided at Dresden, was of considerable importance both in Bavaria and in Prussia. The Elector Max Emanuel of Bavaria sent Joseph Effner to study in Paris under Boffrand. When the Elector and his architect went to Bavaria in 1715, they proceeded with the building of the palaces at Schleissheim (1715–27), including the splendid staircase, and at Nymphenburg (1716–28), both rather French in manner. Effner was later replaced by the Flemish dwarf François Cuvilliés, originally a military architect, whom the Elector had also sent to Paris to study with Jacques-François Blondel. It was Cuvilliés who created the most exquisite Rococo secular building, the pavilion known as the Amalienburg (*Ill. 171*) in the grounds of Schloss Nymphenburg. The exterior is of a grace and refinement which are certainly indebted to his French training, though the separation of the vestigial curved pediments from their windows by Rococo carved ornaments, and the festoons and pendants between the pilasters on either side of the door, are more whimsical than anything the French would have thought appropriate to an exterior situation. The inside, especially the circular Hall of Mirrors in the centre, has the most exquisite delicacy, elaboration and refinement. The walls offer a continuous series of oval-topped mirrors, interrupted only by doors and windows. Their wooden surrounds are carved with a profusion of plants, figures, animals and birds, cornucopias and musical instruments, all silver-gilt in contrast to the cool blue background. An undulating cornice marks the transition from walls to ceiling, which, apart from some more trees, plants, figures and birds around its lower edge, is painted the same watery blue. All this detail is perhaps more naturalistically treated, and in bolder relief, than anything by Boffrand or Robert de Cotte, but its French inspiration is clear.

The style of the interiors created at Charlottenburg and in Sanssouci at Potsdam by Georg Wenceslaus von Knobelsdorff for Frederick the Great in the middle of the century is also predominantly French. But the culmination of German secular interior decoration, in the Residenz of the Prince-Bishop of Würzburg, built by Balthasar Neumann between about 1719 and 1744, owes quite as much to Austrian, and ultimately Italian in-

170 MATTHÄUS DANIEL PÖPPELMANN (1662–1736) *The Stair Pavilion, The Zwinger, Dresden, 1711–22*

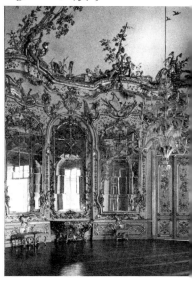

171 FRANÇOIS CUVILLIÉS (1695–1768) *Hall of Mirrors in the Amalienburg, Schloss Nymphenburg, Munich, 1734–9*

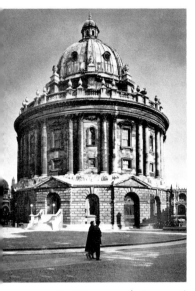

fluences as to French. Neumann had begun his career as a military engineer, and when first commissioned to build the Residenz had not yet proved himself as an architect. He was sent to Vienna and to Paris, to consult Hilde brandt, Robert de Cotte and Boffrand. Hildebrandt's influence is apparent in the external façades and in some of the interior planning, but if the decorative vocabulary is French, the series of exciting spatial sequences, of which Neumann showed his mastery not only at Würzburg but also at the palaces of Bruchsal (1731, des troyed) and Brühl near Cologne (1744–8), derived from the Italian tradition descending through Hildebrandt from Juvarra, Guarini and Borromini. In the great staircase at Würzburg, Neumann's ingenuity in terms of engineering is no less remarkable than in his church of Vierzehnheiligen; but the effect, as one ascends from the lobby below into the brilliant light of the reception area at the top, is of majestic lucidity, enhanced by Tiepolo's frescoes on the ceiling, which seem to open the building to the sky. The grand saloon or Kaisersaal (*Ill. 140*), an irregular octagon with high coving pierced by oval windows, is a marvel of delicate and sumptuous decor ation. The multicoloured marble columns and the glittering arabesques of the stucco-work by Antonio Bossi support the gorgeous colouring of Tiepolo's frescoes between the ribs of the coving and in the centre of the ceiling. Neumann and Tiepolo were indeed perfectly matched. The way in which the figures from Tiepolo's scenes of the betrothal of Beatrice of Burgundy to the Emperor Frederick Barbarossa in the coving spill out at the sides into the spaces below the windows, and the device of stucco curtains held up by flying *putti* to expose the upper parts of the painting, are an exact counterpart to Neumann's methods of connecting spaces and surfaces. Similarly, clouds, draperies and the legs of some of the figures spread from the central ceiling fresco over the elegantly shaped frame, in places seeming to cover the Rococo scrollwork, elsewhere to pass between it and the white painted background. This illusionism no longer expresses religious emotion, but triumphantly displays virtuosity and wit for the sake of sheer delight.

In other countries the Rococo had much less import ance. In England, even before the new French style of decoration had exerted its influence, the Palladianism of Lord Burlington, Colen Campbell and William Kent

had firmly established a tendency towards classicism. Palladianism, in its turn, formed a ready basis for the later development of Neo-Classicism in the latter half of the century. The principal exception to this sequence was the Scot James Gibbs, who had studied with Carlo Fontana in Rome, and admired the English Baroque of Wren. His first important work, the church of St Mary-le-Strand in London, built 1714–17, is clearly indebted to the later Roman Baroque, except for the somewhat eccentric high steeple-like spire inspired by those of Wren's City churches, above the centre of the pedimented front. At St Martin-in-the-Fields (1722–6), where this feature is repeated, the exterior of the main structure is decidedly more Palladian, but inside, despite the simplicity of the plan, there are features which produce an almost Rococo effect. The graceful curves of the nave and aisle vaults, and the rhythms of the plaster decoration have a lightness and grace which Gibbs did not often attain. His later works, especially the Radcliffe Camera (*Ill. 172*) at Oxford (1737–49), return to a Roman gravity and massiveness. This design, of two concentric cylinders, the smaller one higher and domed, has a transitional character: it is at once the last Baroque building of consequence to be erected in England, and a forerunner (particularly in the massive rusticated treat-ment of the lowest storey, with its alternating iron-gated, pedimented doorways and empty niches) of the severe Neo-Classicism of George Dance in the next generation.

William Kent, the friend and protégé of Burlington, also seems to move directly from a Baroque grouping of masses in his exteriors, and a rich and heavy, somewhat Italian Baroque style in his earlier interiors and furniture, to the antique Roman solemnity and pomp of the great hall at Holkham (*Ill. 173*) (begun 1734). The principal impact of the Rococo came late, and affected principally interior decorations, furniture and the minor arts; examples are the profuse and elaborate high-relief work in stucco by Lightfoot at Claydon House, Bucking-hamshire (1752–68), and the furniture of Thomas Chippendale, whose book of designs entitled *The Gentleman and Cabinet Maker's Director*, published in 1754, included many adaptations from French Rococo ideas, as well as essays in the Chinese and Gothic tastes. Curiously enough, Kent participated in England's most important contribution to the Rococo, a new style of

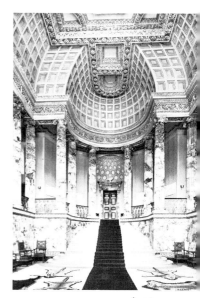

173 WILLIAM KENT (1685–1748) *Great Hall of Holkham Hall, Norfolk, begun 1734*

landscape gardening. English taste generally inclined towards buildings that were geometrically ordered and classical, but preferred gardens to be 'natural'. By 1740 when Lancelot 'Capability' Brown was appointed gar- dener to Lord Cobham at Stowe, where he collaborated with Kent, the old type of Baroque garden, which im- posed a formal layout upon unruly Nature, was replaced by a freer kind of design with winding paths, undulating surfaces and irregularly planted clumps of trees, based upon the ideal landscapes of Claude Lorrain and Gaspard Dughet. Brown's doctrine was that 'Nature abhors a straight line'. The design of a park was so contrived as to provide a succession of surprises, often featuring little classical temples, hermit's grottoes, rustic cottages, Gothic ruins or Chinese summer-houses, which revealed themselves in the course of a perambulation. This conception of the landscape park became tremen- dously influential not only throughout Britain but also abroad. The Picturesque, as it came to be called, belongs partly to the Rococo, in its devotion to the S-bend and its connected spatial sequences; partly to Neo-Classicism, in its aim of recalling the golden age of Virgilian pastoral; and partly to the earliest phases of Romanticism, in its genuine love of natural beauty. It influenced even the Palladians, as in the planning of the Circus and Royal Crescent at Bath by John Wood the elder and his son, or in one of the finest picturesque gardens at Kew (un- fortunately much altered in the 19th century) by Sir William Chambers.

Equally transitional was the Gothicism of Horace Walpole's Strawberry Hill, built between 1747 and 1776, where pseudo-Gothic tracery, canopies, crockets and other details derived from late mediaeval tombs, chantries, etc. were applied to niches, bookcases, walls and ceilings without regard to structure, and with a thinness and flatness which brings them closer to Rococo ornament than to the serious Gothic Revivalism of the 19th century, of which, however, it was a significant forerunner.

In Spain, the principal architects employed by the court in the first half of the century were Italians. The Royal Palace of La Granja near Segovia was begun by a German and continued by Giovanni Battista Sacchetti, who also continued Juvarra's work on the Royal Palace in Madrid, with a very restrained exterior, though the

interior decorations, for instance the ceiling of the grand staircase, are in a somewhat flamboyant late Baroque manner. But the distinctively Spanish Churrigueresque style, briefly described earlier, was continued well into the 18th century by such artists as Narciso and Diego Tomé, who built the University of Valladolid, and by Pedro de Ribera in the façade of the Provincial Hospital in Madrid. It reached its climax in Luis de Arévalo's sacristy of the Cartuja at Granada, and in the façade of the cathedral of Murcia by Jaime Bort Melia, both dating from about 1740. Narciso Tomé's famous Trasparente in Toledo cathedral, a construction of multi-coloured marble and bronze, with illusionistic concealed lighting, is a distant descendant from Bernini's Cathedra Petri, which abandons all the restraint which even the High Baroque exercised; but in its energy of relief it remains nearer to the Baroque than to the Rococo. Without the intervention of any distinctively Spanish phase of Rococo, architecture moved after the foundation of the official Academia de Bellas Artes in 1752 straight into Neo-Classicism.

In Portugal, the most notable buildings, such as the palace-monastery of Mafra, begun in 1717 by the German-born and Rome-trained architect Joào Frederico Ludovico, or the church of São Pedro de los Clerigos in Oporto by the Italian Niccolo Nasoni, can only be described as late Baroque. The Royal Palace at Queluz, however, and a number of lesser country houses and villas have a distinctive Rococo charm. The greatest achievements of the Iberian late Baroque architecture, of course, resulted from the vast building operations in the New World, where, in churches, cathedrals and monasteries in Brazil, Peru, Ecuador, Colombia and Mexico the Baroque found an exuberance and freedom which it had hardly enjoyed anywhere in Europe.

In Russia, on the other hand, the Rococo flourished in the great palaces built for the Empress Elizabeth by Bartolommeo Rastrelli, son of an Italian sculptor brought to St Petersburg by Peter the Great in 1716. He had studied in Paris under Robert de Cotte, but his best works, the palace of Tsarskoe Selo (*Ill. 174*) (1749–56) and the Winter Palace (1754–62) at St Petersburg, show a degree of fantasy in their immense exterior façades, built of brick and painted turquoise and white, which is entirely un-French. His passion for windows led him even

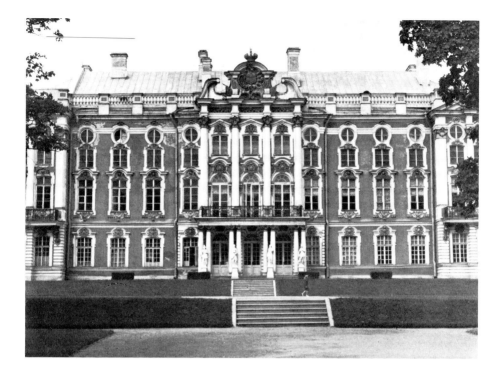

174 BARTOLOMMEO RASTRELLI
(1700–71) *Imperial Palace at Tsar-*
skoe Selo (Pushkino), near Lenin-
grad, 1749 56

to interrupt the entablatures below the pediments at
Tsarskoe Selo with a series of circular lights; and his
interiors, with their profusion of gilded stucco ornament,
mirrors and painted ceilings, are carried out with an in-
ventiveness and conviction which are closer to the Ger-
man than to the French Rococo.

Rastrelli was undoubtedly one of the greatest architects
of his age, capable of creations like the cathedral of
St Andrew at Kiev, and the Smolny Convent at St
Petersburg, which are as impressive as the great churches
and monasteries of south Germany and Austria, but dis-
tinctively Russian. As in Spain, however, the foundation
of an Imperial Academy in 1758, with all the most
important professorships held by Frenchmen, led to the
introduction of classicism and the end of the brief but
brilliant phase of the Rococo.

In spite of the vast quantity of sculpture produced in the
18th century, much of it reaching a very high level of
technical competence, the period did not produce any of
the supreme masters of the art. In Italy, a prominently
placed piece such as the *Neptune* on the Trevi Fountain in
Rome, by Pietro Bracci, is adequate to its decorative

214

function, in a light-hearted and very lively style, but not more; and sculptors like Antonio Corradini and Francesco Queirolo, whose best-known works are in the Capella Sansevero at Naples, seem to have been concerned primarily with displays of astonishing but essentially meaningless technical virtuosity. Unexpectedly, the sculptor of greatest originality appeared in Sicily. The best works of Giacomo Serpotta decorate two small oratories in Palermo. The earlier of them, that of San Lorenzo (c. 1687–96) has pictorial reliefs illustrating episodes in the life of the saint, great numbers of *putti* floating on clouds which project from the walls, and allegorical figures of virtues standing on pedestals, in a somewhat Roman Baroque manner. In the Oratory of San Domenico (*Ill. 175*) (1714–17) his style has changed considerably. The walls are again covered with figures which seem to set the entire interior in motion, but this scheme is notable chiefly for the niched figures of Virtues, whose operatic air does not altogether conceal an inner seriousness. They are certainly among the masterpieces of Rococo sculpture.

175 GIACOMO SERPOTTA (1656–1732) *La Forza, Oratorio del Rosario di San Domenico, Palermo, 1714–17. Stucco*

French Rococo sculpture did not aim, like the German, at depicting religious agony and ecstasy. The most representative figure is that of Etienne-Maurice Falconet, a pupil of Jean-Baptiste Lemoyne, the outstanding portrait sculptor of the previous generation. Falconet became director of the Sèvres porcelain factory in 1757, through the influence of Mme de Pompadour. Some of his Sèvres pieces followed designs of Boucher, but in his independent work, such as the beguiling *Baigneuse* (*Ill. 176*) now at Waddesdon Manor, he achieved a cool elegance of line and a refinement of form which are as much early indications of the tendency towards Neo-classicism as examples of Rococo taste. From 1766 until 1778 he was in Russia; his most important work there, the great bronze equestrian statue of Peter the Great in Leningrad, has a quite different heroic quality which relates it to the forerunners of Romanticism. Edmé Bouchardon, a somewhat exceptional figure in the first half of the century, had kept alive the tradition of French classicism. He spent ten years in Rome, and made several bust-portraits entirely in the antique manner, without wigs and in classical costume; his equestrian statue of *Louis XV* (destroyed in 1792) was modelled on the *Marcus Aurelius*, and his *Fountain of the Seasons* in the

176 ÉTIENNE-MAURICE FALCONET (1716–91) *Baigneuse, 1757. Marble. Louvre, Paris*

Rue de Grenelle in Paris is based upon other Roman prototypes. A little of Bouchardon's severe Romanism was mixed with a great deal of Rococo charm in the work of Jean-Antoine Houdon and Claude-Michel Clodion. Houdon was devoted primarily to the portrait, and to catching the fleeting expressions of the face, as in his bust of *Voltaire*, in the Museum at Gotha; but in statues such as his famous *Diana* (Lisbon, Gulbenkian Collection) his classicism was much closer to the Mannerism of the 16th century than to the style of antiquity. Many of Clodion's most engaging works are in terracotta; the draperies and accessories are modelled with great freedom, and with telling contrasts between bubbling scrolls of hair and smooth, seductive surfaces of flesh.

In Britain, the leading sculptors of the first half of the century were the Flemings John Michael Rysbrack and Peter Scheemakers, and the Frenchman Louis François Roubiliac. Their prolific output of statues, reliefs, portrait busts, funerary monuments, chimney-pieces, etc., brought to England a technical mastery which makes most native work of the previous generations look primitive; but their styles were essentially eclectic blends of international late Baroque with some classicizing tend-encies. There was no considerable sculptor working in a purely Rococo style.

In the last decade of the 18th century, European society suffered a series of upheavals and transformations, the consequences of which brought to an end the aristocratic patronage of art which had largely determined the nature of the Rococo style. Revolutionary fervour, patriotism, and the support of newly powerful middle classes of in-dustrialists, merchants, bankers, mine-owners and agri-culturists, led to different forms of art. The tradition which began with Carracci and Caravaggio, Rubens and Bernini, lost its adherents; the new artists worshipped, generally speaking, at different altars. The change of direction was less radical than elsewhere in a country like Britain, where the middle class had already achieved social and political significance, and much that was most characteristic of the art of the period of Neo-classicism and Romanticism developed from beginnings in British art of the 18th century. But even in England, the feeling of having come to the end of a phase of history was expressed by Sir Joshua Reynolds in his fourteenth Discourse, on the art of Gainsborough, delivered after that painter's death in 1788. Reynolds felt unable to praise any Italian painter of his own time, and sadly referred to Andrea Sacchi and Carlo Maratti as 'truly . . . ULTIMI ROMAN-ORUM'. He nowhere gave any indication that he was even aware of the art of Tiepolo or Solimena, but he dis-approved of the forerunners of Neo-classicism, Pompeo Battoni and Raffael Mengs, and predicted that 'how-ever great their names may at present sound in our ears, (they) will very soon fall into . . . what is little short of total oblivion.' History was to prove him wrong, but his attitude reveals very clearly the gap which separated the end of the Baroque tradition from the beginnings of the Neo-classical and Romantic period.

Bibliography

The following select list of books recommended for further reading is mostly confined to works available in English; books in other languages are included only where little or no literature is available in English. Periodical articles and catalogues of museums and exhibitions are not listed; for periodical literature, the student should consult the *Art Index*. Many of the works here listed contain extensive and more detailed bibliographies of their special fields.

With the exception of Sections I and II, the lists are arranged to correspond with the subjects dealt with in each chapter of this book.

I GENERAL

L. Andersen, *Baroque and Rococo Art*, 1969; G. Bazin, *Baroque and Rococo*, 1964; *The Baroque*, 1968; A. Burgess and F. Haskell, *The Age of the Grand Tour*, 1967; Sir G. Clark, *The Seventeenth Century*, 1960; K. Clark, *Landscape into Art*, 1949; A. Cobban, *The Eighteenth Century*, 1969; C. J. Friedrich, *The Age of the Baroque 1610–1660*, 1952; F. Haskell, *Patrons and Painters*, 1963; A. Hauser, *The Social History of Art*, 1962; R. Huyghe (ed.), *Larousse Encyclopaedia of Renaissance and Baroque Art*, 1964; M. Kitson, *The Age of Baroque*, 1966; J. Lees-Milne, *Baroque Europe*, 1966; M. Levey, *Rococo to Revolution*, 1966; N. Pevsner, *An Outline of European Architecture*, Jubilee ed. 1960; H. T. Roper (ed.), *The Age of Expansion*, 1968; A. Schönberger and H. Soehner, *The Age of Rococo*, 1960; S. Sitwell, *Southern Baroque Art*, 1924; V. L. Tapié, *The Age of Grandeur*, 1960; H. Wölfflin, *Renaissance and Baroque*, 1964; *Principles of Art History*, 1932.

II LITERARY SOURCES

G. P. Bellori, *Le Vite de' Pittori, Scultori et Architetti Moderni*, 1672; J. B. Dubos, *Critical Reflections upon Poetry and Painting*, 1719; J. Forsyth, *Remarks on Antiquities, Arts and Letters during an Excursion in Italy, in the years 1802 and 1803*, 1813; W. Hogarth, *The Analysis of Beauty*, 1753 (ed. J. Burke 1955); C. Lebrun, *Méthode pour apprendre à dessiner les Passions*, 1667; G. P. Lomazzo, *Trattato dell'arte*

della pittura, 1584; R. Magurn (ed.), *The Letters of P. P. Rubens*, 1955; F. Milizia, *Dizionario delle belle Arti*, 1797; M. Misson, *A New Voyage to Italy*, 5th ed., 4 vols 1739; Sir J. Reynolds, *Discourses on Art*, ed. R. R. Wark, 1959; A. A. Cooper, 3rd Earl of Shaftesbury, *Characteristicks of Men, Manners, Opinions, Times*, 3 vols 1714; Watelet and Levesque, *Dictionnaire des Arts*, 5 vols 1792; M. Woodall (ed.), *The Letters of Thomas Gainsborough*, rev. ed. 1963; see also E. G. Holt, *The Literary Sources of Art History*, 1947, revised and expanded as *A Documentary History of Art*, 2 vols 1958.

III CHAPTER ONE – GENERAL

J. Lees-Milne, *Baroque in Italy*, 1959; A. McComb, *Baroque Painters in Italy*, 1934; E. K. Waterhouse, *Baroque Painting in Rome*, 1937, *Italian Baroque Painting*, 1962; R. Wittkower, *Art and Architecture in Italy 1600–1750*, 2nd ed. 1965.

INDIVIDUAL ARTISTS

Caravaggio W. Friedländer, *Caravaggio Studies*, 1955; R. Hinks, *Michelangelo Merisi da Caravaggio*, 1953; M. Kitson, *The Complete Paintings of Caravaggio*, 1969.

Carracci G. P. Bellori (trans. C. Engass), *The Lives of Annibale and Agostino Carracci*, 1968; J. R. Martin, *The Farnese Gallery*, 1968; D. Posner, *Annibale Carracci*, 1971; R. Wittkower, *The Drawings of the Carracci at Windsor Castle*, 1952.

IV CHAPTER TWO – GENERAL

A. de Rinaldis, *Neapolitan Painting of the Seicento*, 1929; D. Mahon, *Studies in Seicento Art and Theory*, 1947; A. Moir, *The Italian Followers of Caravaggio*, 2 vols 1967. See also the works listed under Section III, General above.

INDIVIDUAL ARTISTS

Baccicio R. Engass, *The Painting of Baccicio*, 1964

Cortona G. Briganti, *Pietro da Cortona e la pittura barocca*, 1962

Domenichino E. Borea, *Domenichino*, 1965; J. Pope-Hennessy, *The Drawings of Domenichino at Windsor Castle*, 1948

Guercino D. Mahon, *Studies in Seicento Art and Theory*, 1947

Pozzo R. Marini, *Andrea Pozzo pittore*, 1959

Preti C. Refice Taschetta, *Mattia Preti*, 1961 and 1970

Reni C. Gnudi and G. C. Cavalli, *Guido Reni*, 1955

Rosa L. Salerno, *Salvator Rosa*, 1963

Sacchi H. Posse, *Der römische Maler Andrea Sacchi*, 1925.

V CHAPTER THREE – GENERAL

G. Kubler and M. Soria, *Art and Architecture in Spain and Portugal 1500–1800*, 1954; J. Gudiol, *The Arts of Spain*, 1965; J. Lees-Milne, *Baroque in Spain and Portugal*, 1960.

INDIVIDUAL ARTISTS

Cano H. E. Wethey, *Alonso Cano*, 1955

Murillo C. B. Curtis, *Velazquez and Murillo*, 1883; S. Monteto, *Murillo*, 1932

Ribera E. du Gué Trapier, *Ribera*, 1952

Velasquez C. Justi, *Velazquez and his Times*, 1889; E. Lafuente-Ferrari, *Velazquez*, 1944; J. Lopez-Rey, *Velazquez : A Catalogue raisonné of his oeuvre*, 1963; *Velazquez' Work and World*, 1968; R. A. M. Stevenson, *Velazquez*, rev. ed. 1962; E. du Gué Trapier, *Velazquez*, 1948

Zurbarán M. Soria, *The Paintings of Zurbaran*, 2nd ed. 1955.

VI CHAPTER FOUR – GENERAL

A. F. Blunt, *Art and Architecture in France 1500–*

1700, 3rd ed. 1970; J. Thuillier and A. Chatelet, *French Painting from Le Nain to Fragonard*, 1964.

INDIVIDUAL ARTISTS

Champaigne A. M. de Poncheville, *Philippe de Champaigne*, 1938

Claude M. Röthlisberger, *Claude Lorrain : The Paintings*, 2 vols 1961, *Claude Lorrain : The Drawings*, 2 vols 1968

De La Tour F. G. Pariset, *Georges de la Tour*, 1948

Le Brun P. Marcel, *Charles Le Brun*, 1909

Poussin A. F. Blunt, *Nicolas Poussin*, 2 vols 1967, *The Paintings of Nicolas Poussin : a critical catalogue*, 1966; W. Friedländer, *Nicolas Poussin, a new approach*, 1966.

VII CHAPTER FIVE – GENERAL

C. H. Collins Baker, *Lely and the Stuart Portrait Painters*, 2 vols 1912; E. Fromentin, *The Masters of Past Time*, 1948, ed. M. Shapiro as *The Old Masters of Belgium and Holland*, 1963; H. Gerson and E. H. ter Kuile, *Art and Architecture in Belgium 1600–1800*, 1960; J. Lassaigne and R. L. Deleroy, *La Peinture Flamande*, 1958; E. K. Waterhouse, *Painting in Britain 1530–1790*, 3rd ed. 1969.

INDIVIDUAL ARTISTS

Brouwer G. Knuttel, *Adriaen Brouwer*, 1962

Jordaens L. van Puyvelde, *Jordaens*, 1953

Lely R. B. Beckett, *Peter Lely*, 1951

Rubens J. Burckhardt (ed. H. Gerson), *Recollections of Rubens*, 1950; J. Fletcher, *Rubens*, 1968; J. Held, *Rubens : Selected Drawings*, 2 vols 1959; L. van Puyvelde, *Rubens*, 1952, *The Sketches of Rubens*, 1947; M. Rooses, *Rubens*, 2 vols 1904; W. Stechow, *Rubens and the Classical Tradition*, 1968; C. White, *Rubens and his World*, 1968

Teniers A. Wauters, *David Teniers*, 1897

Van Dyck L. Cust, *Anthony van Dyck*, 1900; L. van Puyvelde, *Van Dyck*, 1950.

VIII CHAPTER SIX – GENERAL

L. Bergström, *Dutch Still-Life Painting of the 17th Century*, 1956; W. Bernt, *The Netherlandish Painters of the Seventeenth Century*, 1970; L. Preston, *Sea and River painters of the Netherlands*, 1937; J. Rosenberg, S. Slive and E. H. ter Kuile, *Dutch Art and Architecture 1600–1800*, 1966; W. Stechow, *Dutch Landscape Painting of the 17th Century*, 2nd ed. 1968.

INDIVIDUAL ARTISTS

De Hooch C. H. Collins Baker, *Pieter de Hooch*, 1925

De Witte I. Manke, *Emmanuel de Witte*, 1963

Hals H. P. Baard, *Frans Hals: the Civic Guard portrait groups*, 1949; S. Slive, *Frans Hals*, 1970; N. S. Trivas, *The Paintings of Frans Hals*, 1941.

Rembrandt O. Benesch, *Rembrandt as a Draughtsman*, 1960; K. Clark, *Rembrandt and the Italian Renaissance*, 1966; H. Gerson, *Rembrandt Paintings*, 1968; L. Münz, *Rembrandt's Etchings*, 2 vols 1952; J. Rosenberg, *Rembrandt, Life and Work*, 3rd ed. 1968; S. Slive, *Rembrandt and his Critics*, 1953; C. White, *Rembrandt as an Etcher*, 1969; *Rembrandt and his World*, 1964.

Ruisdael J. Rosenberg, *Jacob van Ruisdael*, 1928

Steen W. Martin, *Jan Steen*, 1954

Vermeer L. Gowing, *Vermeer*, rev. ed. 1970; P. T. A. Swillens, *Johannes Vermeer painter of Delft*, 1950; A. B. de Vries, *Jan Vermeer van Delft*, 1948.

IX CHAPTER SEVEN – GENERAL

M. S. Briggs, *Baroque Architecture*, 1913; P. and C. Cannon-Brookes, *Baroque Churches*, 1969; T. H. Fokker, *Roman Baroque Art*, 1938; J. Lees-Milne, *Baroque in Italy*, 1959; G. Masson, *Italian Villas and Palaces*, 1959; H. A. Millon, *Baroque and Rococo Architecture*, 1961; J. Pope-Hennessy, *Italian High Renaissance and Baroque Sculpture*, rev. ed. 1971; R. Wittkower, *Art and Architecture in Italy 1600–1750*, 2nd ed. 1965.

INDIVIDUAL ARTISTS

Bernini F. Baldinucci (trans. C. Engass), *The Life of Bernini*, 1966; H. Hibbard, *Bernini*, 1965; R. Pane, *Bernini architetto*, 1953; R. Wittkower, *Gian Lorenzo Bernini, Sculptor of the Roman Baroque*, 2nd ed. 1966.

Borromini P. Portoghesi, *Borromini*, 1968

Guarini P. Portoghesi, *Guarino Guarini*, 1956

Longhena C. Semenzato, *L'Architettura de Baldassare Longhena*, 1954

Maderno U. Donati, *Carlo Maderno*, 1957

Rainaldi E. Hempel, *Carlo Rainaldi*, 1919.

X CHAPTER EIGHT – GENERAL

R. Blomfield, *History of French Architecture 1494–1661*, 1911, *History of French Architecture 1661–1774*, 1921; A. F. Blunt, *Art and Architecture in France 1500–1700*, 3rd ed. 1970; K. Downes, *English Baroque Architecture*, 1966; H. Gerson and E. H. ter Kuile, *Art and Architecture in Belgium 1600–1800*, 1960; E. Hempel, *Baroque Art and Architecture in Central Europe*, 1965; G. Kubler and M. Soria, *Art and Architecture in Spain and Portugal 1500–1800*, 1954; P. Lavedan, *French Architecture*, 1956; J. Lees-Milne, *Baroque in Spain and Portugal*, 1960; J. Rosenberg, S. Slive and E. H. ter Kuile, *Dutch Art and Architecture 1600–1800*, 1966; Sir J. Summerson, *Architecture in Britain 1530–1830*, 4th ed. 1963; P. Verlet, *Versailles*, 1961; W. Weisbach, *Spanish Baroque Art*, 1941; M. D. Whinney, *English Sculpture 1530–1830*, 1964; M. D. Whinney and O. Millar, *English Art 1625–1714*, 1957.

INDIVIDUAL ARTISTS

Campen K. Fremantle, *The Baroque Town Hall of Amsterdam*, 1959

Coysevox G. Keller-Dorian, *Antoine Coysevox*, 1920

Gabriel G. Gromort, *Jacques-Ange Gabriel*, 1933

Gibbons D. Green, *Grinling Gibbons*, 1964

Girardon P. Francastel, *Girardon*, 1928

Hawksmoor K. Downes, *Hawksmoor*, 1969

Jones Sir J. Summerson, *Inigo Jones*, 1966

F. Mansart A. F. Blunt, *François Mansart*, 1941

J. H. Mansart P. Bourget and G. Cattaui, *Jules Hardouin Mansart*, 1956

Puget M. Brion, *Pierre Puget*, 1930

Vanbrugh L. Whistler, *The Imagination of Vanbrugh and his fellow artists*, 1954

Wren E. F. Sekler, *Wren and his place in European Architecture*, 1956; Sir J. Summerson, *Sir Christopher Wren*, 1953

XI CHAPTER NINE – GENERAL

M. Florisoone, *Le Dix-Huitième siècle*, 1948; F. Fosca, *The Eighteenth Century, Watteau to Tiepolo*, 1952; E. and J. de Goncourt, *French Eighteenth Century Painters*, 1948; M. Levey, *Painting in XVIIIth Century Venice*, 1959; J. Thuillier and A. Chatelet, *French Painting from Le Nain to Fragonard*, 1964.

INDIVIDUAL ARTISTS

Bellotto M. Wallis, *Canaletto, the Painter of Warsaw*, 1954

Boucher H. Macfall, *Boucher the man, his times, his art*, 1908

Canaletto W. G. Constable, *Giovanni Antonio Canal 1697–1768*, 1962; F. J. B. Watson, *Canaletto*, 1949.

Chardin G. Wildenstein, *Chardin*, rev. ed. 1969

Fragonard G. Wildenstein, *The Paintings of Fragonard*, 1960

Greuze C. Mauclair, *Greuze et son temps*, 1926

Guardi V. Moschini, *Francesco Guardi*, 1957

Longhi T. Pignatti, *Pietro Longhi*, 1969

Pannini F. Arisi, *G. P. Pannini*, 1961

Piranesi A. H. Mayor, *Giovanni Battista Piranesi*, 1952

Robert P. de Nolhac, *Hubert Robert*, 1910

Solimena F. Bologna, *Francesco Solimena*, 1958

Tiepolo A. Morassi, *G. B. Tiepolo, his life and work*, 1955, *A Complete Catalogue of the Paintings of G. B. Tiepolo*, 1962.

Vernet F. Ingersoll-Smouse, *Joseph Vernet peintre de marine*, 1926

Watteau H. Adhémar, *Watteau, sa vie, son oeuvre*, 1950; A. Brookner, *Watteau*, 1967.

XII CHAPTER TEN – GENERAL
E. Croft-Murray, *Decorative Painting in England*, 1962; E. Waterhouse, *Painting in Britain 1530–1790*, 3rd ed. 1969.

INDIVIDUAL ARTISTS
Gainsborough E. K. Waterhouse, *Thomas Gainsborough*, 1958

Hogarth F. Antal, *Hogarth and his place in European Art*, 1962; R. B. Beckett, *Hogarth*, 1949; A. P. Oppé, *The Drawings of William Hogarth*, 1948; R. Paulson, *Hogarth's Graphic Works*, 1965.

Ramsay A. Smart, *The Life and Art of Allan Ramsay*, 1952

Reynolds E. K. Waterhouse, *Reynolds*, 1941.

XIII CHAPTER ELEVEN – GENERAL
A. Blunt, *Sicilian Baroque*, 1968; J. Bourke, *Baroque*

Churches of Central Europe, 1962; P. and C. Cannon-Brookes, *Baroque Churches*, 1969; Lady Dilke, *French Architects and Sculptors in the 18th century*, 1900; G. H. Hamilton, *The Art and Architecture of Russia*, 1954; E. Hempel, *Baroque Art and Architecture in Central Europe*, 1965; H. R. Hitchcock, *Rococo Architecture in Southern Germany*, 1968; C. Hussey, *The Picturesque*, 1927, 1967; F. Kimball, *The Creation of the Rococo*, 1943, 1964; G. Kubler and M. Soria, *Art and Architecture in Spain and Portugal 1500–1800*, 1954; H. A. Millon, *Baroque and Rococo Architecture*, 1961; (N. Pevsner), *Rococo Art from Bavaria*, 1956; A. Schönberger and H. Soehner, *The Age of Rococo*, 1960; S. Sitwell, *German Baroque Art*, 1927; Sir J. Summerson, *Architecture in Britain 1530–1830*, 4th ed. 1963; M. D. Whinney, *Sculpture in Britain 1530–1830*, 1964.

INDIVIDUAL ARTISTS
Bouchardon A. Roserot, *Edmé Bouchardon*, 1910

Falconet L. Réau, *Etienne Maurice Falconet*, 1922

Fischer von Erlach H. Sedlmayr, *Johann Bernard Fischer von Erlach*, 1956

Fontana E. Coudenhove-Erthal, *Carlo Fontana und die Architektur des römischen Spätbarock*, 1930

Günther A. Schönberger, *Ignaz Günther*, 1954

Houdon H. A. Rostrup, *J. A. Houdon*, 1942

Juvarra L. Rovere, V. Viale and A. E. Brinckmann, *Filippo Juvarra*, 1937

Neumann M. H. von Freeden, *Balthasar Neumann, Leben und Werk*, 1962

Pöppelmann H. Hettner, *Der Zwinger in Dresden*, 1874

Prandtauer H. Hantsch, *Jakob Prandtauer*, 1926

Roubiliac K. A. Esdaile, *Life of Roubiliac*, 1928

Rysbrack M. I. Webb, *Michael Rysbrack, sculptor*, 1954

Serpotta O. Ferrari, *Serpotta (I Maestri della Scultura)*, 1966

Vanvitelli F. Fichera, *Luigi Vanvitelli*, 1937

Vittone P. Portoghesi, *Bernardo Antonio Vittone*, 1961.